THE SECRET LANGUAGE OF

CLOR

SCIENCE, NATURE, HISTORY, CULTURE, BEAUTY OF RED, ORANGE, YELLOW, GREEN, BLUE & VIOLET

JOANN ECKSTUT AND ARIELLE ECKSTUT

DESIGNED BY
EIGHT AND A HALF
BROOKLYN, NY

8 1/2

BLACK DOG
& LEVENTHAL
PUBLISHERS

Published by
BLACK DOG AND LEVENTHAL PUBLISHERS, INC.
151 West 19th Street New York, NY 10011

Distributed by
WORKMAN PUBLISHING COMPANY
225 Varick Street New York, NY 10014

Manufactured in China

Cover and interior designed by
EIGHT AND A HALF, BROOKLYN, NY
8point5.com

ISBN-13: 978-1-57912-949-1

h g f e d c b

Library of Congress Cataloging-in-Publication Data
available upon request.

For Olive

(NOT THE COLOR, BUT OUR COLORFUL GIRL)

CONTENTS

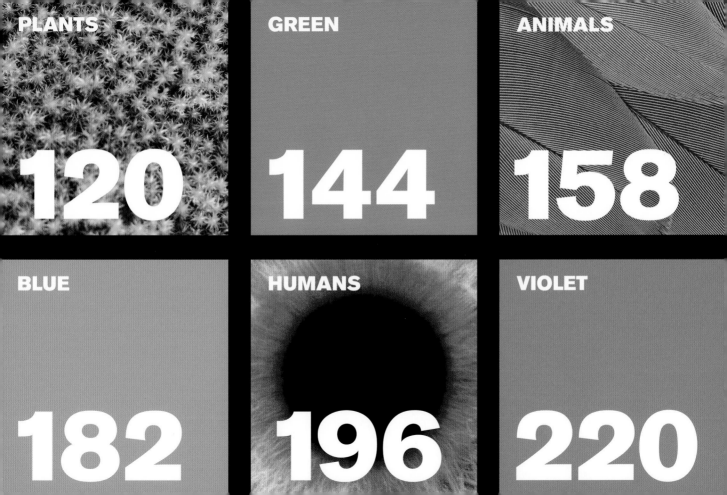

PLANTS	GREEN	ANIMALS
120	**144**	**158**

BLUE	HUMANS	VIOLET
182	**196**	**220**

Anyone who claims to be an expert on color is a liar. A true expert would have to be fluent in physics, chemistry, astronomy, optics, neuroscience, geology, botany, zoology, human biology, linguistics, sociology, anthropology, art history, and cartography; and the list goes on and on. We thought we were color experts before we wrote this book, but we were brought to our senses by the breadth and depth of the material.

Now we like to describe ourselves as color tourists who traveled the world of color–its jungles, deserts, cities, forests, rural villages, seas, monuments, and museums–and made it back alive. Along the way, we collected our favorite things.

Perhaps the most important thing we learned in our travels, the thing that explains why color is so omnipresent in our lives is this: more than 80 percent of the activity in the neocortex (the part of our brain that deals with everything from language to movement to problem solving) comes via our eyes. The vast majority of information we process from the outside world is visual. And everything we see is colored.

WATER, A RAW MATERIAL, INDISPENSABLE TO LIFE.

—FERNAND LEGER

Why all this visual processing? We happen to live on a planet bathed in sunlight. Because of this sunlight we, and many of our fellow living things, evolved to see color. For millions of years, color has served as a map to life on our planet. Our world is color-coded so that all living creatures know what or whom to attract, what to eat, when to be afraid, and how to behave. In other words, color colors nearly everything we do.

Whether you see red, are a shrinking violet, are green with envy, talk a blue streak, or are in a black mood, we hope that our book will celebrate, illuminate, and paint a colorful picture of this amazing force of nature.

A note on the organization of the book: As we researched the subject of color, we found that the information we wanted to share naturally divided itself into two groups: stuff that relates specifically to the hues of the visible spectrum and stuff that relates to the influence of color in physics and chemistry, the universe, planet Earth, plants, animals, and humans. Hence, the organization of this book, which alternates between these two types of chapters.

PHYSICS AND CHEMISTRY

Plato, Newton, Da Vinci, Goethe, Einstein: All these great minds and many more grappled with the profound complexity of color. They sought to understand it, creating systems to explain its mysterious workings.

Some fared better than others, and from the vantage point of our current scientific knowledge, many of their attempts now seem funny, bizarre, or downright fantastic. In the fifth century BC, Plato drew a causal relationship between color vision and the tears in our eyes. The eighteenth–and nineteenth-century philosopher Johann Wolfgang von Goethe tried to impose order on color's chaos by arranging hues into three groups: powerful, gentle/soft, and radiant/splendid. Although we've come a long way in our understanding of color, much remains a mystery.

Color is everywhere, but most of us never think to ask about its origins. The average person has no idea why the sky is blue, the grass green, the rose red. We take such things for granted. But the sky is not blue, the grass is not green, the rose is not red. It has taken us centuries to figure this out.

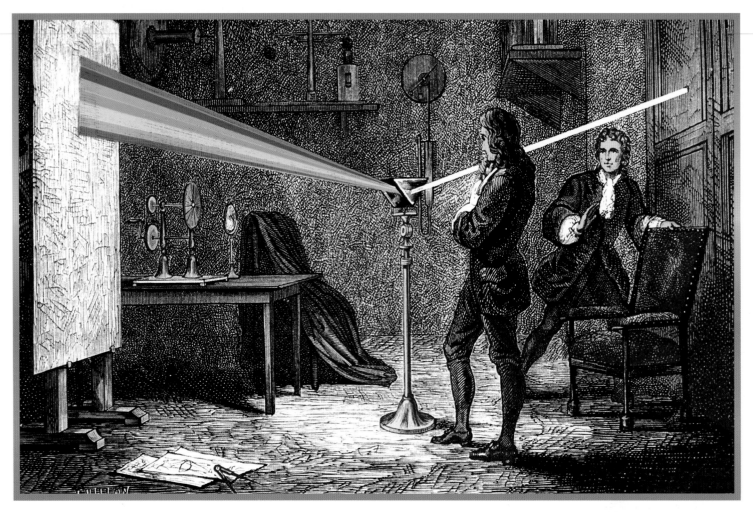

In a very dark chamber, at a round hole, about one-third part of an inch broad, made in the shut of a window, I placed a glass prism, whereby the beam of the Sun's light, which came in that hole, might be refracted upwards toward the opposite wall of the chamber, and there form a colored image of the sun.

—Sir Isaac Newton, *Opticks*

It stands to reason that for thousands of years, many casual observers must have seen what Newton did: that light passing through a prism creates a rainbow on the surface where it lands; but Newton saw something no one else had seen. He deduced that the white light that appears to surround us actually contains all the different colors we find in a rainbow. White was not separate from these colors—or a color unto itself—but was the result of all colors being reflected at once. This counterintuitive and revolutionary theory did not take hold easily. Some of those greatest minds we mentioned simply wouldn't accept this theory. The idea that white light contained all color upset Goethe so that he refused—and demanded others refuse—even to attempt Newton's experiment.

NEWTON'S PRISM Although Newton's discovery was more than enough to upset his contemporaries' digestion, he didn't stop there; Newton also ascertained that colors refracted through a prism could not be changed into other colors. Here's how he did it. He took a prism and placed it between a beam of light (coming from the hole in his window shutters) and a board with a small hole in it.

The hole in the board was small enough that it only allowed one of the refracted colors to pass through it. He then placed all kinds of materials (including a second prism) in front of the beam passing through the small hole to try to alter the refracted color passing through the small hole. Prior to the experiment, he had believed that if, for example, a blue piece of glass was placed in front of a red beam of light, the red would be transformed into another color. But he found that this was not the case. No matter what color or type of material he placed in front of an individual beam of light, he couldn't get the refracted color to change. From this experiment, he deduced that there was a certain number of what he called "spectral" colors—colors that cannot be broken down, colors that are fundamental.

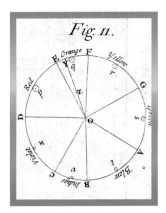

Here's Newton's own color wheel containing red, orange, yellow, green, blue, indigo, and violet.

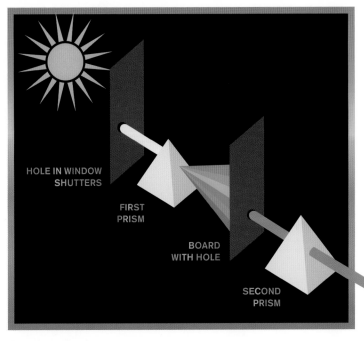

Newton's experiment.

Once Newton confirmed that his spectral colors were unchangeable, he decided to name them—and here's where his method takes a left turn from the scientific to the fanciful. Taken with the idea that the rainbow should reflect the musical scale, Newton decided to name his colors in accordance with aesthetics. There are seven main tones in the musical scale, so Newton came up with seven corresponding colors. Hence the origin of ROYGBIV, the acronym by which we know Newton's seven spectral colors—red, orange, yellow, green, blue, indigo, and violet.

Although the relationship to music was later set aside by scientists who questioned the basis for comparison, ROYGBIV is still used today as a teaching tool, even though indigo is not a color most people can even identify.

The truth is, there's no perfect way to name the colors of the rainbow. Take a look at a real rainbow (as opposed to a kindergartner's felt-tip rendition), and you'll see that its colors merge seamlessly from one to the other. Any judgment on where one color ends and the other begins is arbitrary. Even Newton waffled on this point. At the beginning of his experimentation, his spectrum included eleven colors. Once he'd whittled the number down to seven, he still thought of orange and indigo as less important, calling them semitones in another nod to the musical scale.

There's another issue with naming the colors of the rainbow: The language of color is fluid, morphing over time and across geographies in response to cultural forces that are sometimes too complex to pin down. For example, the color Newton called indigo is the one most people would identify as plain old blue or a true blue that falls midway between green and violet. Newton's blue is what we now call cyan, a more turquoise blue that falls between blue and green.

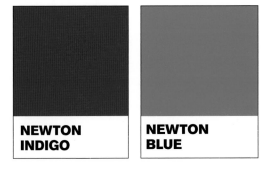

NEWTON INDIGO NEWTON BLUE

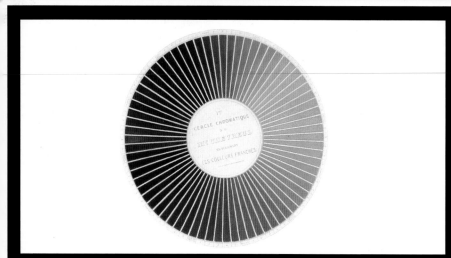

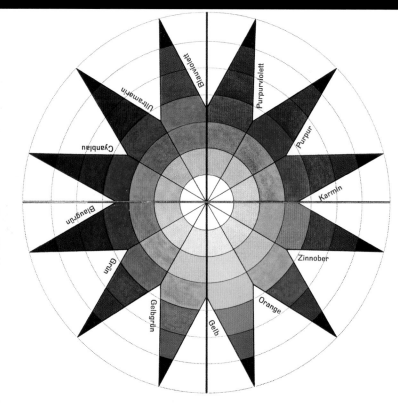

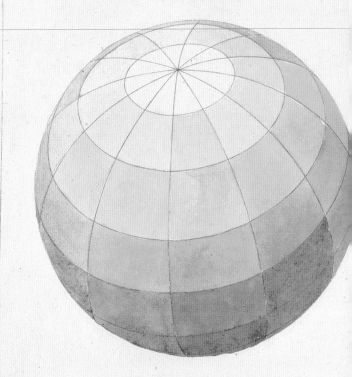

Ansicht des weissen Poles.

Durchschnitt durch den Aequator.

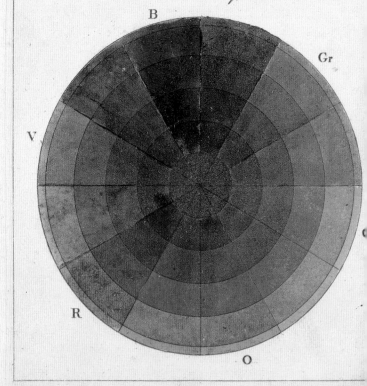

(Top) Michel-Eugene Chevreul (1786-1889) was a French chemist who developed a 72-hue color circle. As pretty as this color wheel is, Chevreul was best known for defining the idea of simultaneous contrast, or how colors interact with one another. (Bottom) Johannes Itten (1888-1967) was a Swiss Expressionist painter and member of the Bauhaus, the famed German design school. He, like Chevreul, was fascinated with simultaneous contrast, and built on the work of his predecessors (including Phillip Otto Runge), to develop this color star. (Center) Phillip Otto Runge (1777-1819) was a German painter and contemporary of Geothe's who developed the sphere model of color. Despite being a Romantic who favored intuition over logic, Runge organized color with white at the top axis, black at the bottom and blue, red, and yellow as primaries.

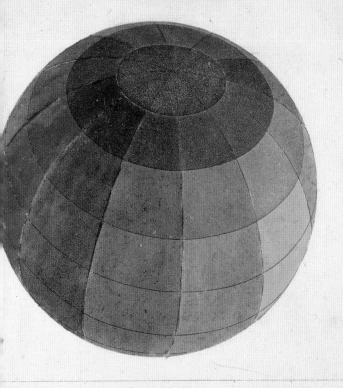

kugel.

Ansicht des schwarzen Poles.

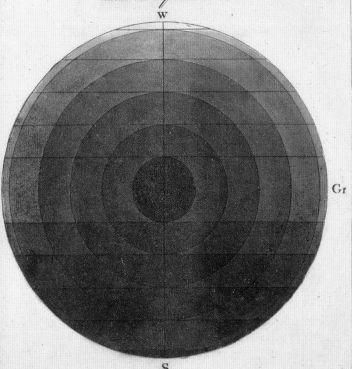

Durchschnitt durch die beyden Pole.

W

Gr

S

(Top) Albert Henry Munsell (1858-1918) was an American painter who gave us the color vocabulary those trained in color use today: hue, value, and chroma. These three attributes led to a unique three-dimensional color system, pictured here. But the color system that dominates today was developed in 1931 by the International Commission on Illumination (CIE). The CIE was the first color system to take into account how our brains actually perceive color (bottom). It dispensed with the idea of color wheels and spheres altogether and instead developed a mathematical model based on the sensitivity of our photoreceptors.

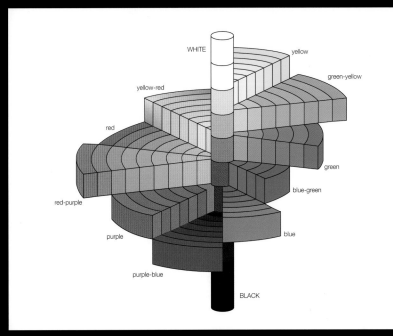

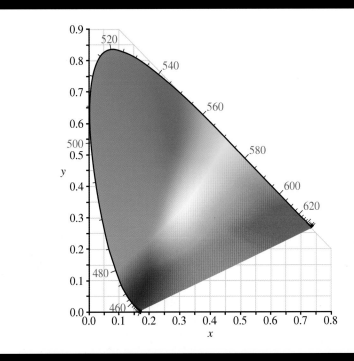

As for the name of the last color in the rainbow, why is it violet as opposed to purple? Violet refers to the spectral color that looks bluish purple. Purple refers not to a spectral color but to a color created by a mix of light.

Color systems pre-and post-Newton have codified a whole host of fundamental colors. By fundamental, we mean colors that our linguistic or scientific models don't allow us to reduce any further. Today, if you were asked to categorize the color navy, you would probably call it a dark blue. If forced to generalize it even further, you would just say it's a shade of blue, but there's nowhere to go from there. Throughout history, our cultural understanding of fundamental colors has shifted dramatically, ranging from the stark black and white model (where colors were categorized merely by how dark or light they were) to systems made up of dozens of colors, to systems in which some combination of red, yellow, blue, green, and sometimes orange and violet/purple typically reigns.

Today, we consider red, orange, yellow, green, blue, and violet as fundamental. These fundamental colors are referred to as hues. Although a color's value (put simply, how dark or light it is) and its chroma (put simply, how dull or bright it is) can change, its hue is essential to its identification.

Regardless of their number, the colors Newton called spectral should not be confused with the colors we've been taught are the primary colors that cannot be mixed and are therefore fundamental (i.e., red, blue, and yellow) or the class of shades known as secondary colors (i.e. orange, green, and purple). These secondary colors, we've been taught, result from the mixing of the primary colors—red and yellow make orange, red and blue make purple, and blue and yellow make green—and therefore are not fundamental. But what Newton found was that orange, green, and violet (which, to repeat, differs from purple) can be spectral and just as fundamental as the colors we call primary. Orange, for example, can result from a mix of light, but it can also be pure. The same is true for red, blue, and yellow, even though we call them "primaries." You can tell a color that is a mixture of light from a spectral color by passing the light through a prism. The orange light that is a mix will break into its components when passed through a prism, but pure orange light will not.

Another major "aha moment" would soon follow for Newton: the discovery that when red light was passed through a prism, it bent only slightly, whereas violet light bent much more. This intriguing observation led Newton to believe that each color was made up of unique essential components. What made red red is different from what made violet violet. Although he was on the right track, Newton incorrectly hypothesized that light is composed of particles that travel in a straight line through some kind of ether. What he called his "particle theory" was eventually widely accepted.

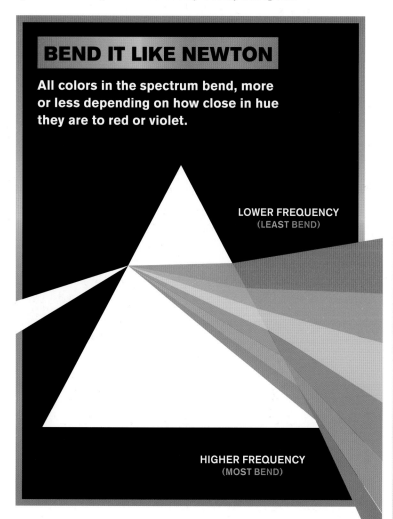

BEND IT LIKE NEWTON

All colors in the spectrum bend, more or less depending on how close in hue they are to red or violet.

LOWER FREQUENCY
(LEAST BEND)

HIGHER FREQUENCY
(MOST BEND)

Fast forward to the beginning of the nineteenth century, when an English scientist named Thomas Young returned to a notion put forth by some of Newton's contemporaries. Although Newton was convinced that light is a particle, Young's experiments led him to believe that light—like sound—is a wave. Another half-century later, the venerable James Clerk Maxwell took Young's work and made a giant leap.

JAMES CLERK MAXWELL AND THE REIGN OF ELECTRO-MAGNETISM Before James Clerk Maxwell's work, electricity and magnetism were believed to be two separate forces, but Maxwell found the forces to be connected, and he called this interconnection *electromagnetism*. Maxwell showed how charged particles repel or attract one another, as well as how these charged particles act like waves as they travel through space.

A particularly exciting part of Maxwell's treatise on the subject showed that a specific group of electromagnetic waves is the cause of visible light—in other words, the cause of color. He identified other groups of electromagnetic waves, too, groups we now recognize as ultraviolet light, radio waves, x-rays, and microwaves, to name a few. All of these fall on the electromagnetic spectrum, and each is measured and defined by its length and frequency, which are inversely proportional. Every color has a different length and frequency, as does every microwave, radio wave, or other wavelength on the electromagnetic spectrum; but there is no essential quality separating visible light from these other kinds of waves—except that our eyes (or to be more precise, our brains) can perceive them as color.

To get a handle on exactly what length and frequency are all about, imagine you are holding one end of a jump rope. Another

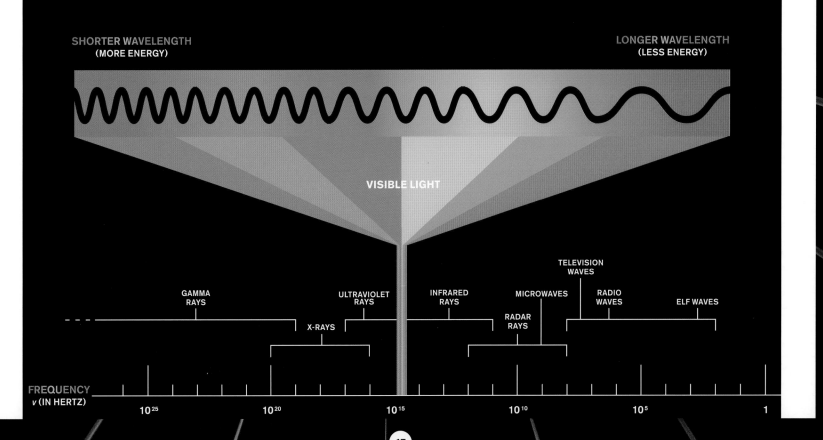

ON THE SAME WAVELENGTH

All electromagnetic radiation (just another word for the movement of a wave through an electromagnetic field) travels through a vacuum at the stupendous speed of 186,282 miles per second, also known as the speed of light. As you can see, the visible spectrum is just a tiny band of the elecromagnetic spectrum.

SHORTER WAVELENGTH
(MORE ENERGY)

LONGER WAVELENGTH
(LESS ENERGY)

VISIBLE LIGHT

TELEVISION WAVES

GAMMA RAYS

ULTRAVIOLET RAYS

INFRARED RAYS

MICROWAVES

RADIO WAVES

ELF WAVES

RADAR RAYS

X-RAYS

FREQUENCY
v (IN HERTZ)

10^{25}　　10^{20}　　10^{15}　　10^{10}　　10^{5}　　1

person stands a few feet away holding the other end. If you move your hand up and down slowly, the movement will create one big arc—or wave—in the center of the jump rope. Move your hand a little faster, and you will get several waves occupying the same space as the single, big wave. Move your hand faster still, and you will get many more waves that are even closer together. The distance between the peak of one wave and the peak of the next wave is the wavelength. The frequency is the number of waves per second. As demonstrated via the jump rope, the smaller the wavelength, the higher the frequency (or number) of waves.

Violet is the color with the shortest wavelength of visible light, at 380 to 450 nanometers (one nanometer is equal to one-billionth of a meter), but the highest frequency at 789 to 668 THz (or terahertz, which is the unit for frequency). On the spectrum of electromagnetic radiation, it is the wave that is closest to ultra-violet and x-rays. Red has the longest wavelength, at 620 to 740 nanometers, but the lowest frequency of visible light is at 480 to 400 THz, closest to infrared and microwaves.

Once Maxwell had shown visible light to be just one piece of the electromagnetic puzzle, other pieces of the puzzle started falling into place—or falling out of place. The scientist Max Planck remained dissatisfied by Maxwell's theory that light was just a wave. His experiments pointed to another dimension of light that he couldn't quite put his finger on. Enter Albert Einstein, who took the reins and eventually settled on the idea that light is indeed not just a wave, but also a particle.

The fact that light can act at times like waves and at times like particles—a phenomenon called the *wave-particle duality of nature*—defies common sense, but it is the best explanation scientists have found. The wave-particle duality of nature led to quantum mechanics, which of all the branches of physics has arguably had, directly or indirectly, the most influence on our current understanding of the origins and workings of the universe.

THE REAL PRIMARY COLORS In addition to determining the physical properties of color, scientists began to ask questions about our perception of color. Why and how do we see color? The answers to these questions lead us down a path that will counter almost everything you've ever learned about color. Take the "white" light Newton was passing through his prism. Newton's conclusion was that all the colors of the rainbow combined to create white. But if you mix red, orange, yellow, green, blue, and violet paint in your palette, you get anything but white. (This, by the way, was the source of Goethe's extreme skepticism about

Newton's theories—he had watched painters mix paint in their palettes and had never seen a multitude of colors add up to white.)

Newton was not dealing with paint, however; he was dealing with light, and light mixes in an entirely different fashion. The mixing of light belongs to the realm of *additive color*. When you add different wavelengths of light together, you don't get the muddy mess you see with paint and the mix doesn't always produce what you'd expect it to because, again, additive color doesn't work like paint. In fact, every color of the rainbow can be achieved by mixing only three colors of light: red, green and blue. Wait, green?

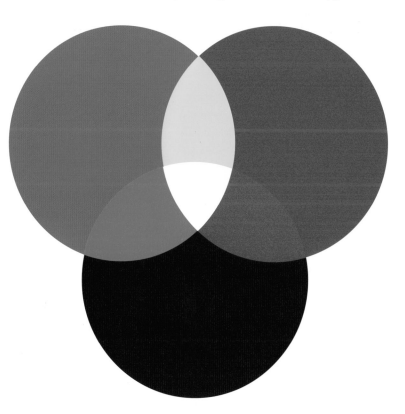

In the additive system of color red+green=yellow, red+blue=magenta, blue+green =cyan, and red+green+blue=white.

That's a different triad from the primary colors—the colors from which all others can theoretically be mixed—that we are taught about in school, namely, red, blue, and yellow. Where did green come from? And where did yellow go? These three new primary colors—red, green, and blue—make no sense from a young painter's perspective. Anyone who has ever mixed paint knows

IT'S HARD TO BELIEVE THAT
EVERYTHING YOU SEE ON YOUR
COMPUTER AND TV ARE THE
RESULT OF THESE RED, GREEN,
AND BLUE DOTS.

that you can't make yellow from any of these colors. Yet, when you mix what appears to our human eyes as red and green light, you do indeed get yellow.

You are probably more familiar than you think with this primary triad. Case in point: the RGB (red, green, blue) color model on your computer monitor. Obviously you see a wide range of colors on your screen, but if you got close to an old computer with visible pixils, you could actually see that the screen is entirely made up of red, green, and blue dots. The same is still true today; the dots are just harder to see. If you took a magnifying glass to your screen, you'd see that magenta type, a field of pumpkins, and a dull brown bunny were all composed of these red, green, and blue dots. A white screen is the result of all three colors lighting up at the same maximum intensity, and a black screen is the result of the absence of color.

James Clerk Maxwell created this first color photographs in 1861.

Televisions and cameras also use an RGB color model, as does theater lighting. Similarly, the first color photography (a feat conducted by none other than James Clerk Maxwell in 1861) was a product of the layering of red-filtered, green-filtered, and blue-filtered negatives on top of one another. Here again, you can see the logical underpinnings of the term additive color whereby adding colors together can beget every color of the rainbow.

Why just red, green, and blue? What was the significance of these three colors? At the beginning of the nineteenth century, Thomas Young (the physicist who came up with the wave theory of light) wanted to find out. His answer would come from a study of the human eye.

YOUR BRAIN ON COLOR If there's one color-related axiom that bears repeating, it is this: Wavelengths of light do not exist as color until we see them. Without the eyes and brain, there's no such thing as color. Light waves are colorless until the moment they hit our eyes, at which point our brains declare, "Blue sky, green grass, red rose!" Most other animals—and even some humans—won't see any of these colors when they look at the sky, the grass, or a rose because, again, none of these entities is intrinsically colored.

This idea that color does not exist outside of our perception is difficult to swallow because it counters what appears to be cold, hard reality. It took a long time for scientists even to consider a relationship between the brain and color. Aristotle, who got an amazing amount right about color way back in the fourth century BC, was convinced that color was intrinsic to the surface of an object; Newton never touched on the perceptual side of the matter.

All of the color that surrounds us is a construction of the brain. As we scan our surroundings, light enters our pupils and passes through our lenses, which focus images onto our retinas. Inside the retina, photoreceptors sense light's varying wavelengths; these photoreceptors are the key to which and how many colors we can see.

The retina boasts three types of cones, the color-sensitive photoreceptor cells. At the moment light hits our eyes and makes its way to our cones, color is merely a sensation—a purely physical phenomenon, just as sound waves hit our ears as a sensation before we hear and categorize the noise as a certain type of sound. Once our cones are activated, color is on its way to becoming a perception. Perception occurs after the brain's higher-order processing centers filter and interpret the information provided by a sensation.

YOU HAVE SOME NERVE

As light (or lack thereof) enters our retinas, our cones and rods send messages to our brain, which ultimately result in the perception of color or shades of gray.

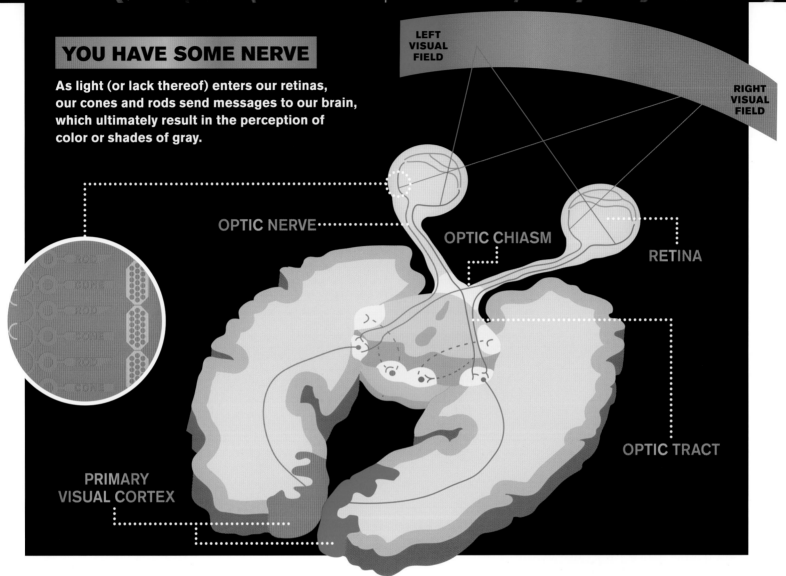

LEFT VISUAL FIELD

RIGHT VISUAL FIELD

OPTIC NERVE

OPTIC CHIASM

RETINA

OPTIC TRACT

PRIMARY VISUAL CORTEX

Here's a more detailed picture of how the process works: When light hits the retina, two kinds of nerve signals are generated: one from our rods (the photoreceptor cells that perceive low levels of light) and one from our cones (the photoreceptor cells that perceive color). These signals leave the eye via the optic nerve, traveling to a type of neural crossroads in the brain called the optic chiasm. There, the nerve signals split; half the signal from each eye moves to the opposite side of the brain along a group of axons called the optic tract. Information from the left visual field (the left side of each eyeball) travels to the right brain and vice versa. Eventually, the data connect in a specific region on the lateral surface of the thalamus (the Grand Central Station of sensory information) and is relayed to the occipital lobe, the primary visual cortex. Up to this point, the data are being processed in a very streamlined way. It's when the regions adjacent to the occipital lobe are called into action that more complex associations start to come into play. Rather than simply perceiving a red mass, the brain adds detail—large red couch, darker red pillows, a bluish stain.

The kind of cone that is activated by light, and in what amount, determines what colors we see. One type of cone senses short wavelengths (which helps us perceive blues and violets); one senses medium wavelengths (which helps us perceive greens and yellows); and one senses long wavelengths (which helps perceive reds, oranges and yellows). The cones themselves are commonly referred to as "red," "green" or "blue"—and it's no accident that they match the same trio of primary colors found in the additive color model.

By synthesizing the activity in each type of cone, our brains are able to perceive the ten million colors most of us can detect, from darkest to lightest, brightest to dullest. Although Thomas Young was not able to deduce exactly how all this transpired, he was responsible for the critical discovery that we had three kinds of receptors and that they are sensitive to red, green, or blue light.

FROM ADDITION TO SUBTRACTION Why *is* the couch red? The sky blue? The grass green? The way we perceive the color of light before it hits an object—whether the light source is the sun, a light bulb, or a computer monitor—falls in the territory of additive color. Once light hits an object or material, however—the couch you're sitting on, the paint in your room, the pages of this book—we've switched over to the realm of *subtractive color*. To explain subtractive color, to understand exactly what it is that's being taken away, we must turn from physics to chemistry.

If you look at the interlocking circles on page 18, you'll see three colors in the places where the circles overlap, namely, yellow, cyan, and magenta.

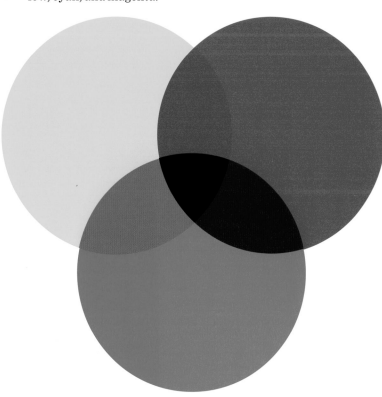

In the subtractive system of color magenta+cyan=blue, cyan+yellow=green, yellow+magenta =red, and red+green+blue=black. Note that in the places where the circles overlap, you'll find the primaries for additive color.

These are the very colors of the ink you load into a printer. As evidenced by what your printer "spits out," when mixed together, the ink from these cartridges can produce every color of the rainbow. That's because these colors, although they are secondary in the realm of additive colors, are the primary colors in the world of subtractive color: magenta, cyan, and yellow pigments are the basis for the plethora of color you see in the material objects all around you (including all those colors in the paint store).

If you're thinking that magenta, cyan, and yellow are remarkably similar to the red, yellow, and blue you used as the primary colors for mixing paint, you are correct. Unfortunately, your teacher was wrong. Art teachers and artists the world over have been following a color model developed back in the first century and then codified in the eighteenth century by Jacob Christoph Le Blon, a German painter and engraver who invented the three-color printing process comprising—you guessed it— red, yellow, and blue. Though Le Blon's color prints were beautiful, he was unable to successfully reproduce many colors. Still, his legacy lives on to this day in the form of frustrated elementary schoolchildren who are unable to mix bright greens, purples, or oranges with their standard blue, red, and yellow tempera paints. Art teachers, take pity on your charges; break out the turquoise and bright purple (or cyan and magenta, to be more precise)!

This monumental if essentially harmless mix-up also affects what we call complementary, or opposite, colors. Although we are taught that red and green, blue and orange, and yellow and purple are complementary to each other, if you draw a straight line between the subtractive and additive primaries, you'll find a more accurate model: red is the complementary of cyan, blue of yellow, and green of magenta.

All that said, the real head-scratcher in subtractive color has to do with the completely counterintuitive way we see it. To be perfectly blunt: when it comes to subtractive color, what you're seeing isn't really there at all.

With most material objects, matter absorbs (or subtracts) particular wavelengths of the visible spectrum and reflects back the remaining wavelengths. Take a red couch. The "red" fabric absorbs all the colors of the visible spectrum except for red, and then it reflects the wavelength we perceive as red light—the wavelength it doesn't absorb—back toward the observer. Once the wavelengths leave the material and are reflected back to our eyes, they revert to the additive color model, with the light mixing according to the rules of the additive color model.

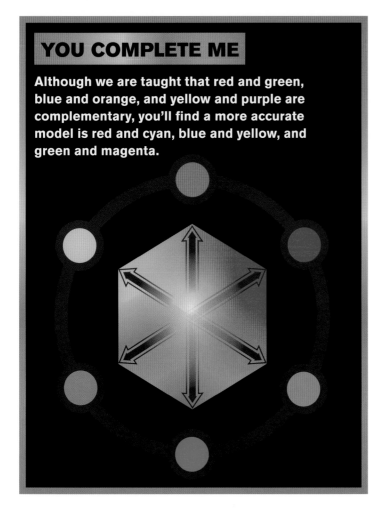

To make matters more confusing, we rarely perceive pure colors. Red fabric is likely to reflect back at least trace amounts of all the colors of the visible spectrum, even though we might not perceive their existence. That's why we see the vast number of colors that we do; there are millions of combinations of wavelengths in the visible spectrum.

BLACK AND WHITE: THE STORY OF NONSPECTRAL COLORS

How do black and white play into this mix? As Newton discovered, in the realm of additive color, white is not one color; rather, it is the product of all colors of the spectrum mixing together at once. Conversely, black is the absence of light altogether—think outer space. In the subtractive system, white is perceived when all light is reflected back from an object and black, when an object absorbs all light.

Then there's gray. Logic would lead you to believe that anything between black and white, between the absence of color and the presence of all colors, would have to be a color of some sort. This is true, except in cases when all the wavelengths of light are equally absorbed and reflected. In the case of subtractive color, if 80% of the projected wavelengths are absorbed into a gray object, you'd perceive a very dark gray, with only a small percentage of light's wavelengths reflected back into the eye. If 20% of the wavelengths were absorbed, you'd perceive a light gray, with the vast majority of wavelengths reflected.

What about brown? We think of it as a neutral color like black, white, and gray, but it's really a form of orange. The colors that surround us are rarely pure. As they mutate from dark to light and from dull to bright, innumerable gradations appear within each hue. Take pure orange, change its value by darkening it, and change its chroma by dulling it, and you'll have brown.

THE SPECIAL CASE OF MAGENTA

In the spectrum of visible light, red sits on one end and violet on the other, but if you're looking for a color between red and violet—the one we call magenta—you won't find it in the spectrum. Red being the longest wavelength and violet the shortest, there's no wavelength that spans the two. The principles of physics dictate that it is impossible to see a spectral magenta (i.e., a magenta that is not a mix of wavelengths).

The colors we refer to as purple result from an uncommon mix of red and blue or violet wavelengths, the latter of which are rare and not easily perceptible by the human eye. We only perceive a material as purple when it absorbs a narrow band of green and reflects the remaining red and blue or red and violet wavelengths back onto our retinas. This is the reason purple was so coveted before the invention of synthetic pigments.

THE CHEMISTRY OF COLOR

In the case of most material objects, the chemical makeup of a material—its particular combination of elements like carbon, oxygen, and hydrogen—is what determines what wavelengths it absorbs and reflects. Just as every color corresponds to a particular wavelength and frequency, every wavelength and frequency correspond to a quantity of energy. The electrons in the molecules that constitute a material contain varying energy levels, and the gaps between these energy levels correspond to varying wavelengths of light. Put another way, light is not a substance; it is the result of the transference of energy through matter in the form of a wave.

A review of high school physics may be in order. Remember the way those electrons orbited an atomic nucleus, much like the way planets orbit the sun? It's not a perfect analogy, but think of each of those orbits as possessing a distinct energy level. For an electron to move from one orbit to another, it has to absorb or emit a precise amount of energy. Blues are at the high-energy end of the visible spectrum, reds at the low end. A colorless material like a clear quartz crystal has energetic gaps that lie beyond the visible light spectrum (which is very small indeed), in another part of the electromagnetic spectrum; no color is perceived because we don't have photoreceptors in our retinas that are sensitive to these other forms of electromagnetic radiation.

The colors we perceive as intrinsic to objects also depend on the available light source. When the source of light changes, the number and ratio of wavelengths striking the material also change. Light sources such as the sun, fire, and incandescent light bulbs (i.e., old-fashioned glass bulbs with wire filaments) emit light via heat, or thermal radiation. Their light contains a broad spectrum of energetic frequencies and wavelengths—a broad spectrum of light. This cacophony means that the objects they strike reflect back more colors, making these objects themselves appear brighter and purer.

Light from fluorescent tubes, computer screens, and LEDs (light-emitting diodes) is created differently. Because far fewer frequencies are present in these forms of light, a material reflects fewer wavelengths back to the eye, making for duller colors, which is why your complexion can look very bright in the sunlight and much duller in fluorescent light, much to the chagrin of office workers around the world.

Although the source of light may change, the particular wavelengths absorbed or reflected by an object generally do not. A red couch will always absorb colors other than red, and it will always reflect red if there is any red light to reflect. The chemical makeup of a material (which includes dye or paint as well as what the material itself is made of) does not usually change, and it determines which wavelengths are absorbed and reflected. Why usually? Because atmospheric conditions can alter an object's chemical composition—think of the way fabric can fade in sunlight. The fading is the result of a chemical change that alters which wavelengths are absorbed and reflected.

THE METAMERISM MATCH Differences in lighting conditions can make it quite frustrating to try to match colors, especially if you're matching them in one environment and taking them home to another. The swatch of fabric that, under the rug store's fluorescent light, appears to be a perfect match for your couch might not be such a dead ringer in the incandescent light of your living room.

The fabric to the left, pictured in incandescent light, looks far brighter than the same fabric to the right, pictured in fluorescent light.

There's more to it than just the light source. If the rug and the couch were made from the same exact materials, they could be a match in both kinds of light. But if the rug and couch are made from different materials, then, even if the same dye or paint is used on both, they will absorb light differently.

Fortunately for interior designers and dedicated shoppers, precise measuring devices and complex mathematical formulas have closed the gap; an advanced matching process called metamerism makes it all possible. Used for all sorts of products in all sorts of industries—from cars to clothes to printing—metamerism is the reason your dashboard, leather seats, and steering wheel maintain their aesthetic integrity, no matter what the light conditions.

COLOR GAMES What Newton, Maxwell, Young or Einstein were unable to explain is the reason a couch can take on two different reds depending on whether it is topped with a slew of orange or blue throw pillows. It took neuroscientists to solve this mystery, which comes down to a complex set of brain-level processes that offer a fascinating challenge to our notions of reality.

The human brain is constantly gathering information and making interpretations based on what it takes in; the amount of information is so vast that the brain valiantly attempts to sequester its intake into categories to avoid overload. As it does

this work, the brain also likes to fill in gaps, fabricating "logical" conclusions to avoid perceptual quagmires. These novelistic tendencies are part and parcel of the brain's herculean efforts to prevent a full tilt shutdown in the face of hundreds of discrete pieces of sensory stimuli.

Whereas the chemistry of a given material colludes with our visual cones to present us with the perception of particular colors, the colors themselves are not actually fixed. Sometimes a color can seamlessly shift from looking more like the neighbor to its left on the electromagnetic spectrum to looking more like the neighbor on its right. Sometimes we even see color that isn't there.

COLORFUL HALOS Look at the blue lines below in this exercise, designed by psychologist Hans Wallach. You should see white in between each blue line.

In the next image, black lines were added to each side of the blue lines. Stare at the blue inside the black lines.

Between the black lines, you should see a blue "halo" or shadow that looks not unlike a blue worm. But here's the surprise: The blue pattern used in this image differs not one bit from that used in the first image. Our brains invent this blue-worm halo. Machines that measure color wouldn't register anything in this image but blue lines with white between them.

Things become even wonkier if you stare at the image for at least 15 seconds. The black lines above and below the blue appear to connect to one another, and the blue worm begins to look as if it's lying on top of these black lines.

Here's another exercise of color halos designed by psychologists Christoph Redies and Lothar Spillman that offers a great illustration of the brain's propensity for extrapolation:

Draw four red lines like this:

Then draw the same red lines, but add black lines to the end of each of the red ones, like this:

Watch a red circle appear in the middle of the image with the black lines. Stare even longer, and you'll see the black lines connect to their partners across the circle.

Simultaneous contrast is not just a curious optical phenomenon—it is the very heart of painting. Repeated experiments with adjacent colors will show that any ground subtracts its own hue from the colors which it carries and therefore influences.

—Josef Albers

Because color is interpreted by our brains, a single color has the ability to shift and change depending on the color adjacent to it. A particular red placed beside a blue will appear quite different when it is set next to an orange. This phenomenon is known as simultaneous contrast.

To understand how simultaneous contrast works, take a look at the black and white image below, designed by physicist/chemist, Robert Shapely and psychologist, James Gordon.

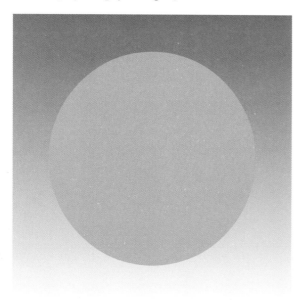

Pay particular attention to the upper and lower parts of the sphere. You'll see that the top appears to be a lighter gray than the bottom, but it's really just the gray in the square behind the circle that is changing color. It's darker at the top and lighter at the bottom. Simultaneous contrast is most evident at the points where the top and bottom edges of the sphere meet the background color.

Now look at the intersecting lines below in this exercise designed by Michael White. The gray lines on the right appear significantly lighter than the gray lines on the left. And yet a machine that measures color, will tell you they're exactly the same.

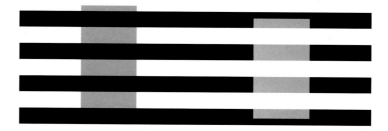

Next comes color and simultaneous contrast. Check out the squares below:

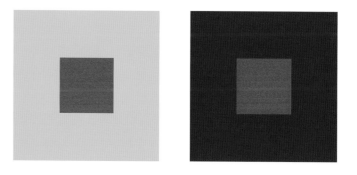

The red square on the left appears to be darker than the red square on the right. But they are exactly the same color. The same holds true for the green squares below:

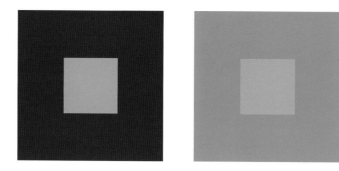

The green square on the left looks brighter than the one on the right, but the hue, just as in the last example, is the same. In each case, when the squares are placed on top of the lighter color, they look darker; placed on the darker color, they look brighter.

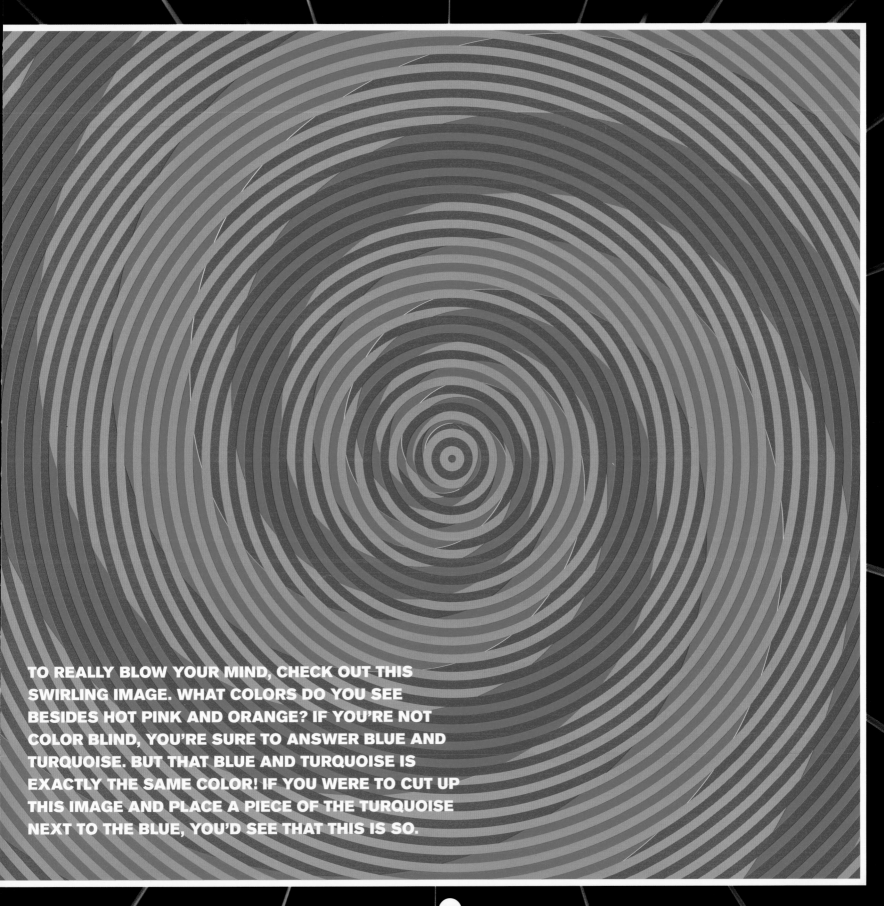

TO REALLY BLOW YOUR MIND, CHECK OUT THIS
SWIRLING IMAGE. WHAT COLORS DO YOU SEE
BESIDES HOT PINK AND ORANGE? IF YOU'RE NOT
COLOR BLIND, YOU'RE SURE TO ANSWER BLUE AND
TURQUOISE. BUT THAT BLUE AND TURQUOISE IS
EXACTLY THE SAME COLOR! IF YOU WERE TO CUT UP
THIS IMAGE AND PLACE A PIECE OF THE TURQUOISE
NEXT TO THE BLUE, YOU'D SEE THAT THIS IS SO.

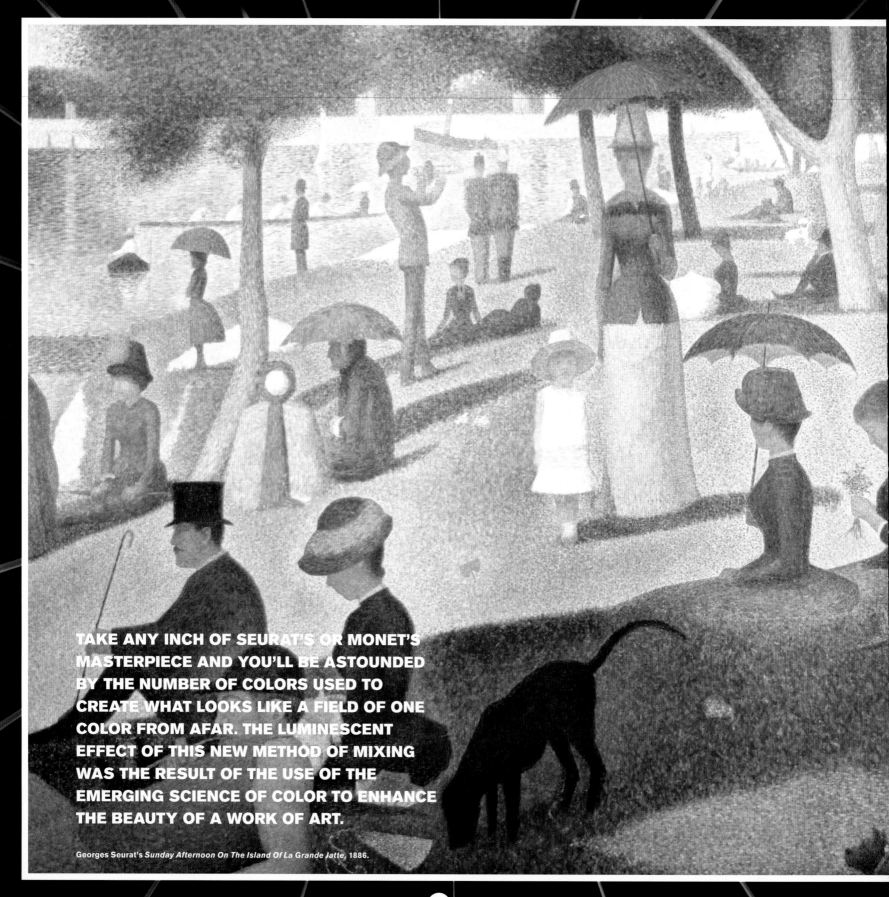

TAKE ANY INCH OF SEURAT'S OR MONET'S MASTERPIECE AND YOU'LL BE ASTOUNDED BY THE NUMBER OF COLORS USED TO CREATE WHAT LOOKS LIKE A FIELD OF ONE COLOR FROM AFAR. THE LUMINESCENT EFFECT OF THIS NEW METHOD OF MIXING WAS THE RESULT OF THE USE OF THE EMERGING SCIENCE OF COLOR TO ENHANCE THE BEAUTY OF A WORK OF ART.

Georges Seurat's *Sunday Afternoon On The Island Of La Grande Jatte*, 1886.

THE ART OF SCIENCE AND THE SCIENCE OF ART

The year 1839 saw the publication of the defining text on simultaneous contrast, *Principles of Harmony and Contrast of Colours* by chemist Michel Eugene Chevreul. Chevreul had served as the director of dyeing at a tapestry company in Paris, and he found himself fielding constant complaints about the "want of vigour" in the black pigments. He compared the manufacturer's blacks to those considered the best in the marketplace and found nothing lacking. Although these blacks looked strong on their own, he made a remarkable discovery when he put them next to other colors. When flanked by deep blue and purple, these blacks lost their intensity; when they were set next to yarns with highly contrasting colors, they looked far more saturated. This truth turned out to be extended to all colors. Place blue next to yellow (its complement), and they both pop. Set blue next to violet (which sits next to it on the color wheel), and both seem to take on properties of the other and blend.

Chevreul also noticed that the actual point of contact between two highly contrasting colors had the most "pop." The artists of the Renaissance had seen the power of this principle and made the most of it via a technique called *chiaroscuro*—the

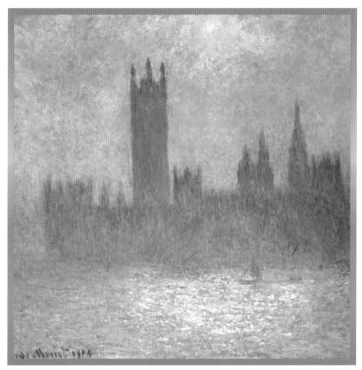

Claude Monet's *The Parliament, London, Effect of Sun in the Fog,* 1904

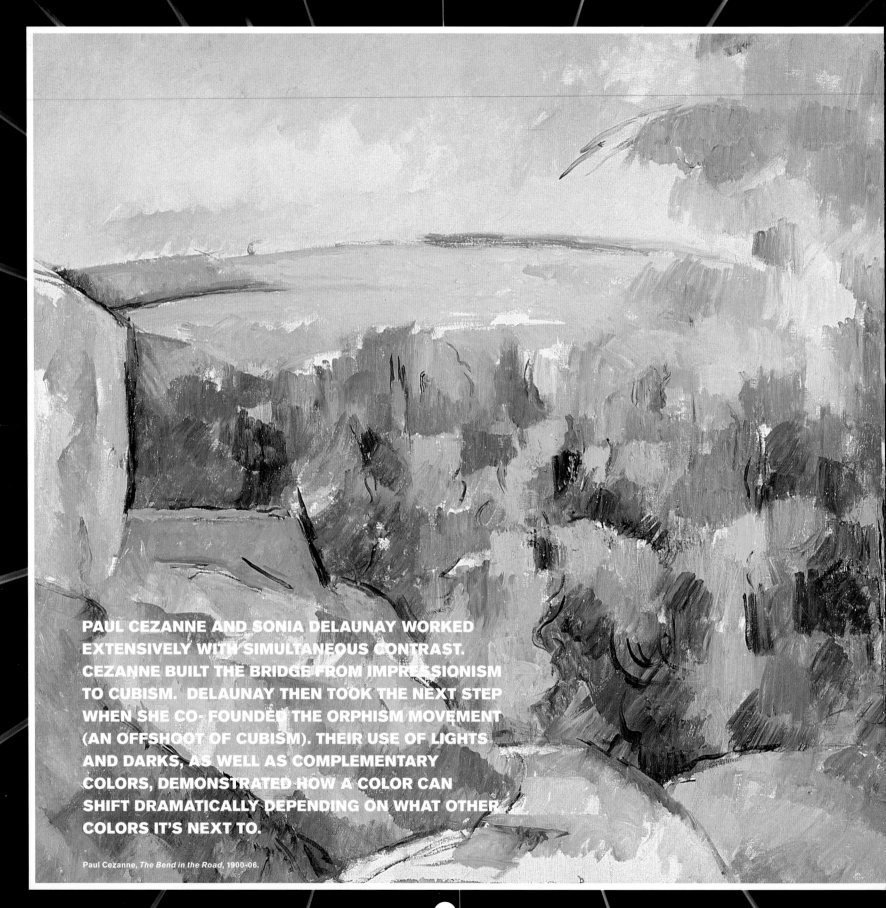

PAUL CEZANNE AND SONIA DELAUNAY WORKED
EXTENSIVELY WITH SIMULTANEOUS CONTRAST.
CEZANNE BUILT THE BRIDGE FROM IMPRESSIONISM
TO CUBISM. DELAUNAY THEN TOOK THE NEXT STEP
WHEN SHE CO- FOUNDED THE ORPHISM MOVEMENT
(AN OFFSHOOT OF CUBISM). THEIR USE OF LIGHTS
AND DARKS, AS WELL AS COMPLEMENTARY
COLORS, DEMONSTRATED HOW A COLOR CAN
SHIFT DRAMATICALLY DEPENDING ON WHAT OTHER
COLORS IT'S NEXT TO.

Paul Cezanne, *The Bend in the Road*, 1900-06.

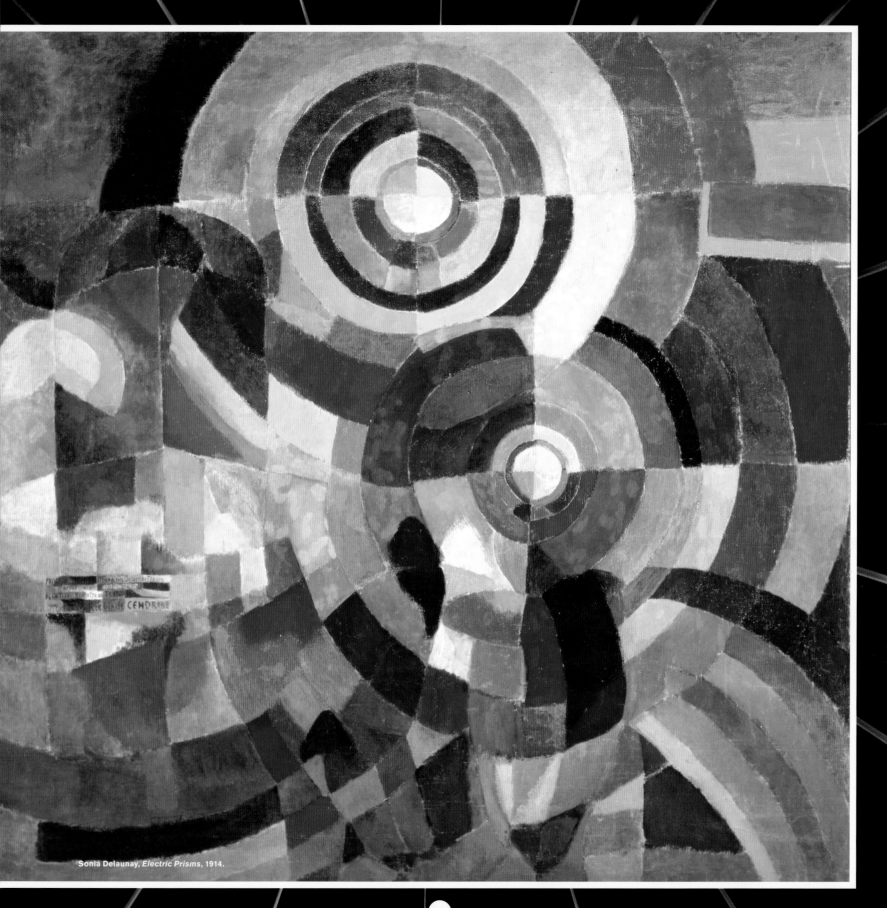

Sonia Delaunay, *Electric Prisms*, 1914.

YOUR PALENESS

Before the advent of synthetic pigments, every color added to the palette was in itself a scientific discovery of major import because with each new color, artists expanded their ability to map, mirror, and comment on the world around them. Whether artists chose to depict their world through a realistic or more exaggerated use of color, a larger palette opened up the playing field. Put a red face on the devil, and you instantly turn him ever so much more evil. Paint the queen's face so pale that she looks like bone china, and you accentuate her "royalness."

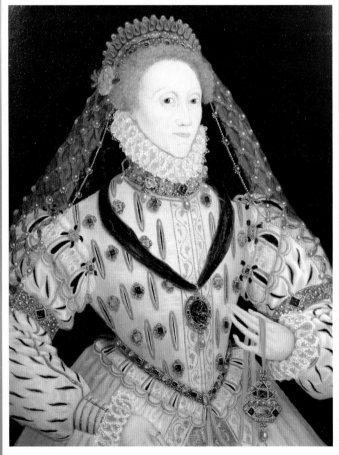

Elizabeth I (1533-1603), c.1600

Modernist artist and teacher Joseph Albers used simultaneous contrast not just as a technique but as the primary subject of his work.

simultaneous use of very dark and very light paints to create an effect of light, movement, and three-dimensionality; but Chevreul was the first chemist to study and to name the law of simultaneous contrast.

Today, paint of seemingly every hue, value, and chroma is available in ready-to-use tubes at your local art supply store, but it wasn't until the mid-nineteenth century—just over a decade after Chevreul wrote *Principles of Harmony and Contrast of Colours*—that this was so. For the bulk of human history, the science and art of color were not divided. Before this time, artists were chemists who were intimate with both the pigments they used and the chemical properties of those pigments, the act of turning pigment into paint was an integral part of the artistic process.

By the time the Impressionists started painting, modern chemistry could offer close to 2,000 colors. Against the backdrop of the scientific knowledge that Newton and Chevreul had supplied, color suddenly went from a tool used for rendering form and invoking symbolism (like in the Virgin Mary's blue cloak), to a tool used to express a wide range of artistic intentions. The

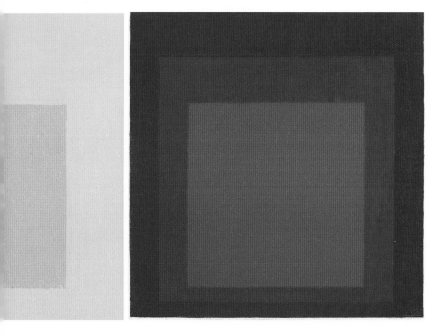

the prominence of color), color took center stage. Newton and Chevruel's theories continued to play starring roles in art, sometimes intentionally, sometimes not.

Today, for many artists, the abundance and low cost of paint have diminished or even eradicated the relationship between science and color; indeed, the science of color is not part of the curriculum in most art departments at any level of education. Children continue to be taught the subtractive model of color (without ever knowing what it is called), and red, yellow, and blue remain the primary colors, even though science gave us a much more precise model some time ago. The science of color is by no means purely academic, as one can use the lens of color to explore the very nature of our universe. In fact, that's just where we're headed next.

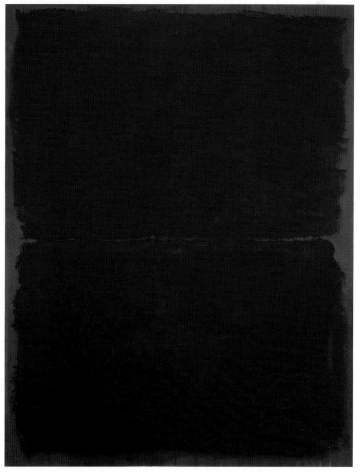

Eschewing representational art, the abstract Expressionist Mark Rothko used simultaneous contrast in his color fields in an effort to project pure spiritual states.

groundbreaking science behind color was an integral part of the Impressionists' method, and with the science and availability of color in lock step, a new kind of artistic reality was born.

Scientifically-minded painters like Georges Seurat believed that if, per Newton, light was made up of all colors of the spectrum, it would be truer to nature to depict color using tiny dots or small brushstrokes that spanned the entire spectrum. Seurat and his fellow Impressionists also put Chevruel's theory into practice with these small strokes of contrasting or similar colors to create dimension and the illusion of light. A tree in a Seurat painting might appear green from a few feet away, but get up close and you'll see reds and oranges, yellows and blues carefully placed beside the greens that dominate. The resulting effects were much deeper and strangely more realistic when viewed from afar.

Observers of the art world in the late nineteenth century would have been hard-pressed to believe that color could come to an even greater prominence than it already held; but when the Russian Constructivists, Neo-Realists, Fauves, and Abstract Expressionists arrived on the scene in the early twentieth century (to name just a few of the major art movements that embraced

RED

The flashiest and sultriest of hues, red is a color that has fanned the flames of revolutions. It's a color that groups as diverse as Satanists, Communists, and American conservatives have all claimed as their own. Red can be used equally to express love or hate and may signal sin, fertility, courage, guilt, or good luck, depending on your longitude and latitude. Whether you "see red" symbolically, in its angrier turn of phrase, or follow its practical injunctions as a law-abiding citizen, it *will* stop you in your tracks. Just be careful not to get lured into the red-light district by a red herring and end up red-faced, branded with a scarlet letter.

It's hard to imagine a time when people did not distinguish navy from baby blue, blue from green, even blue from red. But if we trace our languages all the way back to antiquity—to a time before the written word—the world appears virtually colorless, at least in terms of language. Besides black and white, there was only one color that numerous cultures felt the need to distinguish, one color that was consistently first to be named across cultures on every continent. That color is red—the color of blood, primal and elemental. Not coincidentally, the name for red was derived from the word for blood in languages as diverse as Semitic Hebrew to that of tribes on the islands off New Guinea.

IRONCLAD Our blood is made up of protein, iron, and oxygen. It's the iron and oxygen that are responsible for its red hue. Iron is attached to the protein hemoglobin, whose job it is to transport oxygen from red blood cells to the rest of the tissues in the body. When we inhale, oxygen mixes with the iron in our hemoglobin and turns our blood a true red. Red blood cells make up about 40% to 50% of our blood and tint the totality red. The more oxygen, the brighter the red. Blood flowing from the heart via the arteries has first passed through the lungs and is much richer in oxygen than blood flowing back to the heart via the veins—the latter has deposited its oxygen trove throughout the body and is

coming back for more. When an emergency medical technician (EMT) arrives at an accident and sees bright red blood, he or she knows an artery has been cut.

A form of iron oxide, rust is the stuff that makes up the surface of the planet Mars, known as "the red planet." Rust is created when iron comes into contact with oxygen or water and turns an orange-red. Iron oxide is also the stuff of the very first pigments used by humans, pigments that included ochre (which, despite

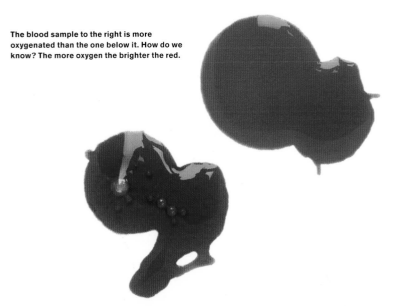

The blood sample to the right is more oxygenated than the one below it. How do we know? The more oxygen the brighter the red.

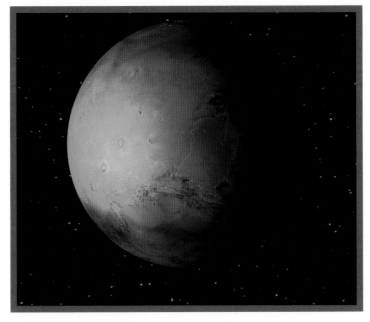

Iron gives Mars its rust-red color.

its common use as a mustard color, is often more red than yellow) and sienna (the base of its more popular counterpart, burnt sienna). Ochre and sienna were used to create some of the earliest known art works, the cave drawings at Lascaux, which date back to 17,000 BCE. These pigments have been used ever since, by virtually every major artist, at least up through the nineteenth century. Rembrandt used sienna and ochre as standard colors in his palette, as did Van Gogh.

Because rust is plentiful on farms (think of all that rusty farm equipment hanging around), it was also used as the base for paint on red barns, which are commonly associated with the iconic New England landscape. Starting in eighteenth-century America, farmers made use of this highly durable, easy-to-use, top-drawer fungus fighter that keeps mold from forming on wood.

Interestingly, blood was also used to tint paint red. Rust or blood would be mixed with other common products found on a farm like milk and linseed oil to create an easy-to-make paint.

To this day, ochre and sienna and other iron oxides are used as pigments in a plethora of man-made products, from makeup to commercial paints. Mother Earth herself has made fantastic use of these pigments throughout the clay and rocks that make up so much of our landscape.

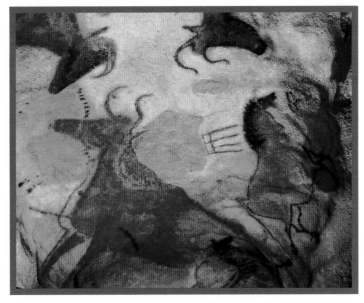

The sublime use of sienna at the hands of cave artists at Lascaux.

RED BUGS IN MUGS In 2012, a vegetarian Web site took the coffee giant, Starbucks, to task, stating that its strawberry Frappuccinos were not, in fact, vegan per their description. Instead, Starbucks was using crushed dead bugs to color these drinks pink. Cue public relations nightmare. Organizations like People for the Ethical Treatment of Animals insisted they use an alternative dye. Regular consumers of the pink-hued Frappuccino went bug-eyed. But the color cognoscenti were bemused, knowing just how many products are tinted by the pigment—and bug—in question, cochineal.

Cochineal was worshipped by the early Aztecs. During Mexico's post-colonial era, it was, next to gold, the country's most desired export—an insect that distinguished the powerful

You'd never know this gray insect contains a substance so sublime. At left is a pile of cochineal bugs with a secreted drop of the precious pigment. At right is a cactus pad—from which the cochineal is harvested—studded with the insects.

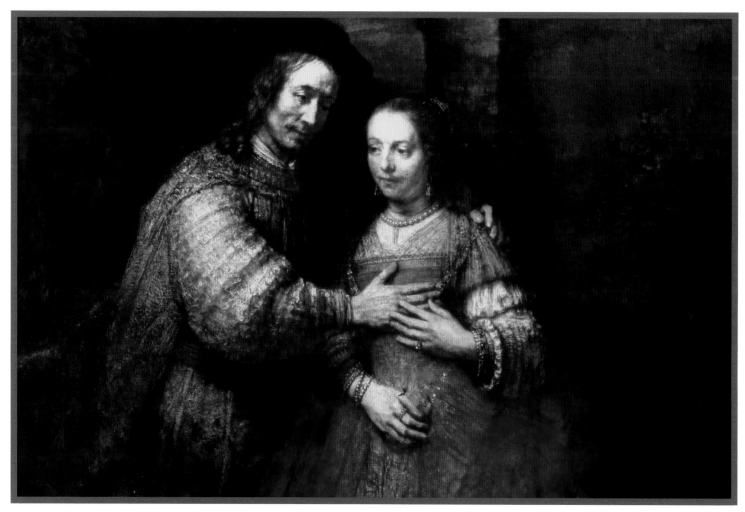

Rembrandt used cochineal to create the stunning red dress of his *Jewish Bride.* Chances are, the dress itself was dyed with cochineal as well.

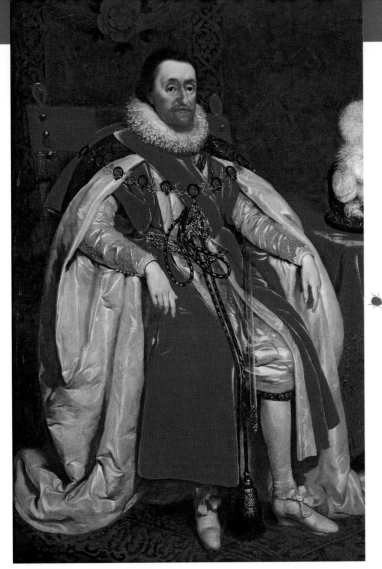

King James I of England and VI of Scotland circa 1621, decked out in his red robes.

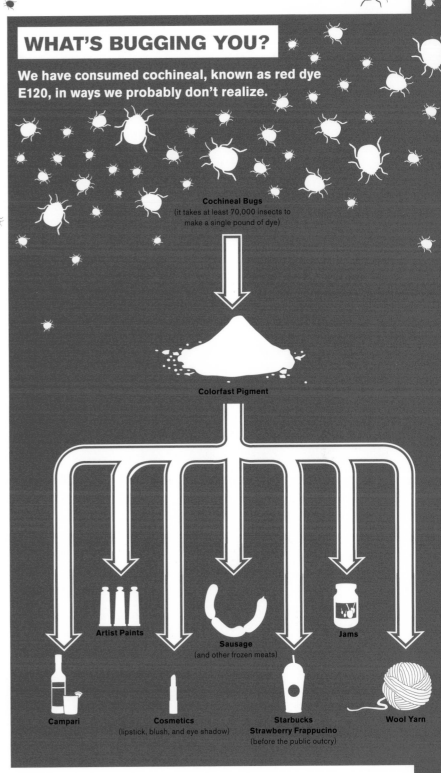

WHAT'S BUGGING YOU?

We have consumed cochineal, known as red dye E120, in ways we probably don't realize.

Cochineal Bugs
(it takes at least 70,000 insects to make a single pound of dye)

Colorfast Pigment

Artist Paints

Sausage
(and other frozen meats)

Jams

Campari

Cosmetics
(lipstick, blush, and eye shadow)

Starbucks Strawberry Frappucino
(before the public outcry)

Wool Yarn

from the powerless as the color of the fabric that clothed the rich. The Aztecs were the first to harvest cochineal, which they dried and crushed to a fine powder to derive the wonderfully colorfast pigment they used in their art and clothing. When the Spanish arrived and saw the brilliant red color in the Aztec's textiles, they were awed. Europe had no red dye to match cochineal in either brilliance or staying power. Although it took at least 70,000 insects to make a single pound of red dye, the Spanish were undeterred and started exporting the pigment to Europe. The dye soon became all the rage, despite its steep price.

The Spanish managed to keep a monopoly on the pigment for 200 years, but their monopoly ended the day a clever Frenchman smuggled a cactus pad studded with cochineal insects into Haiti and started his own manufacturing outfit. From there, the technique took off, with many countries eventually peddling the pigment.

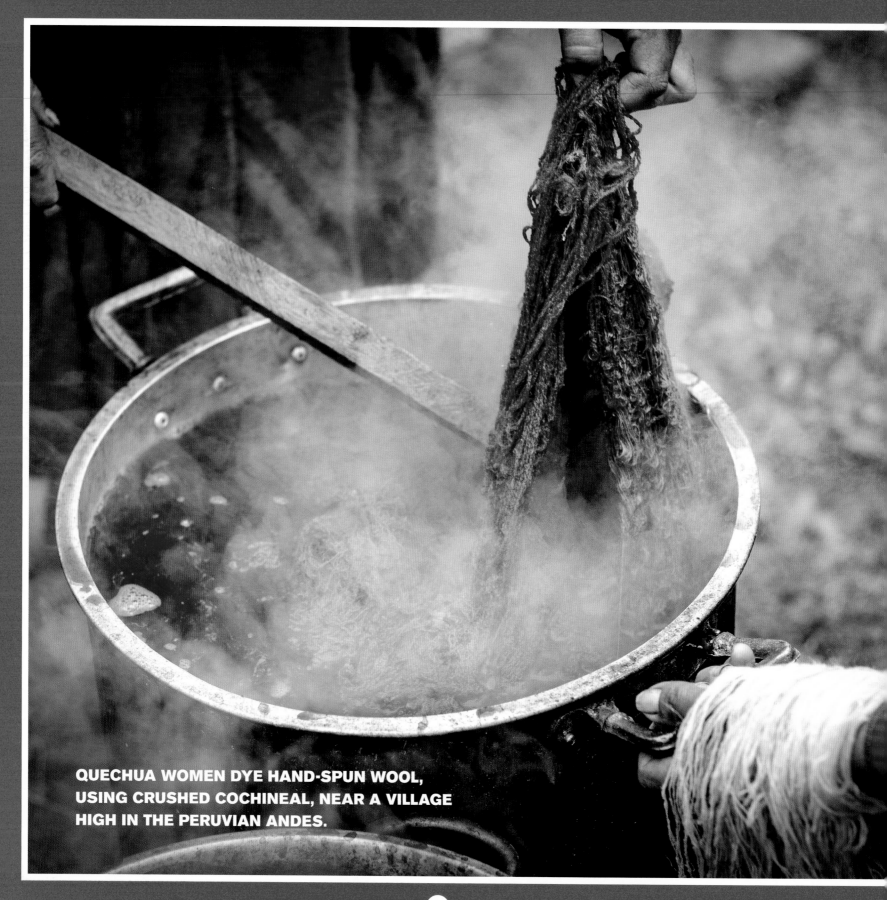

QUECHUA WOMEN DYE HAND-SPUN WOOL, USING CRUSHED COCHINEAL, NEAR A VILLAGE HIGH IN THE PERUVIAN ANDES.

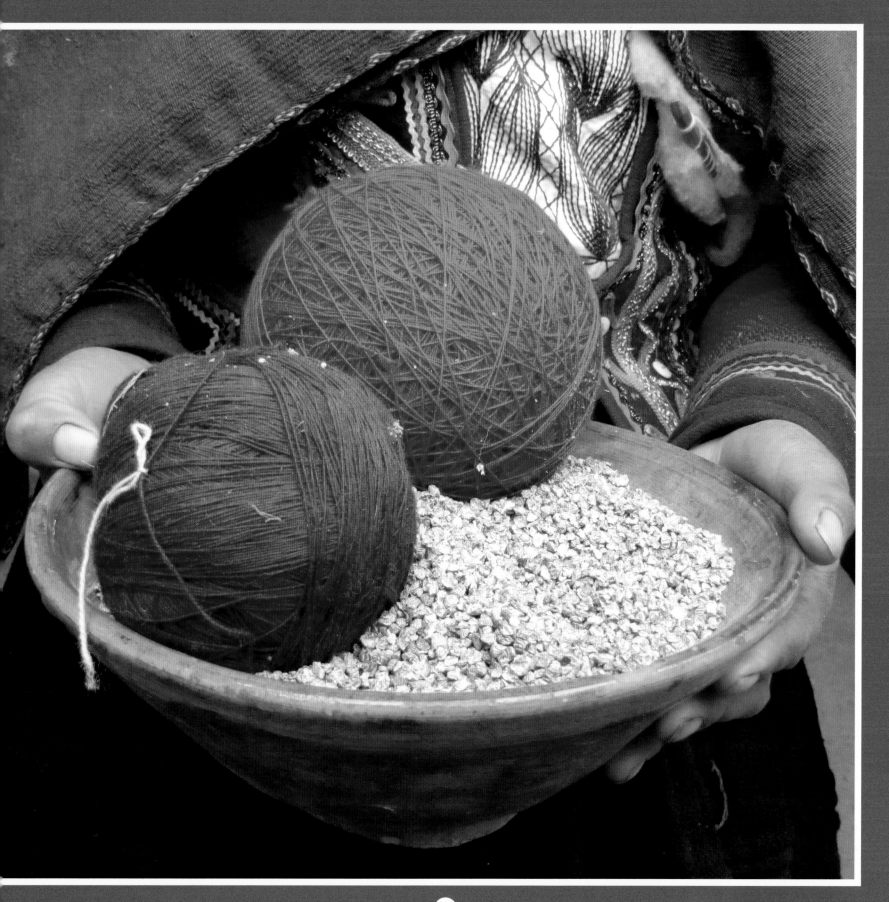

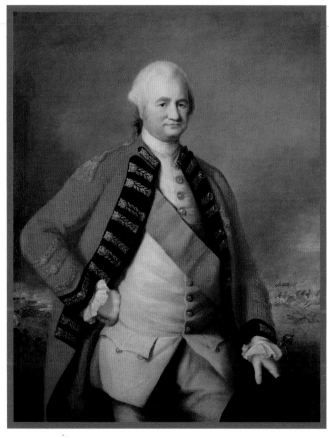

The red coats of the British Redcoats were often dyed with cochineal until more affordable synthetic dyes were invented. Here's a Blue-blood Redcoat, Robert Clive AKA 1st Baron Clive, painted in 1773.

In the 1870s, a new synthetic dye, alizarin, was produced. Overnight, cochineal's stock fell to junk status in the face of this new brilliant, colorfast red that could be achieved for pennies. The hue's newfound availability and affordability made aristocrats far less interested in wearing it. Their taste turned to the subdued range of colors they now considered an elegant alternative to crimson's flashy vulgarity.

Cochineal, for its part, has found its way back into our lives, bringing us full circle to the Starbucks public relations crisis. The world is now filled with toxic red dyes, some of which have proven to cause cancer. In the search for something more natural, many have returned to cochineal. Now more commonly known by its chemical name, red dye E120, cochineal can be found in numerous products, including lipstick and other cosmetics, sausage, jams, yogurt, juices, maraschino cherries, and naturally dyed yarns.

The Catholic Church also played its cards red. In the thirteenth century, Pope Boniface VIII had his cardinals don red cassocks to demonstrate their willingness to give themselves to the church, even to the point of sacrificing their own lives–their blood–like the martyrs who died for Christ.

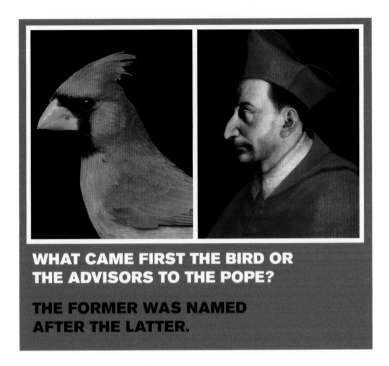

WHAT CAME FIRST THE BIRD OR THE ADVISORS TO THE POPE?

THE FORMER WAS NAMED AFTER THE LATTER.

SEALED WITH RED TAPE From the garments of medieval aristocracy to the letters and documents they posted, kings, popes, and other dignitaries throughout the Middle Ages guaranteed the privacy of their correspondence via elegant red envelope seals made from expensive red wax. That practice prevented messengers or other prying eyes from violating the papers contained therein.

Wax eventually gave way to tape: red tape. One of its first mentions involved the sixteenth century's Henry VIII, who was desperately trying to convince Pope Clement VII to grant him an annulment of his marriage to Catherine of Aragon. As they traveled between England and the Pope, the necessary documents were sealed in red tape to ensure that no one tampered with them.

Use of the phrase *red tape* to describe the hoops bureaucrats force us to jump through is said to have originated with Charles Dickens, who wrote, "There is a good deal of red tape at Scotland Yard, as anyone may find to his cost who has any business to transact there."

THE RANK OF RED

In medieval Europe, in the absence of the Internet, newspapers, cameras, or even a printing press, how was anyone to identify their monarch's likeness? The populace wouldn't necessarily know its king's regal countenance except by the color of his coat. And if the king and those in his court wore red, surely no one else could; the masses were forced to abide by medieval sumptuary laws prohibiting anyone below the aristocracy from donning the color. Not that anyone of lesser rank could afford garments made of precious red dyes like cochineal.

RED, HOT, AND BIASED The attention-grabbing powers of red play an important role in both attraction and intimidation.

In one study, women were asked to look at photos of men dressed in colored clothing against variously colored backgrounds. Subjects were told only that the study was about first impressions. The results of the study revealed that women

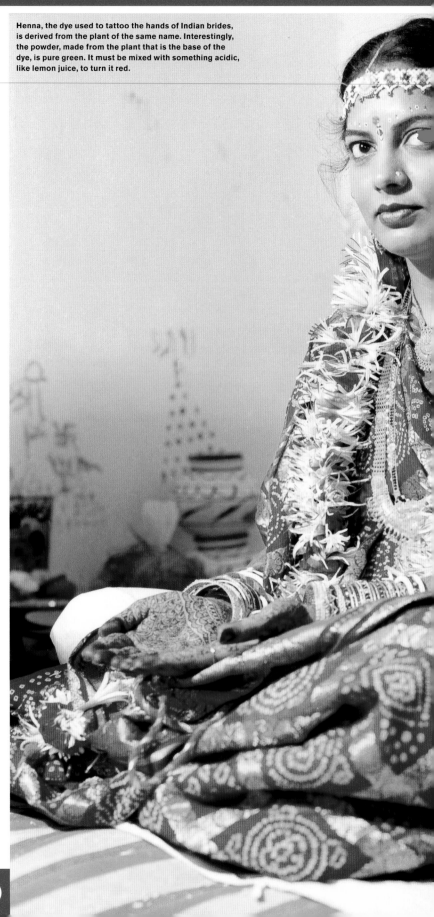

According to one study, women may be more likely to pick the guy in the red when asked, "Who looks the sexiest?"

were consistently more likely to label men as sexy when they were either dressed in red or photographed against a red background. The authors of the study concluded that this bias is related to the perception that red indicates high status. This red bias is true for many other animals, including birds, nonhuman primates, and even crustaceans.

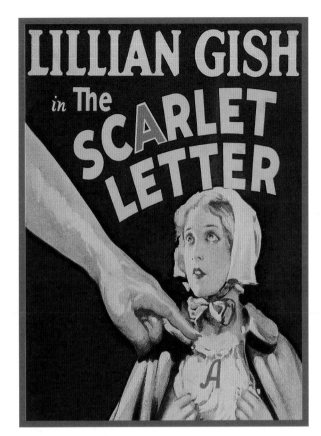

Lillian Gish as Hester Prynne in the 1926 movie version of *The Scarlet Letter.*

In some cultures, a woman in a bright red dress might also signal sex appeal. The implications of a woman in red span from titillation to sexual transgression. In Nathaniel Hawthorne's 1850 novel, *The Scarlet Letter,* Hester Prynne is forced to wear a scarlet letter "A" on her dress as punishment for her adultery. In the classic movie *Jezebel,* Bette Davis's character scandalizes her community by daring to wear a red dress to a ball. Her willingness to flout convention actually causes her fiancé to break their engagement.

In northern India, however, women traditionally wear red on their wedding day. Brides not wear only red saris but also red bindis (decorations affixed between their eyebrows) and red henna tattoos on their hands. For Hindus, red symbolizes not only potential but also power—including sexual power. Red continues to be an important color for married Hindu women even until death. If a woman dies a widow, she is shrouded in white before being cremated. If she dies before her husband dies, she is shrouded in red.

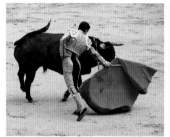
only once Dorothy lands in the land of the Munchkins?) The contrast between her ruby slippers' sparkling red and the vibrant gold of the yellow brick road proved a wonderful way to light up the screen. And the magical properties of those red shoes still reverberate in imaginations the world over.

Originally, six or seven pairs of ruby slippers were made for Judy Garland, the last of which was sold at auction for somewhere in the vicinity of two million dollars. Another pair was supposedly stolen. So if you happen upon a pair of these gems, you may have just found that pot of gold over the rainbow.

Wearing red may also a good idea if you want to get an edge on an opponent. As long as you're playing against a man, that is. According to one study, individuals or teams who wore red in the 2004 Olympics were more likely to win. A more recent study of video gamers who chose a red avatar came up with the same results. Experts hypothesize that the power of red goes back to our primitive selves, when ruddiness was a sign of male power and virility. Men with more testosterone tend to have redder complexions, so these rosy visages were feared by men ranked lower on the "pecking order."

THOSE RUBY SLIPPERS It may come as a surprise, but there are no ruby slippers in L. Frank Baum's *The Wonderful Wizard of Oz*. Baum's Dorothy wore silver shoes. How could our memories be so faulty? Or, rather, were our memories of the movie so strong that they overrode the book? As it turns out, the creators of the 1939 film *The Wizard of Oz* made the switch to make the most of the power of Technicolor, at the time a relatively new technology with which moviegoers were infatuated. (Who can forget that the movie starts in a black and white Kansas and turns to color

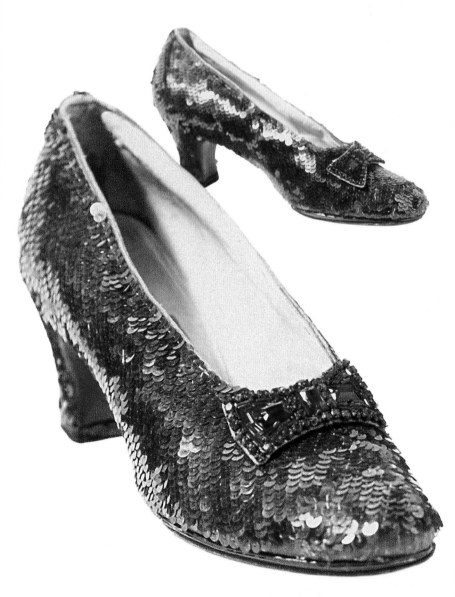

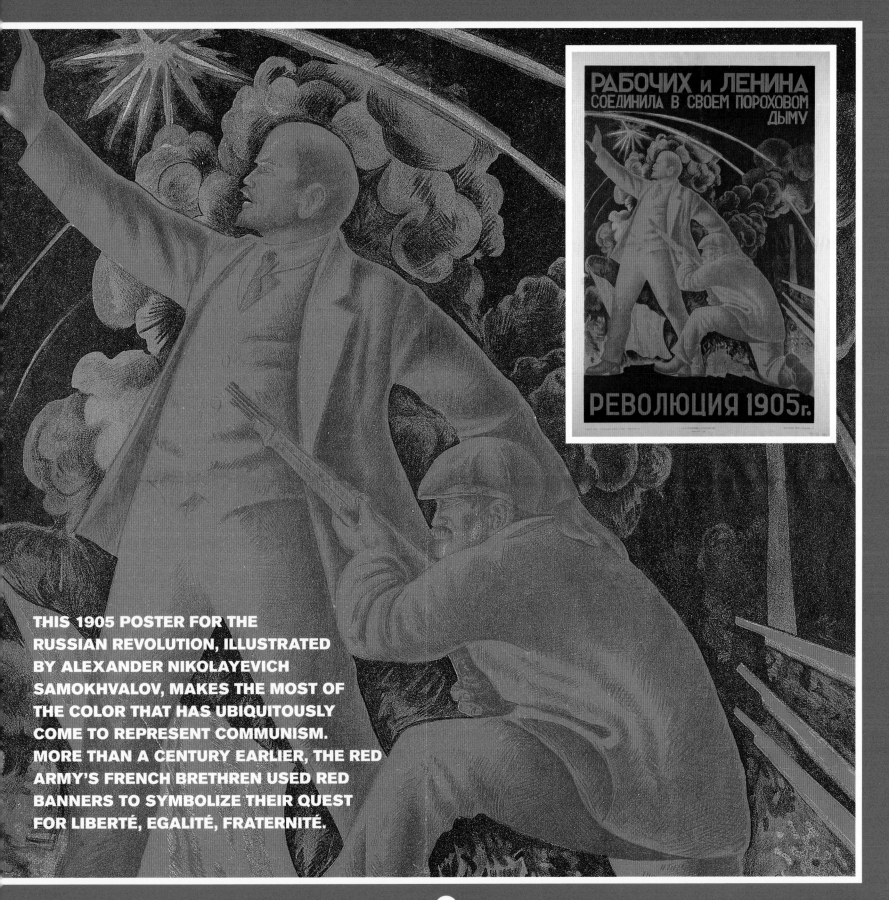

THIS 1905 POSTER FOR THE
RUSSIAN REVOLUTION, ILLUSTRATED
BY ALEXANDER NIKOLAYEVICH
SAMOKHVALOV, MAKES THE MOST OF
THE COLOR THAT HAS UBIQUITOUSLY
COME TO REPRESENT COMMUNISM.
MORE THAN A CENTURY EARLIER, THE RED
ARMY'S FRENCH BRETHREN USED RED
BANNERS TO SYMBOLIZE THEIR QUEST
FOR LIBERTÉ, EGALITÉ, FRATERNITÉ.

Imagine you're in space. Take in the blackness, the uncountable stars with their blue and red tints. See the swirling nebulae, each color a specific ionized gas. As you move back down to Earth, there's the spray of color in the northern lights. Move even closer and approach the white clouds and blue oceans. As night falls, the sky changes from reds to oranges to pinks to the deepest blue.

The elements of our universe are filled with color. Color tells us when to rise and when to go to sleep, when to go outdoors, and when to seek shelter. Color has helped us answer questions about what might live on planets we have yet to visit and whether these planets might be hospitable to humans. It's even helped us answer possibly the biggest question we've ever thought to ask: How was our universe created? Then there's the other question every child is sure to ask, the question to which few parents know the answer. The inevitable: Why is the sky blue?

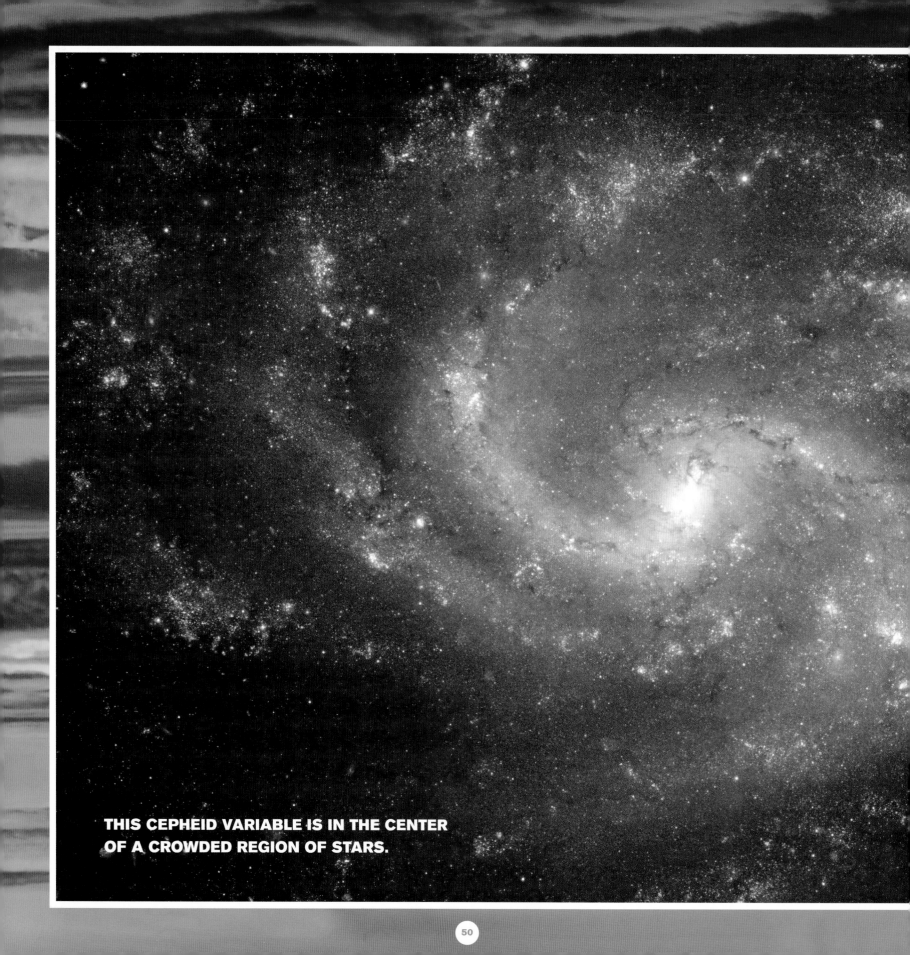

THIS CEPHEID VARIABLE IS IN THE CENTER
OF A CROWDED REGION OF STARS.

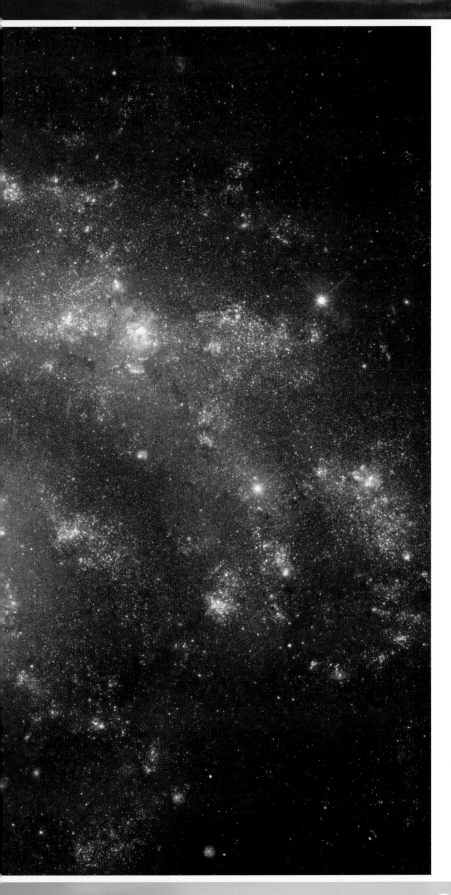

Henrietta Swan Leavitt

Let's take those fundamental questions. How did life begin, and when will it end? Now let's answer them using color. (It's going to take a while to get to the color part, but we promise we will.)

At the end of the nineteenth century, an astronomer named Henrietta Swan Leavitt was given the low-woman-on-the-totem-pole task of looking through thousands of photographic plates taken via telescopes she was not allowed to use because she was a woman. These photo plates capture images of what are known as Cepheid variable stars, "variable" because their brightness changes: They pulse, getting brighter and dimmer and brighter again over anywhere from days to months. The time between pulses is called the "period of the pulsation."

An acute observer, Leavitt was able to correlate a Cepheid's brightness to its period of pulsation, which eventually led her to an important discovery: a technique for measuring the distance of a Cepheid from Earth. Her technique centered on a star's luminosity, or intrinsic brightness. If we don't know a star's luminosity, it's difficult to tell the difference between a dim star close up or a bright star far away. Leavitt found that all Cepheid variables with the same period have the same luminosity. By carefully measuring how a Cepheid pulsed, a scientist could determine its intrinsic brightness. Then, by comparing the difference between how bright it was and how bright it seemed to be, he or she could determine its distance.

Leavitt's work led to a standard that could measure the distance to lots of stars. This standard eventually led to the discovery that the Milky Way is just one galaxy of many and that the universe is far larger than ever previously imagined. Once scientists had a sense of just how large the universe is, they wanted to know whether it had always been that big or had grown over time. In the early twentieth century, astronomers had only measurements of the distances to stars in our own galaxy, some of which are moving toward us and some moving away. These inconsistent movements made them unable to determine whether the universe was expanding or contracting.

The color of galaxies—or rather the gas between galaxies that absorbs and reflects the colors that are visible via telescope—changed that conclusion dramatically. First, a word on why we see the colors we do in the universe: Imagine a beam of light traveling across the universe. Imagine this beam is made up of waves, with alternating peaks and troughs, much like ripples sent along that jump rope on page 17. Imagine that as these waves move, the jump rope is also stretched; the distance between peaks (the wavelength) will grow longer. As we said in chapter 1, the longest wavelengths of visible light appear red, and as the light waves stretch, they get "redder"—hence the term *redshift* for this stretching. "Redder" is only a figure of speech here, however. (Physicists do love to use language in a way that utterly baffles the rest of us.) Although redshift refers to a change in the wavelengths of light, it does not necessarily mean things look redder but rather that wavelengths are shifting along the spectrum toward red. A galaxy that reflects ultraviolet wavelengths may look bluer when it is strongly redshifted, its wavelengths stretching from ultraviolet to blue. With even more redshifting, it would shift from blue to red and then out of the visible light spectrum entirely. Whereas stars that are moving away appear redder, stars that are moving closer to us appear bluer. Appropriately enough, this phenomenon is called *blueshift*.

What's so important about redshift? In 1923, Edwin Hubble measured the redshift and brightness of several galaxies and was able to declare once and for all that—drum roll—the universe was expanding. The redshift in a galaxy tells us exactly how fast it's moving away from us. Galaxies farther away show more stretched out—or redshifted—light, just as you'd expect for an expanding universe.

Could the universe keep expanding? If so, at what rate? Surely it would start to slow down at some point. This was what scientists came to believe until, that is, they started to look at supernovae

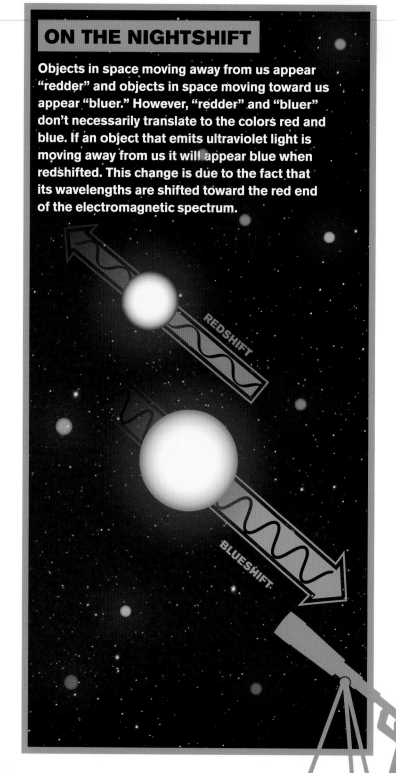

ON THE NIGHTSHIFT

Objects in space moving away from us appear "redder" and objects in space moving toward us appear "bluer." However, "redder" and "bluer" don't necessarily translate to the colors red and blue. If an object that emits ultraviolet light is moving away from us it will appear blue when redshifted. This change is due to the fact that its wavelengths are shifted toward the red end of the electromagnetic spectrum.

REDSHIFT

BLUESHIFT

(the explosions of stars) much, much farther out in space. These supernovae were billions of light years away—a light year being close to six trillion miles.

Supernovae are amazingly bright. For a few weeks, one supernova can outshine the hundreds of billions of stars in an entire galaxy, which means we can see supernovae that are much farther away than normal stars and that the scientists who study them can probe farther into the universe. All supernovae families share approximately the same peak brightness, so as with Cepheids, you can figure out how far away they are by comparing how bright they are versus how bright they look. If you factor in the redshift of the supernovae along with their brightness, you can calculate how fast space has been expanding since the light left the explosion. These calculations led to another major discovery about our universe: its expansion rate is increasing. This was a revelation, as it would have been logical to assume that the expansion rate was diminishing, like a braking car—still moving forward, but more slowly. Instead, scientists found that the universe is stepping on the gas.

Color was crucial to this discovery in more ways than one. In addition to factoring in the colors of the supernovae, scientists realized that the dust around supernovae was also creating its own color—red, to be exact. (Dust reddening, unlike redshifting, involves an actual reddening; the dust obstructs shorter wavelengths of light, blocking and scattering them but allowing redder wavelengths to be seen.) By measuring this reddening, scientists were able to calculate just how much dust was in the foreground and "color correct" their assessment of the supernova's distance.

This Hubble space telescope image of the Crab Nebula uses a technique called "false color." But don't let the name fool you. Astronomers use false color to translate the colors of space that are out of the visual spectrum into colors that we can see. So they're not so much false as misunderstood. In this photo, blue represents neutral oxygen, green is singly-ionized sulfur, and red indicates doubly ionized oxygen.

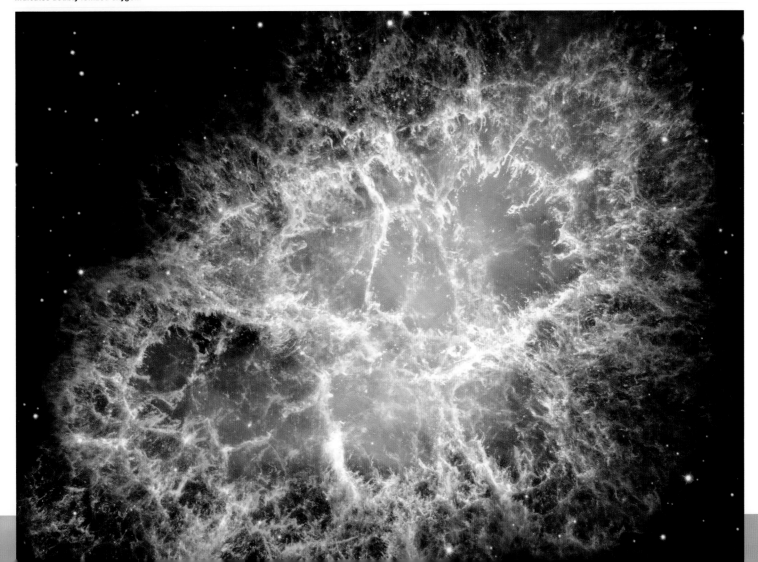

WHAT GIVES A STAR ITS COLOR?

CHEMICAL MAKEUP IS LESS RELEVANT TO THE COLOR WE SEE WHEN WE LOOK UP AT THE NIGHT SKY THAN IS TEMPERATURE, THE "THERMAL RADIATION" OF A STAR'S OUTER LAYERS. (THINK OF THE RED-GLOWING WIRES IN A HOT TOASTER; THAT'S THERMAL RADIATION AT WORK.)

THE RED, WHITE AND BLUE OF STARS When it comes to color and stars, our red-hot and ice-blue associations get turned on their heads. The colder the star, the longer its wavelengths of emitted light—and the redder its appearance. As things heat up, the colors of the emitted light shift across the rainbow toward the blue end of the spectrum. The surface of the sun, for example, much hotter at approximately 6,000°C than the average toaster, adds to red wavelengths a mix of shorter wavelengths that appear yellow, green, and blue. These multiple wavelengths, when combined, make the sun look white (if you look directly at it, which you should not do). If we stood right next to one of the hottest objects in our galaxy, a quasar—or quasi-stellar object—it might not appear very bright to our eyes; it is so hot that most of its light is in the ultraviolet, beyond the blue and violet, range

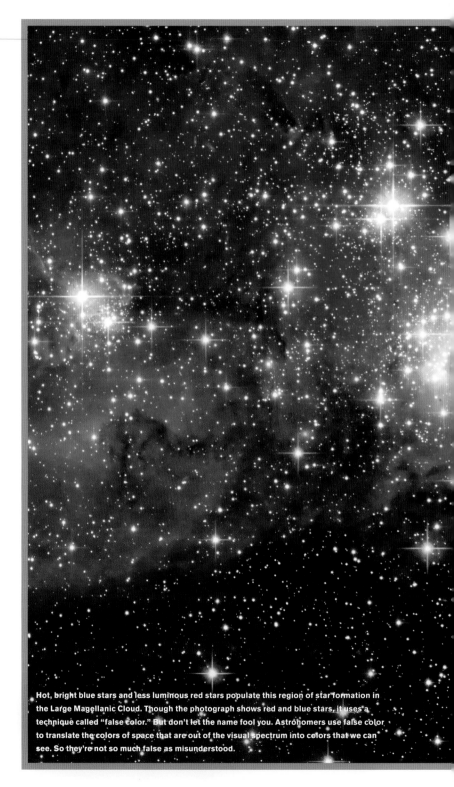

Hot, bright blue stars and less luminous red stars populate this region of star formation in the Large Magellanic Cloud. Though the photograph shows red and blue stars, it uses a technique called "false color." But don't let the name fool you. Astronomers use false color to translate the colors of space that are out of the visual spectrum into colors that we can see. So they're not so much false as misunderstood.

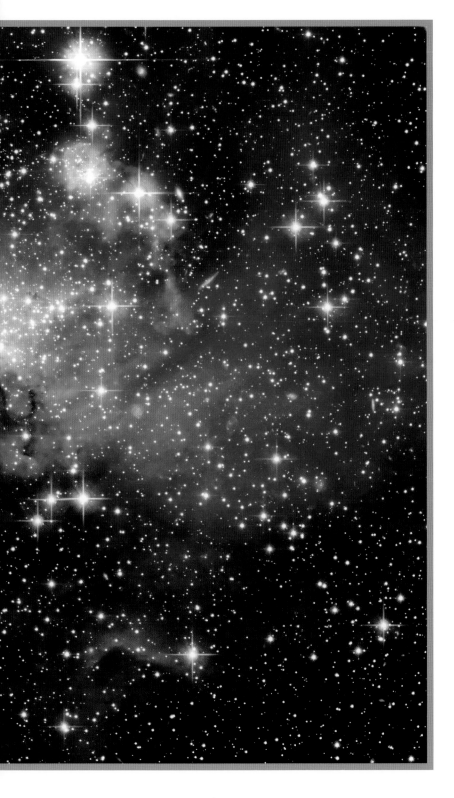

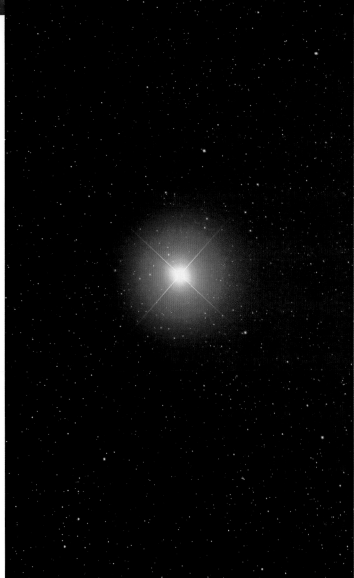

Here's Sirius, a blue star, shining brightly.

of our eyes. (Of course, that's only if we were right next to it. Quasars are so far away that when we view them from Earth, their light is so redshifted that some of the ultraviolet has actually made its way into the infrared!)

Our perception of thermal radiation limits star colors to red, white, and blue. Other colors, like green and violet, are present in some stars' mix of emitted light, but these stars emit so much red and blue light that all the wavelengths combine to give the appearance of white. Even stars called "violet" emit enough blue light to mitigate the violet; blue dominates the small band of violet our eyes are able to perceive, rendering the violet hue unnoticeable.

THAT'S SO BLUE-HOT

When it comes to heat, our color language gets flipped around. As you can see, cooler temperatures correspond to red light and hotter temperatures to blue light. Green disappears entirely from the mix, with white taking its place.

LIMIT OF
VISIBLE SPECTRUM

25000 °C
BLUE-HOT

10000 °C

6000 °C
WHITE-HOT

5000 °C

2500 °C

1000 °C
RED-HOT

0 °C
FREEZING

The color of a star also factors into a star's longevity. Hot, blue stars are brighter and expend more energy, burning through their fuel faster. Bright blue stars like Sirius live for only millions of years, whereas stars like our sun, which are cooler, live for billions of years; and some red stars live even longer. Red dwarfs are small, relative cool (5000°C or so) stars that can live for tens of billions of years, possibly hundreds of billions! Red giant and red supergiant stars are also around 5000 degrees, but they're so large that they give off a great deal of heat. They, sadly, have relatively short life spans as stars go.

RED COLD What is the genesis of our associations of heat with red and cold with blue? It could be that under low light conditions, the eye's sensitivity changes. Instead of our cones' usual peak sensitivity toward yellow and green wavelengths, the eye shifts its sensitivity toward blue wavelengths via another set of photoreceptors called rods (see page 21); so in darker settings, which tend to be cooler, we are likely to perceive more blue light. On the red side, many hot things—like those toaster coils and fire—have influenced our perception of what colors represent hot and cold.

It's true that when we heat materials like steel or coal to very high temperatures (around 1000°C), they glow red—hence the phrase "red-hot." But if we keep applying heat, the color shifts across the spectrum until all colors are present, and the materials turn "white-hot" (at around 6000°C, the temperature of the sun). In principle, additional heat would shift the peak well into the ultraviolet zone, but a tail of that emission would extend into the visible spectrum, and so we would call it "blue-hot." However, we would need to get our materials up to greater than 25,000°C to see that, and this generally doesn't happen, so we don't have the term *blue-hot*.

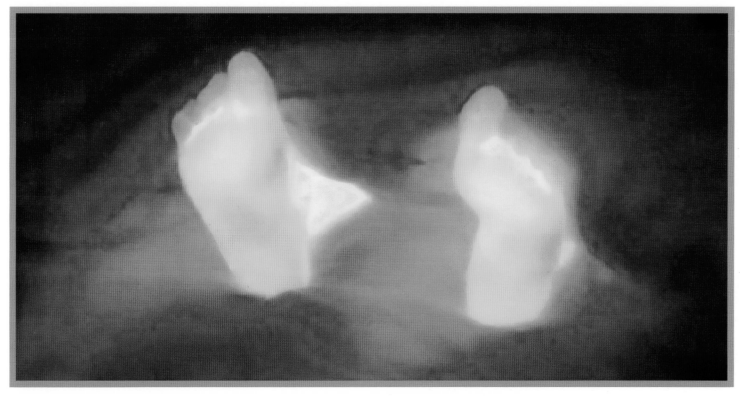

Joseph Giacomin uses thermal photography, which according to him, captures the energy from within, rather than the reflected light of surfaces. You can practically feel the heat coming off these feet!

Speaking of red-hot, human beings are typically around 40°C, which is not even close to the 1000°C you would need to glow red, but it is hot enough to glow in the infrared part of the electromagnetic spectrum (that's just beyond light we perceive as red). If you had an infrared camera, you would see everyone lit up like a 100-watt bulb!

COLOR DETECTIVES Although the overall perceived color of a star stems from the thermal radiation of its inner layers, there is a way to discern what elements are present in the outer layers of a star by looking at the color.

Specific elements—like hydrogen, helium, and oxygen—carry specific color patterns. (Think of the way a copper-bottomed pot turns green or a natural gas stove flame turns blue, unless there's too much oxygen mixed in with the gas, in which case the flame turns orange.) Refracting the light emitted from a star into a rainbow (just as Newton did with sunlight) enables us to see which colors are missing from the star's spectrum. Astronomers accomplish this feat by focusing on one star with a giant telescope and then directing the starlight through a prism or a diffraction grating to separate the spectrum. By identifying which colors are missing, scientists can determine which elements are present in the outer layers. The presence of helium in the sun was discovered via this method before the element was found on Earth.

THE COLORS OF PLANETS The planets of our solar system display an array of colors that is literally otherworldly: Neptune's deep purplish blue, Mars's vaunted red. Unlike stars, whose color comes mainly from core thermal energy, a planet's color is largely derived from its surface or atmospheric elements. Like other matter, each planet absorbs and reflects amounts of the sun's electromagnetic radiation, depending on its makeup. The deep purplish blue of Neptune is a function of its atmospheric methane, which absorbs red light and reflects blue. We owe the red of the Red Planet, Mars, to the iron oxide in the planet's rocks. The orangish stripes encircling Jupiter? Ammonium sulfide. And our own "blue" planet takes its hue from the water that covers more than 70% of its surface.

MY VERY EXCELLENT MOTHER JUST MADE US NEW PIGMENTS

The color of a planet is due to the sun's light reflecting off the planet's surface or atmosphere. Below you'll find the planets in our solar system and what's behind their colors.

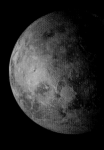

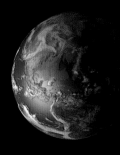

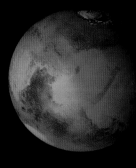

MERCURY
Color: **Gray-Brown**

Surface: **Rocky, dust covered**

VENUS
Color: **Yellow**

Atmosphere: **Sulfuric Acid clouds**

EARTH
Color: **Deep Blue, with white, green, and brown patches**

Surface: **Water, plus cloud cover, foliage, and land**

MARS
Color: **Rust Red**

Surface: **Iron Oxide in rocks**

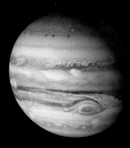

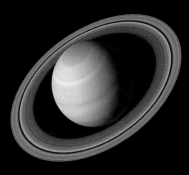

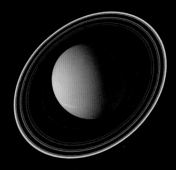

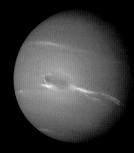

JUPITER
Color: **Dirty yellow with red-orange, white, and brown bands**

Surface: **Ammonium, water droplets, and ice crystals**

SATURN
Color: **Yellow-brown**

Atmosphere: **Hydrogen and helium, ammonia, phosphine, water vapor and hydrocarbons**

URANUS
Color: **Green-blue**

Surface: **Methane gas**

NEPTUNE
Color: **Deep blue**

Surface: **Methane gas**

NATURE'S LIGHT SHOW IN THE SKY The stars and planets are far enough away that their colors do not dazzle the naked eye. But the aurorae—nature's light shows in the night skies, found at very high and very low latitudes in the earth's atmosphere—are nothing short of mind-blowing. Unlike stars, the most common color of an aurora is green. Reds and pinks also make an appearance, as do violet and blue.

The breathtaking colors of an aurora happen when charged particles from the sun hit the earth's magnetic field and excite the atoms and molecules with which they come into contact; when the particles strike oxygen and nitrogen, the elements begin to glow. The colors depend on the elements at play, along with the point in the atmosphere where the collision occurs. The upper atmosphere contains proportionally more oxygen, so more oxygen gets excited and gives off color, usually green and brick red. The slightly lower atmosphere contains more nitrogen, which gives off blue and brighter red.

FINALLY, WHY THE SKY IS BLUE Although outer space is blacker than the darkest darkroom, every day we perceive countless transformations in the sky above our heads. This shift from night to day and black to blue—as well as the many hues of sunrise and sunset in the transition—has to do with the tiny particles in abundance in our atmosphere. These particles provide a refractive surface for the sun's rays. Without these particles, a clear day's sky would appear black, except if you were looking right at the sun. You may recall photos of astronauts on the moon standing in bright sunlight with requisite shadows and all—but the sky is black. Why? The moon has almost no atmosphere.

A multicolor aurora borealis at Atigun Pass, Alaska.

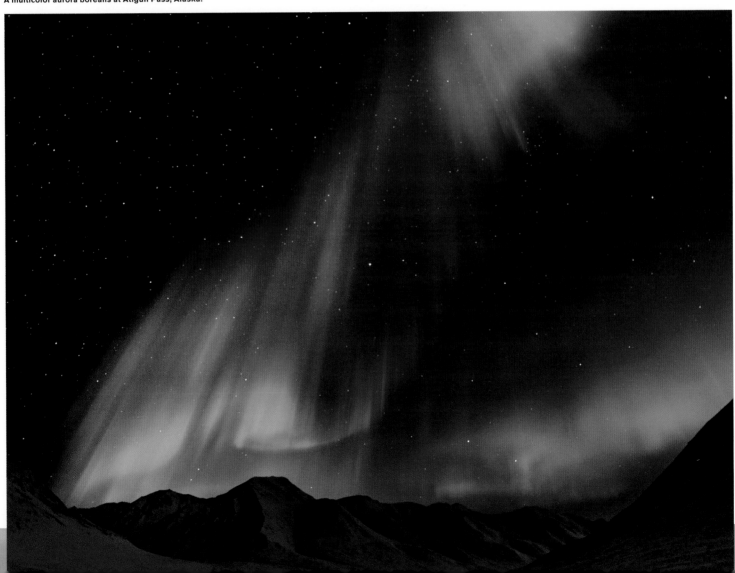

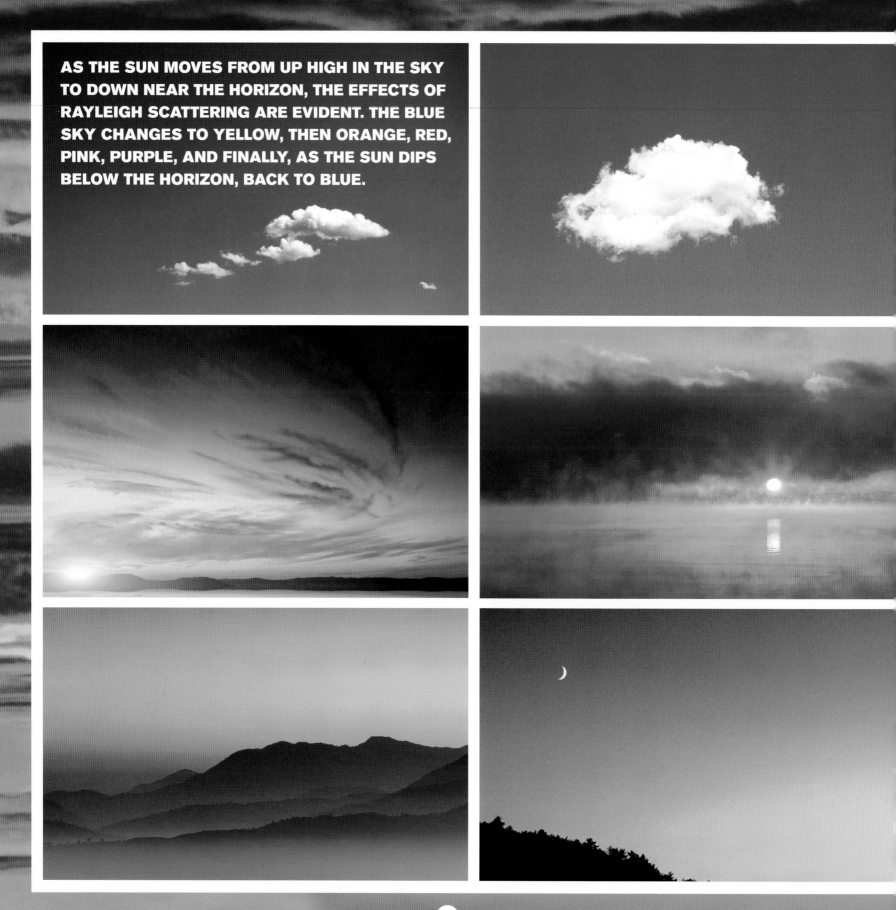

AS THE SUN MOVES FROM UP HIGH IN THE SKY TO DOWN NEAR THE HORIZON, THE EFFECTS OF RAYLEIGH SCATTERING ARE EVIDENT. THE BLUE SKY CHANGES TO YELLOW, THEN ORANGE, RED, PINK, PURPLE, AND FINALLY, AS THE SUN DIPS BELOW THE HORIZON, BACK TO BLUE.

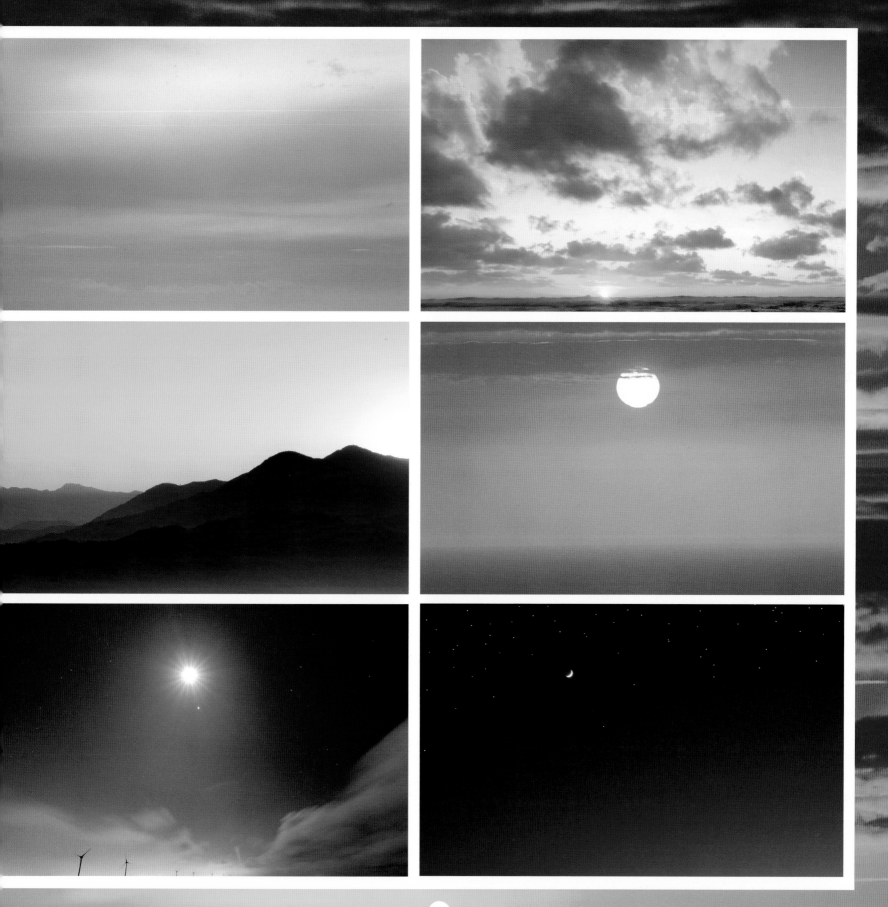

Although the sun is white, Rayleigh scattering often makes it appear yellow. There's a good reason children all over the world depict it as such. This drawing is by Oscar Scher, the son of one of this book's designers!

Mostly too small to absorb and reflect the full spectrum of the sun's light, these particles scatter light about in all directions. Short wavelengths of light (what we perceive as blues and purples) scatter in all directions and long wavelengths of light (reds, oranges, and yellows) are scattered only minimally. Given that violet light scatters the most, you might wonder why the sky appears blue rather than purple. This is, again, because our eyes are sensitive to a much larger range of blue light than to violet light. In essence, in a game of rock-paper-scissors, blues dominate over violet. Indeed, we do perceive blue to be everywhere; but longer wavelengths, because they don't appear to scatter, seem to us as coming directly from the sun. The yellow sun we learn to draw as children, the big yellow circle with the long yellow lines emanating from its center, is a direct result of Rayleigh scattering, named after the Nobel Prize–winning British physicist Lord Rayleigh, who solved the mystery of the sky's color.

At times, the sky is more or less intensely blue, and sometimes it looks almost white—not just on cloudy days but in dry weather or in polluted areas, when dust particles (or pollution) are swept up into the atmosphere. These particles are much larger than average-size pieces of atmospheric matter, which means they are able to catch and scatter all wavelengths of light equally and create the appearance of a nearly white sky. When a big rainstorm clears away the particles, the sky returns to deep blue in the absence of all of the other scattered wavelengths.

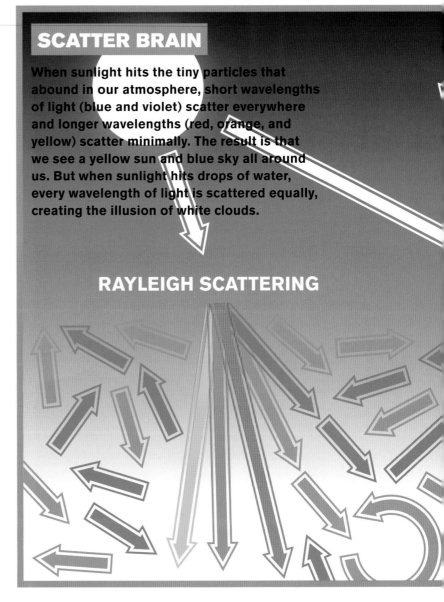

SCATTER BRAIN

When sunlight hits the tiny particles that abound in our atmosphere, short wavelengths of light (blue and violet) scatter everywhere and longer wavelengths (red, orange, and yellow) scatter minimally. The result is that we see a yellow sun and blue sky all around us. But when sunlight hits drops of water, every wavelength of light is scattered equally, creating the illusion of white clouds.

RAYLEIGH SCATTERING

The reds, oranges, and pinks of dawn and dusk follow the same rules. Because of the earth's daily rotation on its axis, the sun is farther from the beholder at these points in the day. At dawn and dusk, the shorter wavelengths of light that dominate when the sun is at closer range are scattered so completely that they don't reach the eye. Instead, only longer wavelengths of light (reds, oranges, and yellows) are able to travel these distances. The sun itself continues to take on the attributes of the longer wavelengths of light, which is why at these times we often see

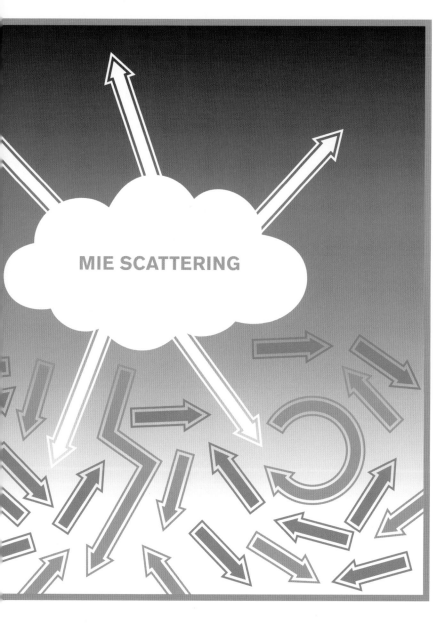

MIE SCATTERING

why we'd like to keep this ozone intact so that those ultraviolet rays are unable to beam down on us and damage our skin). Some, like carbon dioxide, absorb infrared light and warm up the atmosphere, causing the greenhouse effect; and some, like water droplets, are large enough to reflect equally all the wavelengths in the visible spectrum that sunlight provides. The result is white clouds, mist, and fog. This whiteness is also a result of scattering, but not Rayleigh scattering. Instead, as with white skies, the cause is a nonselective form of scattering called Mie scattering (after German physicist Gustav Mie), which reflects each wavelength of light equally, creating the perception of whiteness.

Ever wonder why cloudy or foggy days make everything look duller? This is one atmospheric phenomenon to which common logic does attach: On cloudy days, less light makes it through the cloud cover, minimizing the number of wavelengths we perceive.

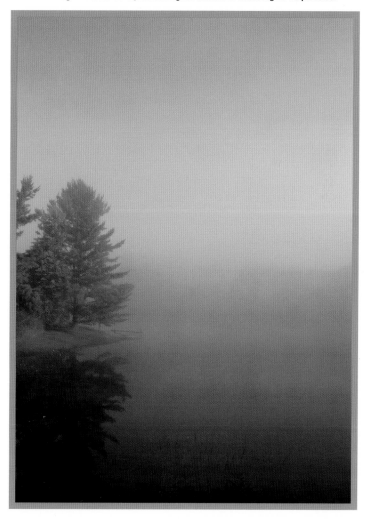

it as a bright red orb. To understand this phenomenon, imagine yourself standing in oncoming traffic on an interstate highway where blue and green cars get forced off the road long before they can reach you, and only red and orange ones are allowed to drive straight through.

Most of the particles in our atmosphere are too small to absorb or reflect all the wavelengths that sunlight provides, but different kinds of particles can absorb and reflect different kinds of light. Some, like molecules of ozone, absorb ultraviolet light (which is

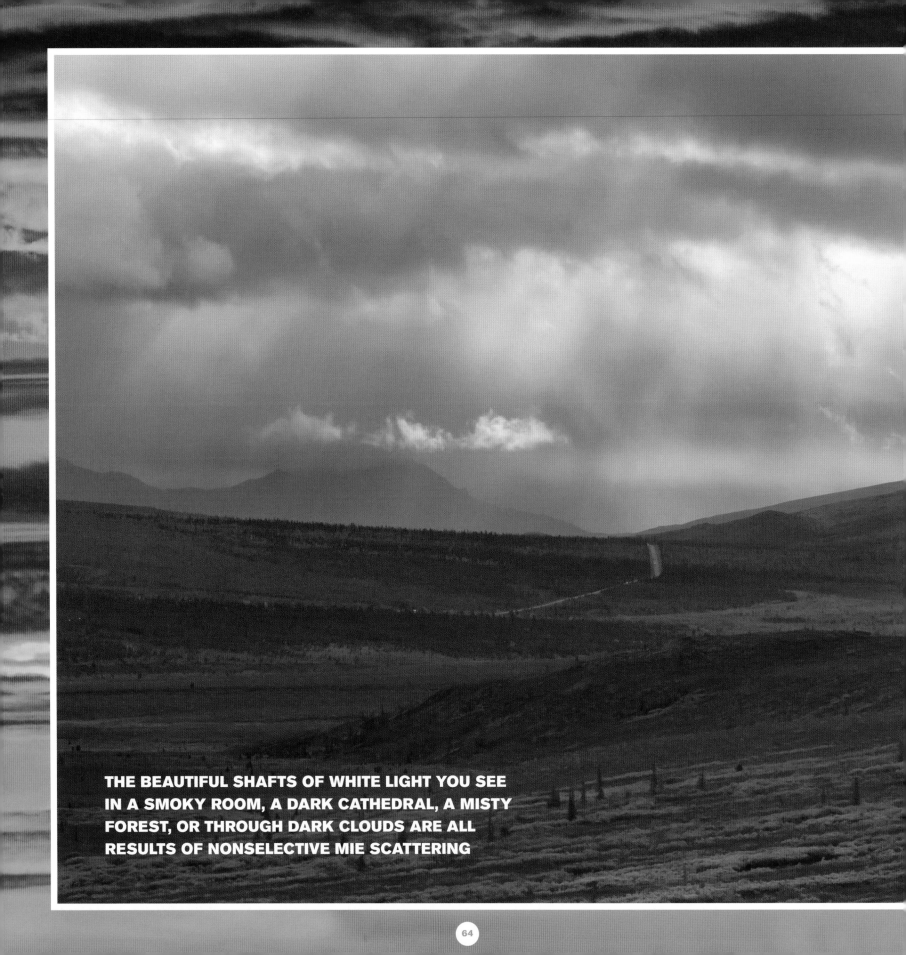

THE BEAUTIFUL SHAFTS OF WHITE LIGHT YOU SEE IN A SMOKY ROOM, A DARK CATHEDRAL, A MISTY FOREST, OR THROUGH DARK CLOUDS ARE ALL RESULTS OF NONSELECTIVE MIE SCATTERING

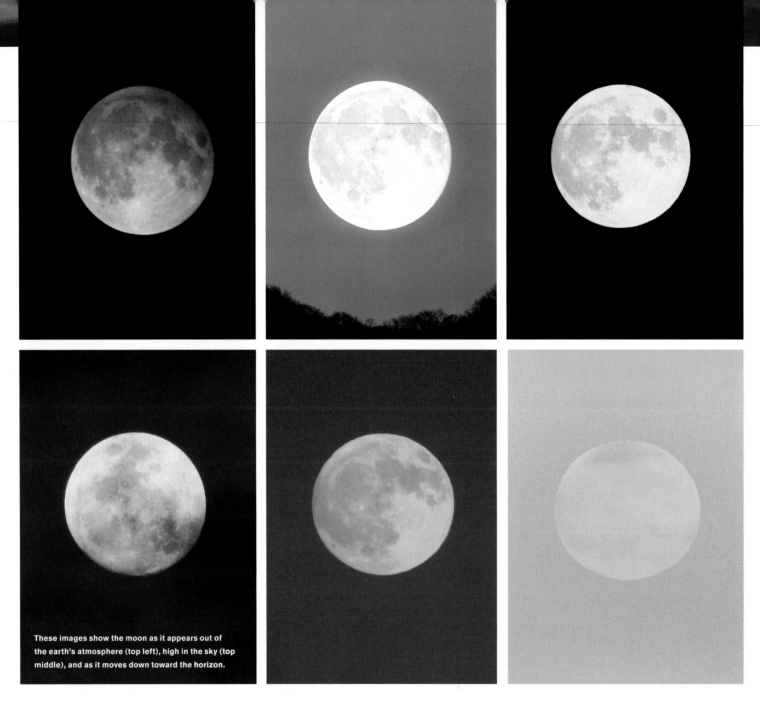

These images show the moon as it appears out of the earth's atmosphere (top left), high in the sky (top middle), and as it moves down toward the horizon.

THE MOON Hard as it is to believe in the face of its bright nighttime glow, the moon does not produce its own light; its glow results from the reflection of sunlight off its surface. But its color is a direct result of Rayleigh scattering. When the moon is high in the sky, it appears whitish gray; and if you were out in Earth's orbit, where the absence of matter means there is no light scattering, it would always appear gray; but when the moon is down by the horizon, in our particle-heavy atmosphere, it can turn almost orange as a result of the same effects of Rayleigh scattering as a setting sun.

When full and high up in the sky, the moon can appear to light up the night, but it never reflects enough light to allow us to see colors beyond blues and violets and mostly shades of gray. This, again, is a function of the fact that the photoreceptors in our brains responsible for seeing most hues aren't active in this kind of low light. Only our rods—our dark, light, and contrast-sensing photoreceptors—are at work in moonlight.

THE FUNDAMENTAL RAINBOW A seemingly miraculous arc that must have charmed and delighted humans from their earliest days, the rainbow is the visual summit of the world of color—Newton's spectrum of fundamental colors writ large, spectral, and evanescent.

In a rainbow, each drop of rain (or atmospheric moisture still present in the atmosphere before or after a rainstorm) acts as a prism. Just as with a prism, white light enters a raindrop and is refracted or bent into the spectrum of full visible light. When this light hits the back of the drop, it is refracted again, further dispersing the resulting colors on their way out.

A rainbow, it is clear, is not a fixed image in the sky—it's a moving, transient play of light. No surprise, then, that a rainbow can never been seen in the same exact way by two different people. With such a countless number of prisms at play, what you see depends on the exact angle at which you are standing. Each rainbow is unique to you.

The order of the colors in a rainbow from top to bottom is just what you'd expect and from longest to shortest wavelength: red, orange, yellow, green, blue, and violet. In a double rainbow's second, less intense arc, the colors are reversed: violet is on the top, red on the bottom. This reversal is due to light reflecting not once, but twice, inside each droplet.

Regardless of order, these "bands" of color are not actually bands at all. A rainbow is a continuous spectrum of color; our brain perceives bands because of the number of photoreceptors in our eyes. People with certain types of color blindness, born with fewer photoreceptors, see fewer bands of color. With additional photoreceptors, we would see additional bands. So the pigeon standing next to you, if all his photoreceptors are intact, will see a band of ultraviolet light as well.

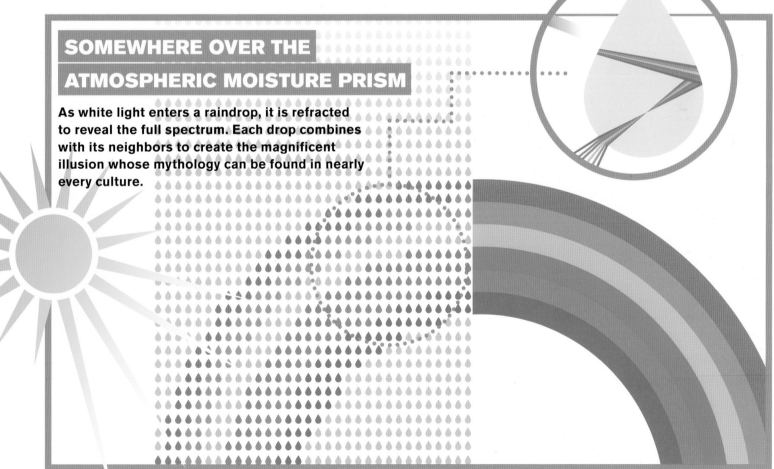

SOMEWHERE OVER THE
ATMOSPHERIC MOISTURE PRISM

As white light enters a raindrop, it is refracted to reveal the full spectrum. Each drop combines with its neighbors to create the magnificent illusion whose mythology can be found in nearly every culture.

A FEW TIPS FOR RAINBOW HUNTERS:
1) BE SURE TO STAND WITH YOUR BACK TO THE SUN
2) IF POSSIBLE, STAND NEAR A CLEAR AREA OF SKY
3) HOPE A DARK SKY APPEARS BEHIND THE RAINBOW.

WITH THESE VIEWING CONDITIONS IN PLACE, YOU'LL
SEE A PARTICULARLY VIBRANT RAINBOW.

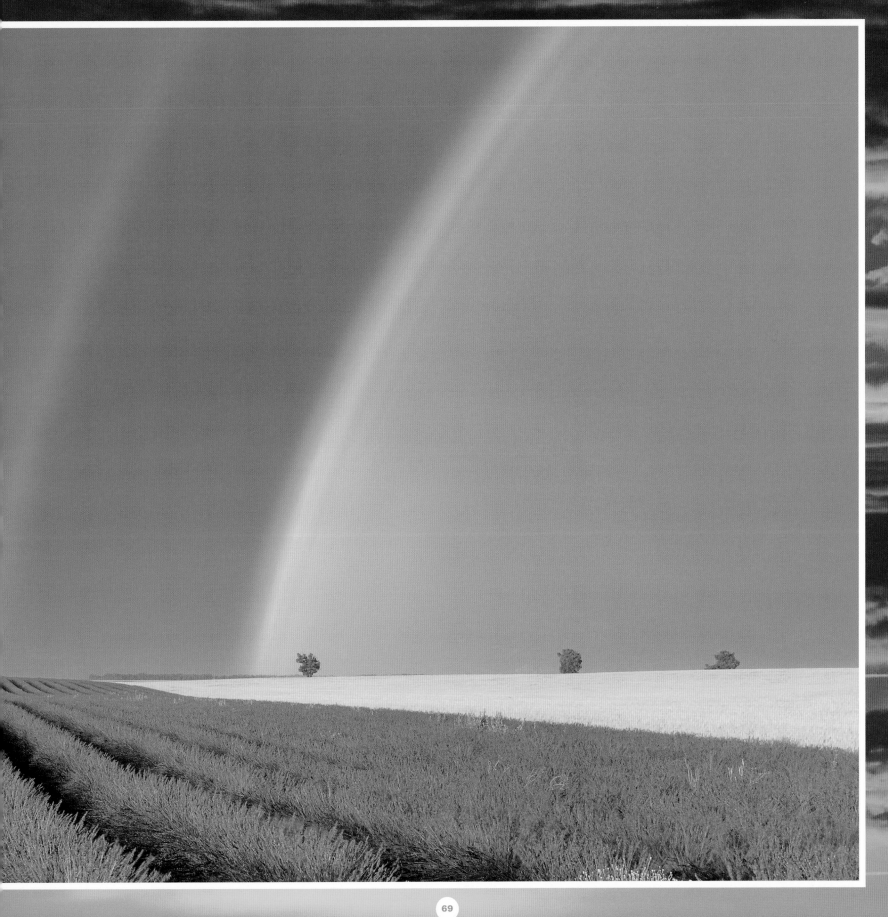

ORANGE

For millennia, orange was a color without an identity. In many languages, it's one of the very last, if not *the* last, color named in the rainbow. Many native cultures still see no need to give orange its own label. Of course, orange has always existed and been plentiful, whether in the form of blooms, fruits, vegetables, animals, or the sky as the sun sets. Through pigments like saffron, it has long colored clothes and canvases. It has been used to symbolize nationhood, religious identity, and athletic affiliations. Yet it doesn't come close to its neighbor, red, in terms of its place in the world. This may have to do with the nature of orange as a visible hue: When pale, it is usually identified as yellow. When dark, it is usually identified as brown. There is a narrow band in which orange can show off its true self, but in that narrow band, it shines.

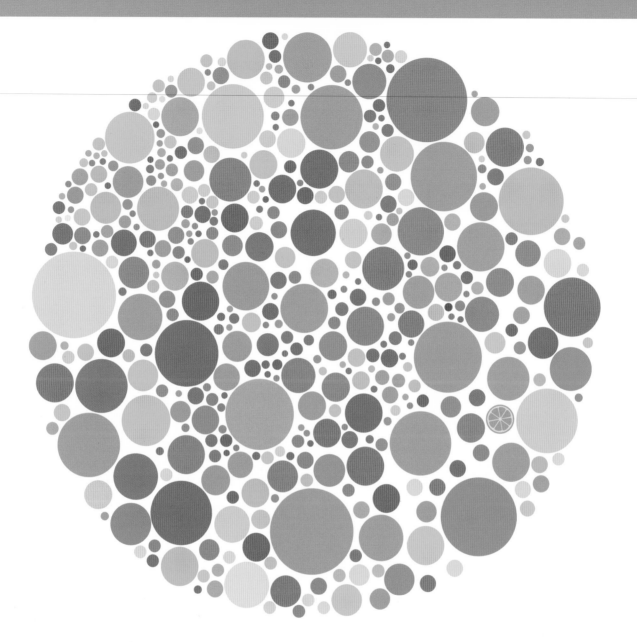

Known for centuries simply as red-yellow (or *ġeolurēad* for English speakers of yore), it wasn't until its eponymous fruit became widely known that the color orange was named. Maybe poets, tired of the inexact descriptor that fell between one color and another, felt the need to fill in the gap. So the fruit itself became the color—not an uncommon occurrence: think of turquoise, indigo, ruby, and violet.

The origin of the word *orange* says as much about the paths the fruit traveled as it does about the fruit itself. Most likely first cultivated in China, the fragrant and juicy specimen was brought by traders of the exotic to the early Persian emperors who collected trees from beyond their dominion's borders. The fruits then traveled from Persia to Moorish Spain, taking on native pronunciations along the way—from *nārang* in Persian to *nāranj* in Arabic and from *nāranga* in Sanscrit to *naranja* in Spain. Once oranges arrived in France, the word took on a little twist and became *orenge*. From there, it was only a small step to orange.

GREAT BRITAIN
"ORANGE"

FRANCE
"ORENGE"

THE JOURNEY OF ORANGE

Today, China grows millions of oranges, but Brazil is now the number-one producer of this juicy, luscious fruit.

PERSIA
"NARANG"

INDIA
"NARANGA"

CHINA
"CHÉNG ZI"

★

Most likely first cultivated in China

SAUDI ARABIA
"NARANJ"

SPAIN
"NARANJA"

What's surprising is that the word was first used as an adjective, in manuscripts dating back to the thirteenth century, to describe not the fruit's color but the bitter taste of its peel. By the sixteenth century, though, the meaning had changed to refer to the color, and all that bitterness was left behind.

AMBER, THE MUMMY MAKER Although often grouped together with semiprecious gems, amber is not a stone at all: rather, it is a fossilized tree resin that has hardened over time and whose orange color flirts with both gold and brown. Amber's nascent malleability is an important part of what gives it its special qualities. In its early formation, the resin catches whatever material falls its way—plants, insects, even small animals—and traps its finds, preserving them as the resin hardens. This process dates back to prehistoric times; lucky and grateful scientists have found amber containing fossils dating back more than two hundred million years.

Farmers harvesting bitter oranges. From the fourteenth-century text, *Tacuinum Sanitatis*, a medieval health handbook.

If you look closely, you can see the scales in this fly's wings. That's how well amber preserves what it catches.

Amber is a wonderful "mummy maker": It dehydrates its victims but preserves their tissue. It also contains natural antibiotic bacteria and fungi, which help to prevent decay. The Ancient Egyptians certainly grasped resin's virtues when they used it to embalm their nobility for posterity.

Amber's special gifts have enabled scientists to glean all sorts of information about the history of living things, but perhaps the most widely known amber-related hypothesis remains elusive, as readers familiar with Michael Crichton's novel *Jurassic Park* will recall. The idea posits that a mosquito that once fed off dinosaur blood is perfectly preserved in amber. Once scientists extract the DNA from the blood the mosquito drank, they will hold the key to re-creating real live dinosaurs. Is this really doable? The problem is, DNA breaks down easily over time, and the qualities that help amber preserve that which falls into its grip are the same qualities that help destroy DNA. Sadly, whole hosts of experiments the world over have failed to produce intact prehistoric DNA. For the foreseeable future, we'll have to be satisfied with dinosaur bones.

GUPPY LOVE Guppies, the tiny, 2- to 3-centimeters-long fish you commonly find in home fish tanks flip their fins all over the planet. The diminutive swimmers come in many colors and shapes and can be found in freshwater streams north, south, east, and west, but the first known guppies lived in Trinidad.

Almost all natural guppy populations, regardless of where they are on the map, exhibit a shared trait: anywhere from one to five orange patches on males. For such a specific, seemingly cosmetic trait to have stayed constant over such a vast geography is startling in and of itself, but the story behind this orange patch makes it even more so. The color comes from two sources, one internal and one external to the male guppy. The internal pigment is made up of drosopterins, which create a red hue. The external pigment comes from the carotenoids the guppies ingest (via algae, herbivorous insects, and tree fruits that fall into the water), which can color them yellow, orange, or red, depending on what exactly they eat.

Although humans may not see much variation in the orange spots of these male guppies, female guppies certainly do.

The orange patches, which vary from a yellow-orange to an orange-red, result from a fine balance between carotenoids and drosopterins. Each particular shade of orange has its female devotees, but the balancing act involved in creating the color that will attract a mate is not an easy one. Algae, for example, are more

carotenoid-rich in some waters than in others, so these orange-spotted guppies must constantly adapt to their environment. In a carotenoid-rich environment, some must produce extra drosopterins to get just the right shade—and vice versa. This bit

of genetic fine-tuning is quite spectacular, especially when you consider that its function is to make the lady guppies swoon.

The variation in female color preferences is due to their excellent color vision. Guppies have at least four different types of photoreceptors that sense color and may have as many as eleven (we humans have only three), including a photoreceptor that is sensitive to ultraviolet light. The number and kind of photoreceptors a female guppy has determine which shade of orange she finds attractive. Those that have photoreceptors that are sensitive to a true orange will prefer males with these color

patches; but if they have photoreceptors that are more sensitive to red, they'll be on the lookout for males with more orange-red ones.

Regardless of their particular photoreceptors, to female guppies' eyes, these spots are most likely a far more exciting color than the one we see—a color that we can't describe because our eyes are unable to detect the vibrant, luminescent, and variable color that their tiny brains detect.

THE HOUSE OF ORANGE If you've ever been to the Netherlands, you're sure to have noticed a preponderance of the color orange. Go to a Dutch soccer game, and you might find yourself swearing off the color forever. It's an all-orange affair. Yet if you look at a contemporary Dutch flag, there's no orange to be found.

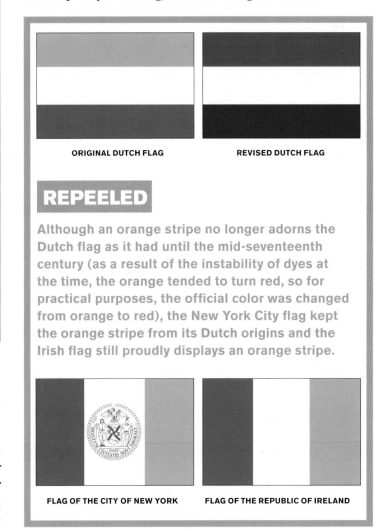

ORIGINAL DUTCH FLAG REVISED DUTCH FLAG

FLAG OF THE CITY OF NEW YORK FLAG OF THE REPUBLIC OF IRELAND

William of Orange is also credited for the ubiquity of an orange vegetable that is found worldwide today: the carrot. The Dutch have a most excellent tale about the reason why carrots are orange. It goes something like this: to honor William of Orange, horticulturalists worked to develop a tribute, an orange carrot, which they created through a painstaking process of selective breeding.

This story is partially true, but there's more to it: Before the sixteenth century, orange carrots weren't a stable variety that could be planned for and planted. Historically, carrots were generally yellow, red, or purple. But art history tells us that orange carrots did exist (visual evidence goes back as far as the first century AD), although they were called "yellow-red" as orange hadn't yet been named.

So although the Dutch did successfully breed an orange carrot that could be planted and reseeded over and again, adopting the humble veggie as a point of national pride, William of Orange cannot claim the credit for our favorite dip accompaniment, nor have orange carrots completely overtaken the land. Variously

An illustration of a carrot from the fourteenth-century text, *Tacuinum Sanitatis*, demonstrates that orange carrots did indeed exist before William of Orange.

So what's it all about? This allegiance to the color orange goes back to William of Orange (aka the Prince of Orange), the man who helped establish the Netherlands as a state during the sixteenth century. Although he was nicknamed William the Silent, he was anything but silent when it came to his belief in freedom of religion. Some believe his convictions derived from the fact that he was raised a Lutheran and converted to Catholicism largely to obtain his title and property. Whatever the reason, William was highly disturbed by the treatment of Protestants in the Netherlands and fought hard against the ruling Spanish to save the Dutch from mass destruction. His fight helped establish the Netherlands as an independent state. The color orange, the namesake of the man who fought not only for religious freedom but also against a despotic Spanish King, was forever graven into the Dutch identity.

Carrots are the second most popular vegetable in the world, after potatoes. There are several hundred varieties cultivated today—the vast majority of which are orange.

William III.
Portrait attributed to Thomas Murray.

THE ORANGE DOESN'T FALL FAR FROM THE TREE

The "Prince of Orange" was the title that accompanied the Principality of Orange, in what is now the South of France. It was held by members of the House of Orange-Nassau, heirs to the crown of the Netherlands. Here's a protracted look at the Williams who claimed the title.

Prince William I
1155-1218

William I
Prince of Orange
1533-1584

William II,
Prince of Orange
1626-1650

King William III
of England and
Ireland
1650-1702

William III died childless after a riding accident, rendering House of Orange extinct.

colored carrots still exist as heirlooms, although they lack the sweetness and flavor of their sunny-colored brethren.

William III of Orange, who was the King of England, Scotland, and Ireland from 1689–1702, as well as the great grandson of William of Orange, can also take credit for helping popularize the color associated with his name. Whereas many of us associate the color green with the Irish in general, it's linked only to Irish Catholics. Irish Protestants took a different path, adopting the color orange in homage to William III. William III was a Protestant who, like his great grandfather, believed in religious freedom and fought for the Protestants of Ireland. His army went up against the Catholic James II (who had preceded William as King) and won. One of the results of his reign was the 1689 Bill of Rights, which granted religious and civil liberties to Protestant subjects of the crown.

Today William III's legacy is still upheld by the Orange Order, the fraternal Protestant organization of Northern Ireland whose members are called Orangemen. All of William's soldiers wore an orange sash, and today Orangemen (and women) wear orange sashes in their frequent parades.

THE BIG ORANGE

Even New York City was briefly named New Orange in honor of William III. This name change occurred in 1673 after the Dutch prevailed in the third Anglo-Dutch War. But only one year later, after the Treaty of Westminster in 1674, the city was given back to the English, and New Orange was New York once again.

Orange Order members march through Belfast in Northern Ireland to celebrate the Battle of the Boyne in 1690, when the Protestant King William of Orange defeated the Roman Catholic King James.

Crocus sativus.

Whether the Orange Order upholds the same principles of civil and religious freedom for which William III risked his life is up for debate. The organization does not allow Catholic members and has been accused of bigotry and sectarianism. But one thing is certain: Because of William of Orange, William III, and the Orange Order, the color itself gained some historical and social significance, if only a small fraction of that of its spectral neighbor, red.

THE MOST EXPENSIVE SPICE ON EARTH Look inside a crocus plant, and you'll see exquisite powdery orange tendrils. In *Crocus sativus,* a particular species of crocus, these tendrils (called stigmas) are the source of the spice and pigment saffron. It takes a whopping 200,000 stigmas to make a pound of saffron, and the crocuses from which they are sourced must be picked by hand in the wee hours of autumn mornings before the sun burns down on their delicate blooms and wilts their precious cargo. With only three stigmas to a crocus flower, it's easy to see why saffron, at $5,000 or more a pound, is the most expensive spice in the world.

PRICE OF SPICE

SPICE	PRICE
SAFFRON	$364.00
VANILLA	$8.00
CLOVE	$4.00
CARDAMOM	$3.75
PEPPER	$3.75
THYME	$2.75

Price for 1 ounce of spice in US dollars.
Based on 2013 market value.

ALTHOUGH BUDDHISTS CHOSE THE COLOR SAFFRON FOR THEIR ROBES, THE CLOTH WAS NOT ACTUALLY DYED WITH SAFFRON. INSTEAD, TURMERIC AND JACK FRUIT WERE COMMONLY USED. IF YOU'RE GOING TO RENOUNCE ALL WORLDLY GOODS, SAFFRON, AT $5,000 A POUND, WON'T MAKE IT ONTO YOUR SHOPPING LIST.

Unlike most spices, saffron comes not from the Far East, but from the Mediterranean. Its connections with humans reach back at least as far as the 50,000-year-old Iraqi cave drawings in which traces of saffron were found. Ancient Greek women loved saffron as a dye for their clothes. Homer wrote in *The Iliad* of "Dawn in robe of saffron." Roman baths used saffron to perfume the air. Saffron pigments helped illuminate medieval manuscripts, and throughout time, saffron was believed to have numerous medicinal uses. It could cure a toothache, act as a stimulant, or spice up your sex life as an aphrodisiac.

Fluorescent orange traffic furniture.

A bundle of saffron threads.

FLUORESCENT ORANGE Although yellow is the color most visible during the day, orange best captures our attention once the sun starts to rise or set. Add a background of blue sky, sea, or ice and you're more likely to spot fluorescent orange than any other color. That's why orange and fluorescent orange are commonly used for life vests, life preservers, rafts, and other emergency equipment. Fluorescence glows even from a distance, especially in the presence of the ultraviolet light most abundant at dawn or dusk. That's why we use fluorescent orange on construction cones, hunting gear, prison garb, and the vests worn by traffic cops and crossing guards.

PAINTED A DEEP ORANGE TO BOTH BLEND WITH THE OCHRE HILLS IT TOUCHES AND TO STAND OUT AGAINST THE WATER AND SKY, SAN FRANCISCO'S GOLDEN GATE BRIDGE IS PERHAPS THE WORLD'S MOST MEMORABLE ORANGE LANDMARK. THE PAINT COLOR IS NAMED "INTERNATIONAL ORANGE" AND IT IS USED ON A REGULAR BASIS TO TOUCH UP THE LAST COMPLETE PAINT JOB THAT WAS PERFORMED IN THE 1980s.

A bird's-eye view over the many terrains of our planet would encompass brown dirt, multicolored pebbles, beige sand, swirls of blue water, and mountains of white snow.

The surface of the earth is, appropriately enough, filled with "earth tones." From Kalamazoo to Timbuktu, it's also dotted with rainbows of crystallized rocks, swaths of glacier-borne aquamarine pools, and a shocking array of soil colors that span the spectrum from red to violet, far from the brown the word *dirt* elicits. These colors were nature's first maps, designed before any living creatures inhabited our planet, their colors revealed only once animals developed the vision to see them.

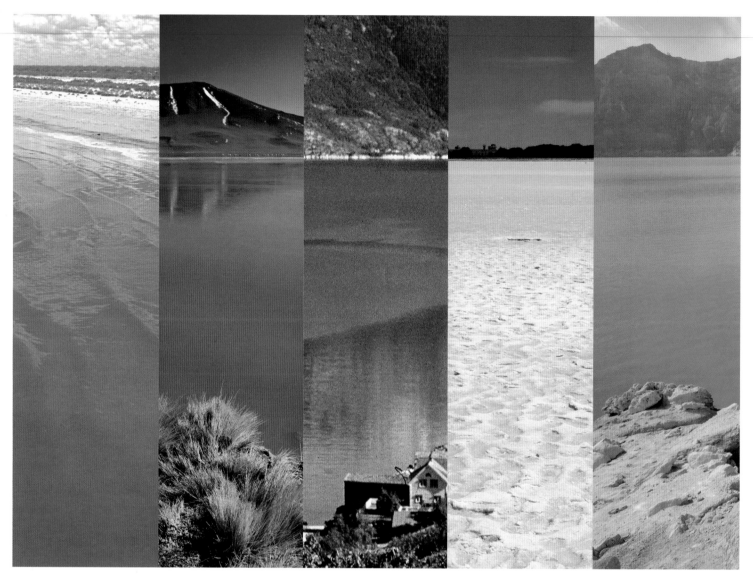

Swimming pools with aqua-painted walls aside, true blue bodies of water are a rarity. A stream amid weeping willows might run a mossy green, a lake on a winter's day almost black, a humble creek a fitting muddy brown, and the ocean sometimes blue but also everything from a stunning aqua to a dark forest green. (Water can wear more exotic guises as well, as names like the Red Sea make plain.)

Water molecules—made up of hydrogen and oxygen—absorb red, orange, and yellow light and reflect blue and green light. This is the primary reason for water's generally blue-green color range, but it's also just the beginning of the story, for water can also scatter light, reflect light, or be filled with matter that contributes its own reflective properties. The color of the sky, the amount of waves in the water, as well as the time of day and time of year can also affect the color of water.

If a body of water contains algae, microscopic organisms, or sediment, its color shifts, sometimes subtly and sometimes dramatically. For example, when rock flour, the silt created by glacial erosion, enters moving rivers, its cloudy appearance often turns a river gray or white; but when it hits a lake where the water is relatively still, it can turn the water a vibrant turquoise due to the same Rayleigh scattering that turns the sky blue (see page 62).

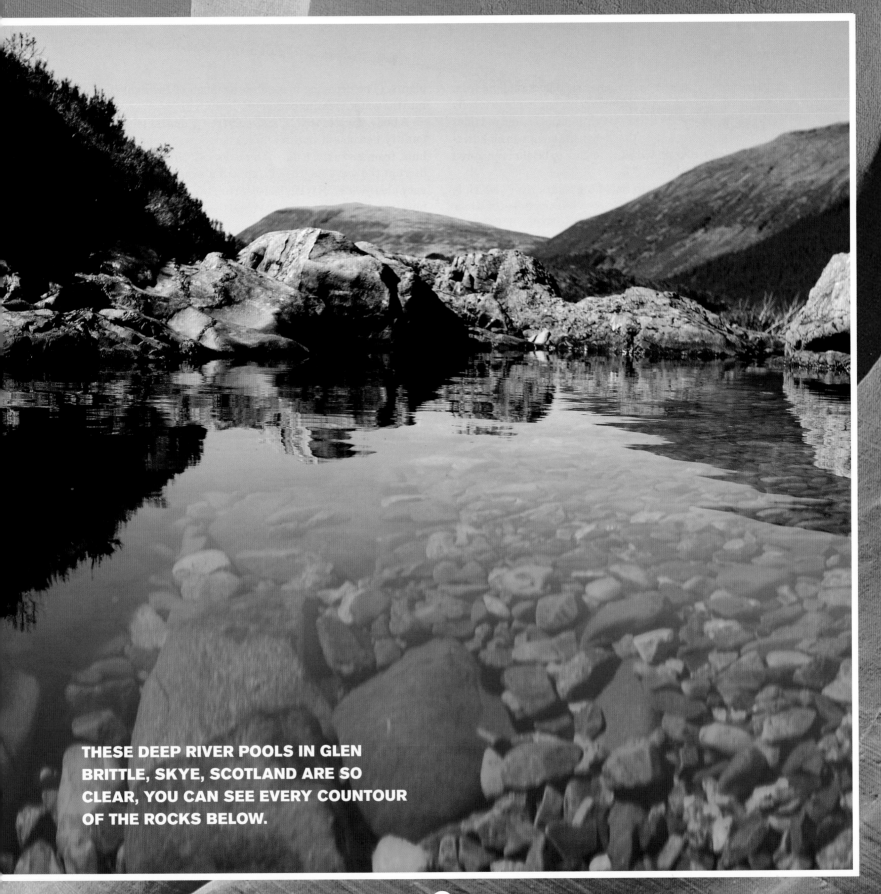

THESE DEEP RIVER POOLS IN GLEN BRITTLE, SKYE, SCOTLAND ARE SO CLEAR, YOU CAN SEE EVERY COUNTOUR OF THE ROCKS BELOW.

Algae, which itself comes in numerous colors ranging from red and yellow-green to blue-green and brown, can powerfully color the water it inhabits. The Red Sea, pink lakes, and red tides get their names from the algae that, when in bloom, can make water appear anywhere from bubblegum pink to bright orange-red to magenta to brownish red.

The Amazonian Rio Negro (meaning "black river," which is more brown than black) is one of many brown bodies of water on our planet; its color comes from the breakdown of decaying plants. (The decaying mass absorbs much of the light coming into the water, creating darkness.)

A body of water that is relatively free of matter (salt doesn't qualify because it doesn't affect color) will appear a lovely blue, from its surface down to its depths. Nothing is there to disrupt the wavelengths of light from passing through it. In very clear water, Rayleigh scattering is also at work, making blue light move about, intensifying the perception of the blueness of the water.

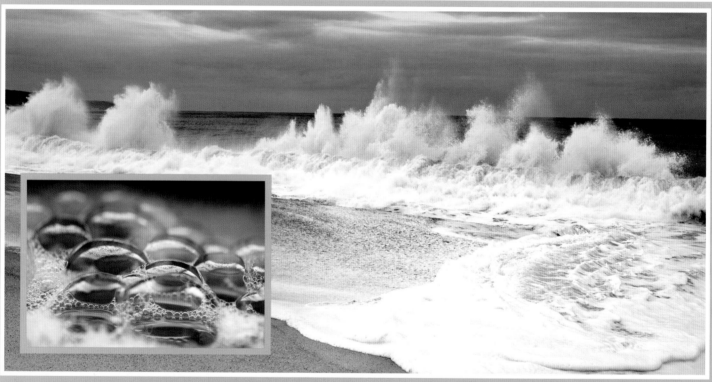

WHY DO WE FIND WHITE WAVES AND FOAM IN SO MANY BODIES OF WATER, REGARDLESS OF THEIR HUE?

LIGHT SCATTERING IS INVOLVED, BUT IN THIS CASE SO ARE SPHERES—THAT IS, BUBBLES! ALTHOUGH INDIVIDUAL BUBBLES SCATTER A RAINBOW OF LIGHT (MUCH TO THE DELIGHT OF BUBBLE-BLOWING CHILDREN), WHEN THERE IS A MULTITUDE OF BUBBLES, THEIR WAVELENGTHS ADD TOGETHER TO FORM WHITE LIGHT.

The very white snow you see to the right is the result of the full spectrum of light bouncing off of the soft crystals seen in this macro view, above.

SNOW AND THE BOUNCE EFFECT Water is the ultimate shape-shifter. Depending on its state—liquid, gaseous, or solid—it displays an amazing variety of behavioral and reflective patterns.

Go outside after a fresh layer of snow has fallen, and you may be "blinded by the light." When sunlight hits snow, its full spectrum of wavelengths is almost entirely reflected back at us. Snow is made up of tiny crystals that bounce the light like players at an Olympic ping-pong match. This bouncing light easily escapes the snow as a result of its lack of density.

Unlike the way light bounces around snow, when light hits a glacier, it doesn't bounce around at all. Instead, the light is trapped inside the glacier's very solid crystals (snowy crystals, by contrast, are quite soft), where it is then refracted into all the colors of the spectrum. However, low-energy wavelengths of light on the red end of the spectrum are absorbed by the densely packed crystals, whereas high-energy wavelengths of light on the blue and violet end of the spectrum are not absorbed. The result is the glacier's shocking turquoise color, especially vivid in the cracks and crevices, where the scattering is most intense.

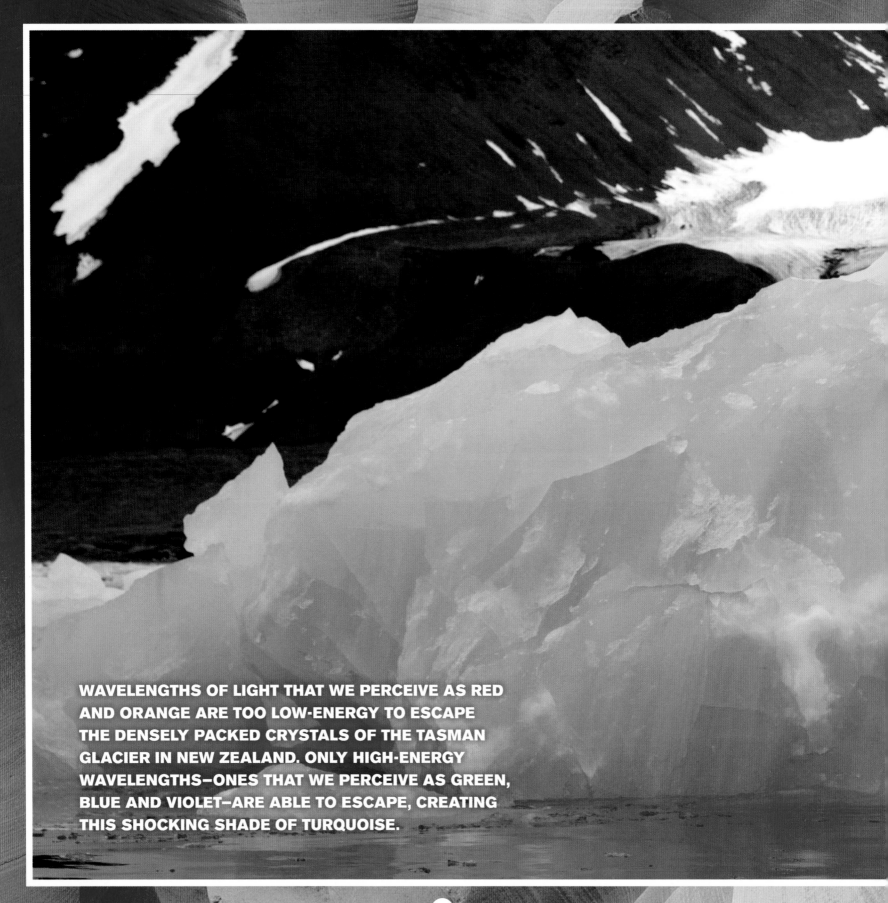

WAVELENGTHS OF LIGHT THAT WE PERCEIVE AS RED AND ORANGE ARE TOO LOW-ENERGY TO ESCAPE THE DENSELY PACKED CRYSTALS OF THE TASMAN GLACIER IN NEW ZEALAND. ONLY HIGH-ENERGY WAVELENGTHS—ONES THAT WE PERCEIVE AS GREEN, BLUE AND VIOLET—ARE ABLE TO ESCAPE, CREATING THIS SHOCKING SHADE OF TURQUOISE.

THE ROCK OF AGES Minerals are the building blocks of rock, formed inside the earth's mantle and pushed up through its crust, resulting in volcanoes and igneous rocks. The process is labor intensive, but Earth has been creating rock this way for four billion years. Like the dry flakes that come off the outer layers of our skin, rocks made up of these minerals form the upper crust of our earth.

Many of the rocks that constitute this upper crust were once magmatic—molten or liquid—matter that lay below the earth's surface. In their liquid state, the minerals were modified by their exposure to different pressures and temperatures. Whether formed below or above the crust, the aggregation of various minerals, and their relationship to one another, is what creates the different types of rock; and nearly every type of rock comes in a host of colors, colors that are determined partially by the temperatures and pressure to which the rocks were subjected or the presence of transition metals (a group of elements you'll find on the periodic table).

When rocks are still in liquid form, in what's called a *melt*, they possess a particular chemical composition. A rock that starts out molten turns hard (or in geology terms, *freezes*) at a specific temperature, which varies depending on its makeup. That freezing point, in turn, will imbue varying optical properties into a rock's minerals, as will the rate at which the rock cools. Faster or slower cooling will impart additional colors and optical effects. A melt with silica dioxide molecules will form

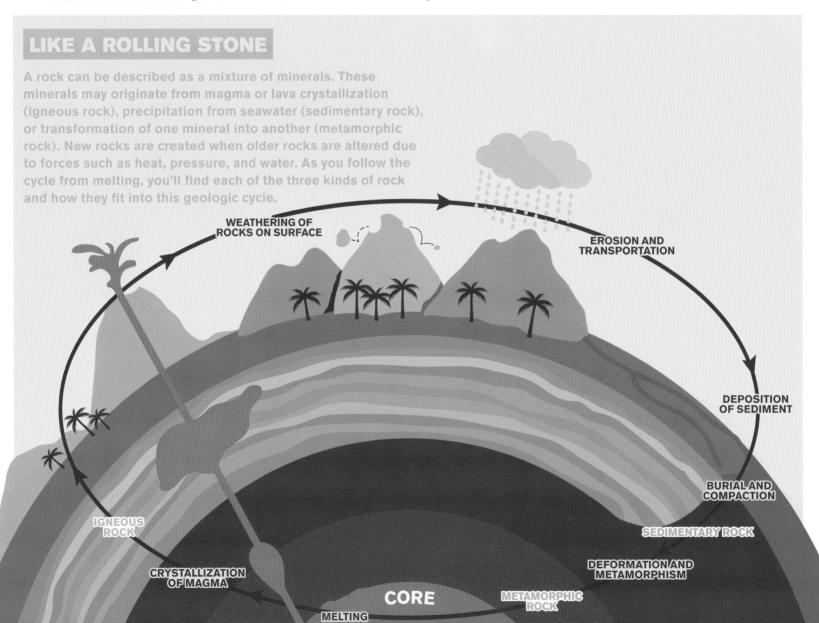

LIKE A ROLLING STONE

A rock can be described as a mixture of minerals. These minerals may originate from magma or lava crystallization (igneous rock), precipitation from seawater (sedimentary rock), or transformation of one mineral into another (metamorphic rock). New rocks are created when older rocks are altered due to forces such as heat, pressure, and water. As you follow the cycle from melting, you'll find each of the three kinds of rock and how they fit into this geologic cycle.

WEATHERING OF
ROCKS ON SURFACE

EROSION AND
TRANSPORTATION

DEPOSITION
OF SEDIMENT

BURIAL AND
COMPACTION

IGNEOUS
ROCK

SEDIMENTARY ROCK

CRYSTALLIZATION
OF MAGMA

DEFORMATION AND
METAMORPHISM

CORE

METAMORPHIC
ROCK

MELTING

quartz. If the melt freezes rapidly because of a volcanic ejection, it will form into a rock that may be opaque and white. If the same melt freezes slowly (very, very slowly, over a million years' time), its molecules will align in an ordered, six-sided crystalline structure, forming a clear quartz crystal that can range in color from gray to rose.

Every mineral has a chemical structure all its own. Under pressure, however, a mineral's internal structure can be stretched, pulled, and bent until it is deformed. The new deformed structure will reflect light differently from the original structure; if quartz— a clear or semiopaque rock—is deformed by tectonic forces such as the creation of mountains, it will metamorphose into quartzite, a completely opaque rock, where its crystalline structure is bent.

In addition to the rate at which a rock freezes and the pressure it endures, the temperature of the liquid helps determine the color, Depending on its heat, the composition of the rock can change if other elements are added to it. These elements, called *enrichments*, can change a rock from clear to purple, for example. In the case of quartz, if trace amounts of manganese enrich the melt, the otherwise clear quartz will become amethyst quartz.

The veins in rock are the result of one of two related phenomena: (1) either gases or fluids came up through the cracks in the earth's crust while the rock was being formed, or (2) the fluids in the veins of these rocks were enriched by ions and molecules.

A clear quartz crystal (above) and one of the many varieties of its opaque brethren, white quartzite (below).

Amethyst is a form of quartz, enriched with manganese.

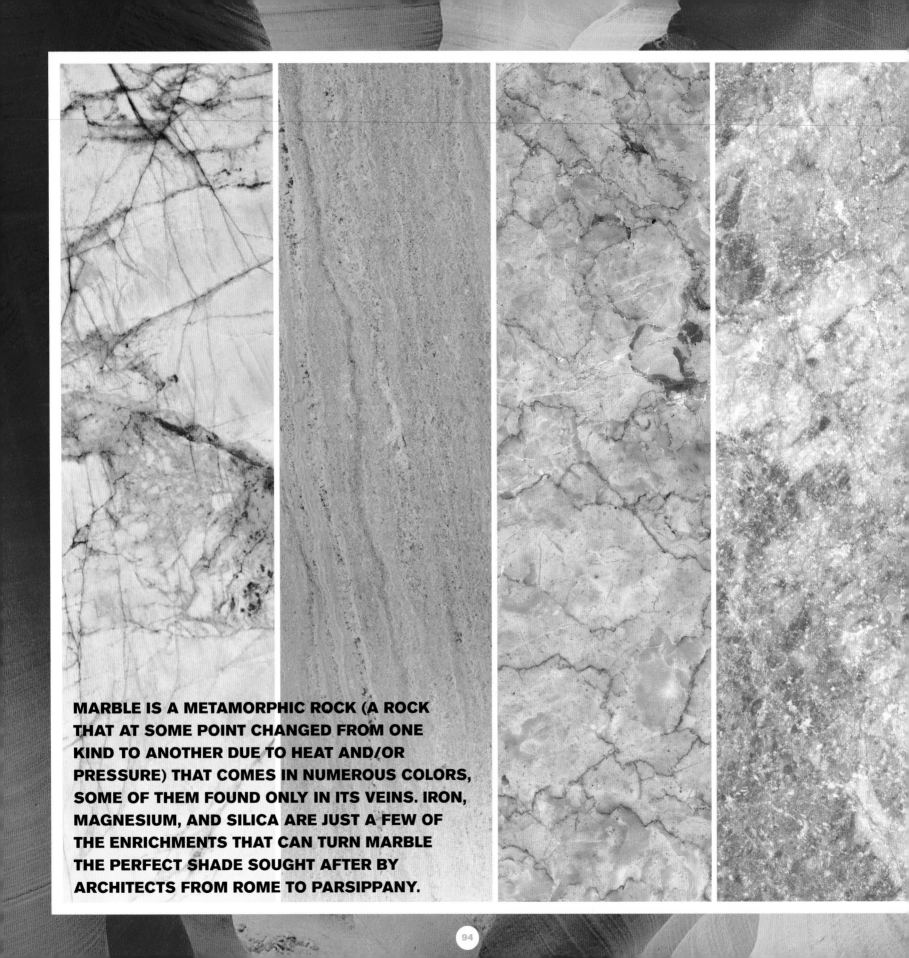

MARBLE IS A METAMORPHIC ROCK (A ROCK
THAT AT SOME POINT CHANGED FROM ONE
KIND TO ANOTHER DUE TO HEAT AND/OR
PRESSURE) THAT COMES IN NUMEROUS COLORS,
SOME OF THEM FOUND ONLY IN ITS VEINS. IRON,
MAGNESIUM, AND SILICA ARE JUST A FEW OF
THE ENRICHMENTS THAT CAN TURN MARBLE
THE PERFECT SHADE SOUGHT AFTER BY
ARCHITECTS FROM ROME TO PARSIPPANY.

Although we tend to think of sand as beige, it comes in an array of colors due to the minerals it is composed of.

How do the many colors of sand relate to rock? Sand is just a mineral or minerals in granular form. Some grains are made up of pure, single minerals like silica, and some are made up of multiple minerals. To qualify as sand, minerals have to be worn down to a certain size. Each grain has to fall between 0.0625 mm (anything smaller is called silt) and 2 mm (anything larger is called gravel). Sand's colors? They are as numerous as the minerals or mix of minerals that constitute its particular grains.

A GEM OF CREATION What separates a gem from a plain old rock? *Gem* is a general term for a particularly dazzling mineral,

whether it is in its pure crystalline form (such as a diamond) or completely "unordered" but beautiful because of how it refracts light (such as an opal).

In crystalline gems, all atoms are in what is known as their "preferred orientation." This orientation is predictable, so that the particular crystalline gem's structure is the same no matter where on earth it's found, and it results in recognizable and visible patterns. That lovely amethyst quartz pictured on page 93 is a form of quartz in one of its preferred orientations. With its six sides often topped by a six-sided pyramid, it makes for a stunning sight. It's no surprise that humans have chased after amethyst and its fellow gemstones for millennia.

POLISHED PERSPECTIVE

Why are wet rocks more colorful than dry rocks? The difference is due to nonselective scattering. Most rocks found in nature have a rough surface, even if on a small scale, and therefore scatter light to some extent. A wet surface reduces the light scattering and allows you to see the finer details of the rock. This is also what happens when you polish a rock or gem; you make the surface very smooth, which allows the details of the stone to be seen clearly.

CUT, COLOR, CLARITY, AND COST!

GEM	PRICE
EMERALDS	$2,400–$4,000
RUBIES	$1,850–$2,200
SAPPHIRE	$900–$1,650
AMETHYST	$10.00–$25.00
PEARL	$5.00

Prices approximate wholesale purchase price per carat of U.S. cut gemstones in January 2010. Source: USGS Mineral Resources Program

For the incredible array of gem colors in the world, we have two main phenomena to thank: enrichments and optical effects. As already mentioned, a stone containing even a tiny percentage of enrichments can be transformed from clear to colorful, and the presence of the same enrichments in two different minerals can result in colors all over the visible spectrum. Take the often colorless beryl, a beryllium silicate mineral, add a few chromium ions, and you get—emeralds. Add the same amount of chromium to corundum, a very hard aluminum silicate and another colorless mineral, and you'll wind up with rubies. Add a trace amount of titanium, iron, magnesium, or copper ions, and the result is sapphires.

Beryl + chromium = emeralds

Corundum + chromium = rubies

Corundum + iron (or other ions) = sapphires

Gems often reflect one span of visible light quite strongly, giving them a particularly bright and beautiful glow. Iron enrichment can create reds, greens, yellows, and blues (as in aquamarines). Chromium enrichments lead to reds and greens (as in rubies and bright green jade). Copper enrichments produce vibrant greens and blues (as in malachite and turquoise). Manganese enrichments create reds, pinks, and oranges (as in magenta tourmaline or amethyst).

A GEM OF A MINERAL

Copper, chromium, manganese, and iron are some of the enrichments responsible for the stunning array of gem colors. In many cases, it only takes a scant few of these ions to cause a mineral to go from colorless to intensely colorful.

COPPER

Turquoise

Aquamarine

Sapphire

Malachite

Iron

Garnet

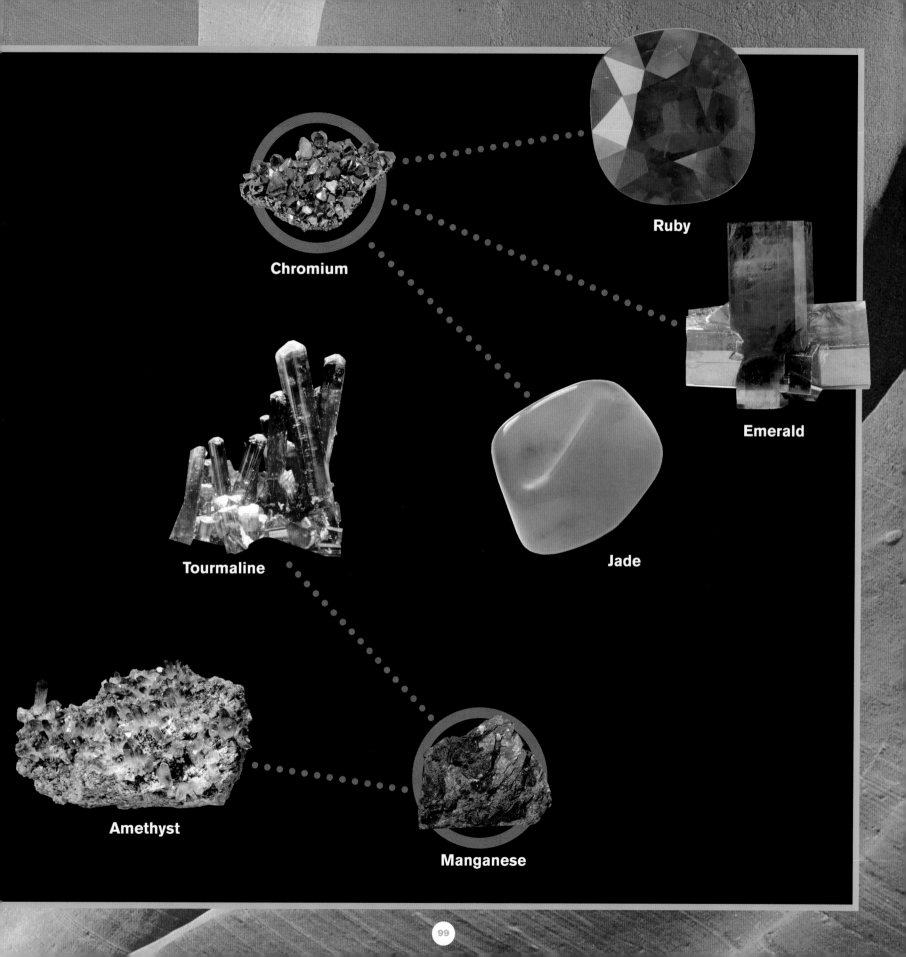

Chromium

Ruby

Emerald

Tourmaline

Jade

Amethyst

Manganese

You can see the rainbow of color in the opal to the right versus the limited palette of the opal on the left.

The intensity of a gem's color owes much to the presence of enrichments, but it can also be manipulated by heat and radiation via gamma rays and x-rays used by human hands. So if you're looking to buy a gemstone, you'll want to know whether or not it was altered by one of these methods. If its color was produced by nature's hands, the stone will be worth much more.

THE SPECIAL CASE OF OPALS An opal is an example of a gem with no crystalline structure; it's just a mush of silica dioxide laced with enrichments. Whereas enrichments are responsible for some of the luminescent background colors swirling in its milky sea, they don't tell the opal's whole story. Structure, too, comes into play. In opals with small crystals, light dispersion is limited to only the blue and violet parts of the spectrum. In opals with large crystals, you'll get to see the entire rainbow as you move the stone left and right, back and forth.

The high priestesses of gemological light refraction, diamond crystals are excellent at dispersing the full spectrum of visible light, the source of their trademark jazzy luster.

Although both opals and diamonds create a rainbow effect, they do it very differently. Diamonds are highly structured, refracting light more energetically and predictably. Opals' "messy" structure means they diffract light unpredictably, which is why the stones display so many unique color combinations.

ALEXANDRITE OR ALEXANDWRONG?

Believe it or not, these two photos have captured the same stone—once by daylight (top) and once by candlelight (bottom). We love the mineral called alexandrite for its dramatic display of how different sources of light can interact with the same material in very different ways

Clay cracking in the Dead Vlei in Nambia

THE BEAUTY OF SOIL AND CLAY William Bryant Logan, author of *Dirt,* calls his vilified subject matter "the ecstatic skin of the earth." Take a closer look at the stuff, and you'll undoubtedly agree.

Most people think of soil (to use dirt's sanitized moniker) as brown. But a collection of samples taken from all over the world displays a stunning variety.

Just as a gardener's watering can will immediately turn a dusty grayish brown soil into a rich brownish black, atmospheric moisture, or lack thereof, can radically affect soil's appearance. Soil's colors also depend on the degree of oxidation. Lighter-colored orange, red, and brown soils tend to be well oxidized and darker blue and black soils, less so. Soils that are totally leached of organic matter are very light. Bone-white soil is leached of everything or comprises calcite (calcium carbonate).

Clay—the scotch to a soil's whiskey—is the product of the breakdown of a group of secondary minerals in the soil. Over time, water filters through the soil, weathering the minerals and changing their shape and electrical conductivity; colors change accordingly. Red and yellow clays, for instance, owe their hue to the oxidation of iron—the same cause of the red in our blood and on the planet Mars.

THE DIRT ON SOIL

If you think of dirt as just brown, check out the soil colors below. As these pages from the *Munsell Soil Color Book* (the same Munsell from page 15, who helped establish modern color theory) show, soil is much more colorful than you might think.

SOIL COLOR CHART 5R

SOIL COLOR CHART 10YR

SOIL COLOR CHART 5Y

SOIL COLOR CHART GLEY 1

SURFACE LITTER
TOPSOIL
SUBSOIL
PARENT MATERIAL
BEDROCK

LAYER BY LAYER

Soil formation derives from a combination of broken-down plant material and rock involving factors such as climate, topography, parent material, time, and organisms. Each of these factors can affect the color of soil.

LOOKING INTO THE FLAME In the same way that you can tell the temperature of a star by its color, the color of fire can tell you a lot about its heat and contents. The base and hottest part of a forest fire will typically be white, changing to yellow, orange, and red as it cools—another piece of evidence in the case against the expression "red hot."

Different matter burns off in different colors as well, depending on the chemical composition of what is burning and what wavelengths of light it absorbs and reflects. In your typical fireplace fire, the orange glow comes from sodium, the blue parts from copper and hydrogen. (Which is why copper-based fireworks are always in demand on the Fourth of July.)

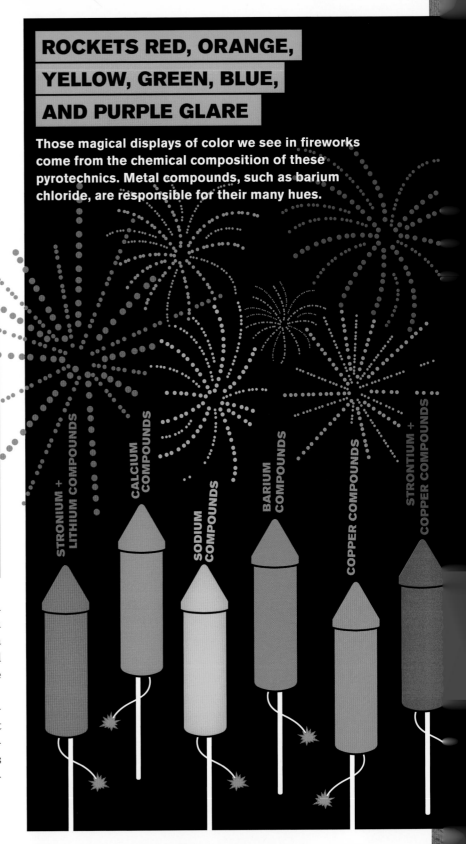

ROCKETS RED, ORANGE, YELLOW, GREEN, BLUE, AND PURPLE GLARE

Those magical displays of color we see in fireworks come from the chemical composition of these pyrotechnics. Metal compounds, such as barium chloride, are responsible for their many hues.

STRONIUM + LITHIUM COMPOUNDS

CALCIUM COMPOUNDS

SODIUM COMPOUNDS

BARIUM COMPOUNDS

COPPER COMPOUNDS

STRONTIUM + COPPER COMPOUNDS

JUST AS WITH FIREWORKS, DIFFERENT CHEMICAL
ELEMENTS CAUSE DIFFERENT COLORED FLAMES.
FROM GREEN, PRODUCED BY THE PRESENCE
OF COPPER, TO ORANGE, PRODUCED BY SODIUM
THERE IS NO ONE COLOR OF FIRE, RATHER A
TRUE RAINBOW OF FLAMES.

YELLOW

You spot a taxi a few blocks away. You hail it and get in. The cabbie speeds off before you've even closed the door. He's going way too fast, but he slows down as he sees a road sign indicating a dangerous curve ahead. He brakes again for a forklift in front of him. As he continues to navigate, you pull out a contract with a Post-it note tagging the page that requires your signature. You flip to that page, and a highlighter shows you exactly where to sign. Each of these items that caught your and the cabbie's eye is yellow. Yellow's luminescence has also dazzled emperors, painted millions of pencils, cautioned us to slow down, and gotten our attention.

More than any other color of the spectrum, yellow stands out. This is because the sensitivity of our eyes is at its peak when it encounters wavelengths of light we perceive as yellow. So if you were looking at a pale yellow, it would appear brighter than a pale blue, to which our eyes are not nearly as sensitive. We can also distinguish many more shades of yellow than blue because of our sensitivity to the color.

Although we were most likely always able to see yellow, scientists postulate that we probably developed an extra sensitivity to yellow to distinguish yellow and orange-yellow fruits from the green leaves surrounding them. These fruits were too big for birds and needed pollinators. We just happened (or did we?) to develop our increased sensitivity to yellows at the same time.

THE EMPEROR'S CLOTHES One of the world's oldest civilizations, China has a history that has long been saturated with the color yellow, starting with the man credited with being its first ancestor, a mythic character named The Yellow Emperor of Huangdi. The Yellow Emperor's reign is said to have begun in the twenty-sixth century BC, and his inventions and leadership helped Chinese civilization take root.

Whether a purely mythic character or a real man, no one knows for sure, but The Yellow Emperor is distinguished by a color that plays an important role in Chinese culture. The five-color system that accompanies the Five Elements used in everything from ancient Chinese philosophy to contemporary Chinese medicine, from tai chi to feng shui, established yellow as a color superior to all others. In this system, yellow sits in the middle of its fellow hues, making it equally yin and yang, a quality no other color could claim. It is also the color associated with gold and the abundance and wealth it brings.

Starting in the seventh century, with the Tang Dynasty, and continuing all the way through the twentieth century's Qing Dynasty, a decree forbade anyone other than the emperor from

YELLOW IN THE MIDDLE

The Wu Xing, or Five Elements, associates yellow with the earth, the center, the dragon, harmony, and stability.

FIRE

WOOD

EARTH

WATER

METAL

The Qianlong Emperor by Guiseppe Castiglione, an Italian Jesuit and court painter in China, c. 1739 or 1758.

From above, the roofs of the Forbidden City make for a vision of yellow.

wearing bright yellow. Other shades of yellow were reserved for his sons. The emperors were literally surrounded by yellow: the shade graced their garments and adorned their walls and roofs.

Whereas the Chinese reserved yellow for its most honored citizen, other cultures held the color in far lower regard, and the sunny hue is featured in a surprising number of sinister historical incidents. For centuries, Muslims tagged those they considered "other" with a yellow signifier. This tradition dates back to the ninth century, when the Jews and Christians of Baghdad were required to wear yellow badges. The practice was to be adapted in other parts of the world

Patches like this one were sewn onto armbands that Jews were forced to wear during the Nazi regime.

as well. In the thirteenth century, England's Edward I issued a statute requiring all Jews to wear a patch of yellow felt. In the sixteenth century, when India was under Islamic rule, one of Akbar the Great's generals used yellow armbands to tag Hindus. And in the 1930s, the Nazis infamously required Jews to be identified through armbands or badges with yellow stars of David. Even today, the Taliban uses yellow armbands to mark Hindus in Afghanistan.

HATS FOR PEACE Although yellow can be used symbolically to declare war on a race of people, it can declare peace in the form

of a hat. During religious ceremonies in the Gelug tradition of Tibetan Buddhism—one of the world's most peaceful religious groups—lamas (aka teachers) wear distinctive yellow hats. The Gelug tradition was established in the fourteenth century, but by the sixteenth century, it had gained strength over all other traditions owing to the Fifth Dalai Lama, Ngagwang Lobzang Gyatso. This great leader was able to unite the provinces of Tibet and eventually take both religious and political control over the country.

However, the fact that the Gelug tradition chose this particular hue for their hats does not, in fact, have any special religious or symbolic meaning. Yellow was used to differentiate the Gelugs from the other traditions whose followers wore red hats. The most famous lama with a yellow hat is none other than the Dalai Lama.

ZEN PALETTE

In Buddhist Tantra literature, there is a four-color system that includes white, yellow, red, and blue-black. Yellow is the color used to represent things on the rise: from wealth and health to knowledge and wisdom. White represents peace, red represents power, blue-black represents wrath.

WEALTH AND HEALTH
KNOWLEDGE AND WISDOM

PEACE

POWER

WRATH

Buddhist monk of the Gelug tradition, in Shigatse, Tibet.

WHILE SUNFLOWERS ARE MORE COMMONLY ASSOCIATED WITH THE SOUTH OF FRANCE, THEY ARE ACTUALLY NATIVE TO NORTH AMERICA. AMERICAN INDIANS, FROM WHAT IS NOW ARIZONA AND NEW MEXICO, WERE THE FIRST TO CULTIVATE THESE MAJESTIC PLANTS STARTING AROUND 3,000 BC. JUST ONE OUNCE OF THEIR HIGHLY NUTRITIOUS SEEDS CONTAINS 160 CALORIES AND THE OIL CONTAINED THEREIN HAS BEEN USED IN EVERYTHING FROM COSMETICS TO DIESEL ENGINES TO FRYING PANS ALL OVER THE WORLD.

The yellow bodies on The Yellow Cab Company's cars surely stood out against a sea of black.

HAIL YELLOW The black and yellow logo of the Hertz car rental company wasn't the work of a modern advertising agency. John Hertz has a claim on the color yellow going back to 1915, when he started The Yellow Cab Company in Chicago with a fleet of cars with bright yellow doors. Although some historians contend that yellow cabs were already trolling the streets of other cities at that point, many counter that Hertz was first to use the color for his cabs to attract pedestrians' attention. He supposedly even paid for a study to help determine which color would gain the most notice from a distance. Whether by study or instinct, Hertz's decision has clearly stood the test of time as yellow taxis now cruise streets from the Philippines to Romania to Uruguay.

CHECKERED PAST

While the shape of the taxi has changed dramatically since the beginning of the last century, save for the very first taxi circa 1910, its signature yellow hue has not.

1910
Darracq
all red

1930
Ford
black roof and running board with yellow body and hood

1940
DeSoto
red fenders, yellow body, black and white checkered stripe

1950
Checker
green doors, roof and trunk, white and black checker stripe across body, yellow fenders and hood

1960
Checker
all yellow with, white and black checker stripe across body

1970
Coronet
all yellow with black logo on door

1980
Crown Victoria
all yellow with black logo on door

1990
Crown Victoria
all yellow with black logo on door

2000
Prius
all yellow with black logo on door and black checkered stripe on back fender

CZECHOSLOVAKIA L.&C. HARDTMUTH "KOH-I-NOOR" ※ 1500 ※ B ※

The first Koh-I-Noor pencil.

THE BEST-SELLING PENCIL

One standard-size pencil can produce approximately 45,000 words—the equivalent of a short novel. But will a pencil last longer if it's yellow? People seem to think so, according to one informal study. Henry Petroski, in his book *The Pencil: A Design of Design and Circumstance,* recounts an experiment in which a pencil manufacturer placed equal numbers of yellow- and green- painted pencils in their offices. When employees were questioned about the quality of the pencils, they repeatedly complained about the green ones: They broke more often, were a pain to sharpen, and were harder to write with; but except for their color, they were exactly the same. The yellow pencil is so engraved in our consciousness that we seem to have branded yellow as an essential quality for "pencilhood."

Relics from the Koh-I-Noor pencil's past.

The first famous yellow pencil, the Koh-I-Noor, truly did go above and beyond. Naming it after the famous diamond wasn't just a handy sales tool. Like the diamond, the graphite contained in the pencil was derived from carbon, and it was the carbon that was responsible for the hardiness of both.

Made with the best quality Chinese graphite, the Koh-I-Noor pencil was three times the price of its competitors. It may have been painted yellow in honor of its Chinese heritage, or maybe it was because it was made by an Austrian company; the Austro-Hungarian flag was gold and black, which would have made the combination of graphite and yellow particularly patriotic.

Before the Koh-I-Noor, painted pencils (yellow or otherwise) were seen as inferior to unpainted pencils, which encased their graphite in higher quality wood. They didn't need paint to cover their flaws. But when the Koh-I-Noor was introduced in 1890 and then appeared at the World's Columbian Exposition in Chicago in 1893, visitors were impressed by its beauty and durability. Unpainted pencils couldn't compete, and to this day, three of four pencils sold are yellow.

Pencils aren't the only writing utensils that shine in yellow. The early 1960s brought color into our textbooks and notebooks with the invention of a new kind of water-based ink that was only ever so slightly opaque and didn't flood the page or seep through paper. Yellow was the perfect color for the job, standing out without competing with the text it covered.

Carter's Ink was the first company to develop such a pen in the United States, giving it the moniker Hi-Liter, which has since been adapted into the generic term *highlighter.* In the 1970s, further innovation advanced the new work and study tool. Avery Dennison created a highlighter with fluorescent ink. Highlighted text not only stood out—it glowed!

If you're convinced that your highlighter helped you get through school, you might be right. When you read a highlighted section of text, the visual system in your brain interacts with the language system, and the greater the number of distinct brain circuits that are active while studying, the more likely you'll remember what you read.

Richard Outcault's "Yellow Kid" comic from the *New York Journal*, 1896.

There's yet another form of yellow ink that begs to be read. Scan the tabloids at your local newsstand, and you're sure to encounter numerous examples of what's known as "yellow journalism," that is, the stuff of tabloids. Defined by hyperbolic, eye-catching and often ridiculous headlines, yellow journalism is meant to do one thing: sell papers. And it works, sometimes regardless of the half-truths tucked behind its leads.

But what makes this type of journalism yellow? The phrase dates back to the 1890s, when exaggerated journalism was taking hold as the result of a confluence of lightning-fast printing presses and feuds between money-loving newspaper magnates like William Randolph Hearst and Joseph Pulitzer. The phrase came out of a dispute between the two men. Pulitzer published Robert Outcault's cartoon strip "The Yellow Kid," one of the most popular strips of its day, in his paper the *New York World*. "The Yellow Kid" was printed with a new type of yellow ink that adhered to the paper instead of coming off on readers' fingers. When Hearst hired Outcault away to his paper, the *New York Journal,* Pulitzer was so angry that he hired another cartoonist to continue the strip in the *New York World*. Take Hearst and Pulitzer's determination to sell papers no matter what, add this new yellow ink, and voila, the term *yellow journalism* was born.

Phototherapy via blue lights is the go-to method for mitigating high levels of bilirubin in babies.

SUN-KISSED BABIES It's all too common for babies to be born with jaundice, a condition that taints their skin with a yellow hue. The culprit is a yellow substance called bilirubin, which is naturally present in human skin and mucus. In healthy babies and adults, bilirubin is the byproduct of red blood cells that have broken down. It normally travels through the blood to the liver, where it is metabolized and then excreted. But because babies' livers are often not developed enough to metabolize the bilirubin, it stays in their system. An excess of bilirubin can not only turn babies yellow, it can also cross over from the blood into the brain and cause lifelong damage, including hearing loss and learning disabilities.

Babies' vulnerability to jaundice was a puzzle for centuries until in 1956, Sister J. Ward, the nun in charge of premature babies at Rochford General Hospital in Essex, England, made a surprising discovery. Sister Ward was a believer in the curative powers of fresh air, and she would often take her preemies out for a stroll in the sunlight to give them a break from their incubators. She noticed that infants who were exposed to the sun appeared to lose their yellowish hue, but that the parts of their skin that had been covered up remained unchanged. Her hunch was confirmed when a biochemist at the hospital left a test tube of bilirubin plasma in the sun before measuring it. The specimen was drawn from a severely jaundiced baby, but the results did not correlate. When a new specimen was drawn and measurements were taken immediately, the numbers matched up. Between these two random occurrences, a new hypothesis was formed: exposure to sun resulted in a reduction of bilirubin.

What's happening here is that short wavelengths of light (which we perceive as blue) emitted from the sun are absorbed into the bilirubin molecules, altering their structure; the molecules are converted from fat-soluble to water-soluble, allowing excessive bilirubin to be flushed out in the urine stream. Today babies are treated with phototherapy, which uses visible blue light to cure their jaundice. And we have the yellow sun to thank for stealing the yellow from our babies.

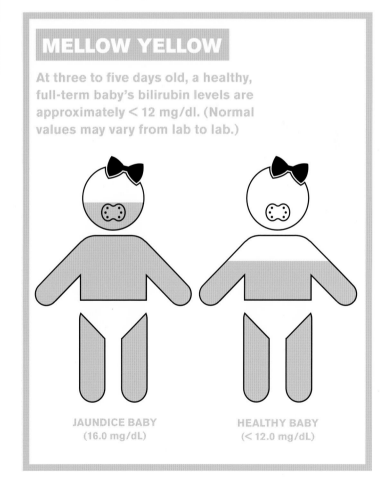

MELLOW YELLOW

At three to five days old, a healthy, full-term baby's bilirubin levels are approximately < 12 mg/dl. (Normal values may vary from lab to lab.)

JAUNDICE BABY
(16.0 mg/dL)

HEALTHY BABY
(< 12.0 mg/dL)

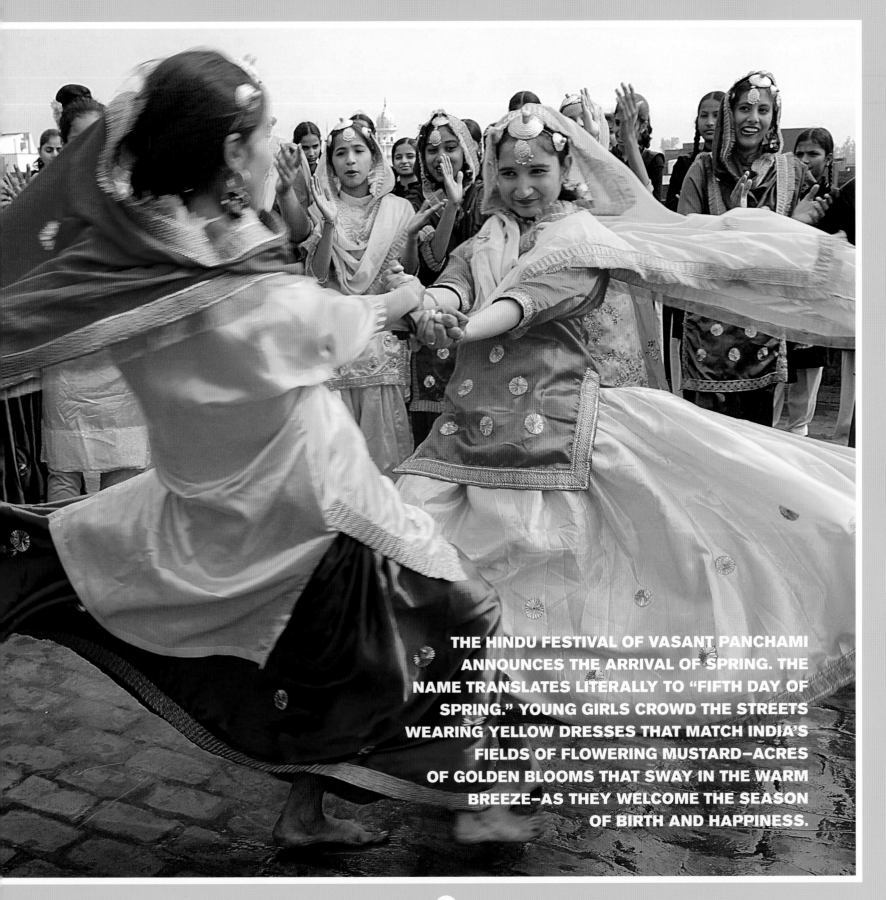

THE HINDU FESTIVAL OF VASANT PANCHAMI ANNOUNCES THE ARRIVAL OF SPRING. THE NAME TRANSLATES LITERALLY TO "FIFTH DAY OF SPRING." YOUNG GIRLS CROWD THE STREETS WEARING YELLOW DRESSES THAT MATCH INDIA'S FIELDS OF FLOWERING MUSTARD—ACRES OF GOLDEN BLOOMS THAT SWAY IN THE WARM BREEZE—AS THEY WELCOME THE SEASON OF BIRTH AND HAPPINESS.

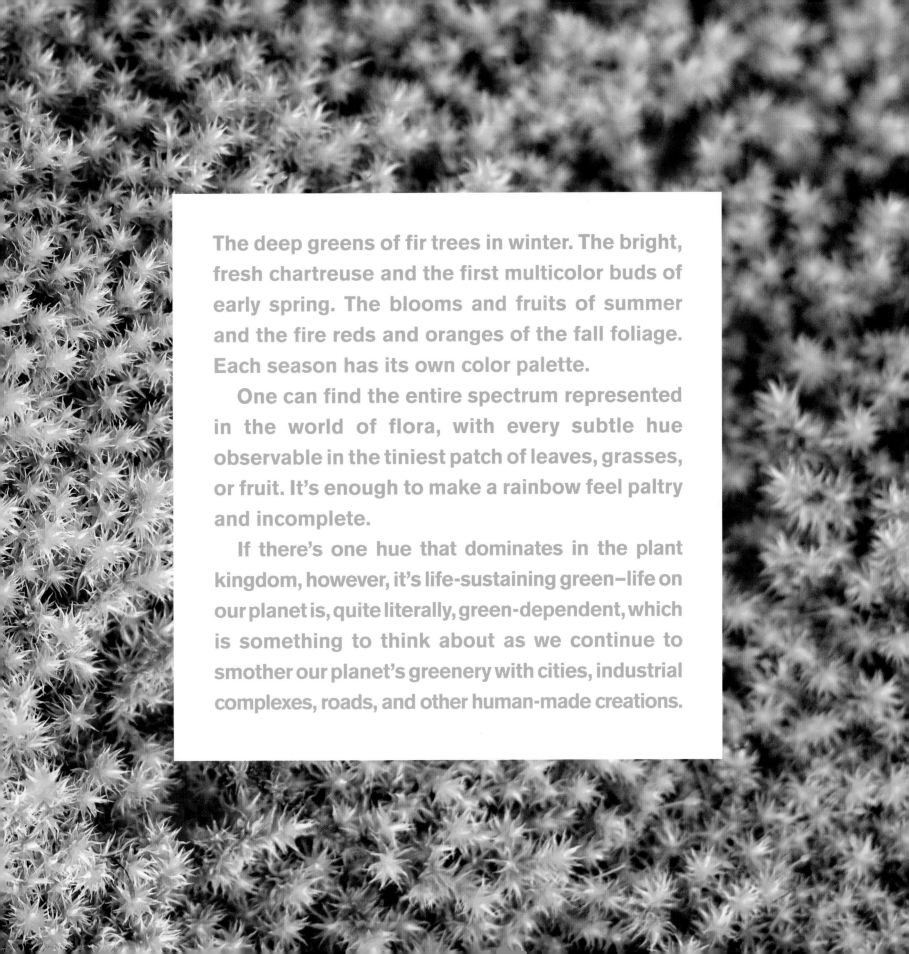

The deep greens of fir trees in winter. The bright, fresh chartreuse and the first multicolor buds of early spring. The blooms and fruits of summer and the fire reds and oranges of the fall foliage. Each season has its own color palette.

One can find the entire spectrum represented in the world of flora, with every subtle hue observable in the tiniest patch of leaves, grasses, or fruit. It's enough to make a rainbow feel paltry and incomplete.

If there's one hue that dominates in the plant kingdom, however, it's life-sustaining green—life on our planet is, quite literally, green-dependent, which is something to think about as we continue to smother our planet's greenery with cities, industrial complexes, roads, and other human-made creations.

From the Arctic to the desert, from the rain forests to the plains, from the great oceans to the tiniest streams, plant life exists amid a mind-boggling array of conditions. Some environments are filled with light, whereas others nearly require a flashlight during the day; some are frozen over for vast parts of the year, and others exist in a perpetual summer of excruciating heat and little water.

Plants must make do with what they have, and so they have evolved, adapting over time to best deal with whatever environmental conditions they face. Whether a plant is hairy, waxy, bumpy, dull, or shiny is a direct result of its environment and its need to make the most of whatever light it is given. In the dense, dark rain forest, where little light penetrates, some plants are even iridescent.

When it comes to color and plants, every shade of leaf, flower, and fruit tells a story, not just about the environment, but also about chemistry, pollination, and even the origins of animal life on our planet.

WHY PLANTS SPAN THE SPECTRUM Plant life began with algae over a billion years ago. Algae served not only as the building blocks for more complex plants but also for the full spectrum of color we now see in vegetation. Algae divide into various color groupings, from reds to greens to browns. Within these groupings is a wide range of both subtle and substantial shifts in hue. This range of color is due to biological pigments that cause color shifts not only in plants but in animals as well.

It took a long, long time for evolution to get from algae to the mind-boggling array of blooms and fruits we see today.

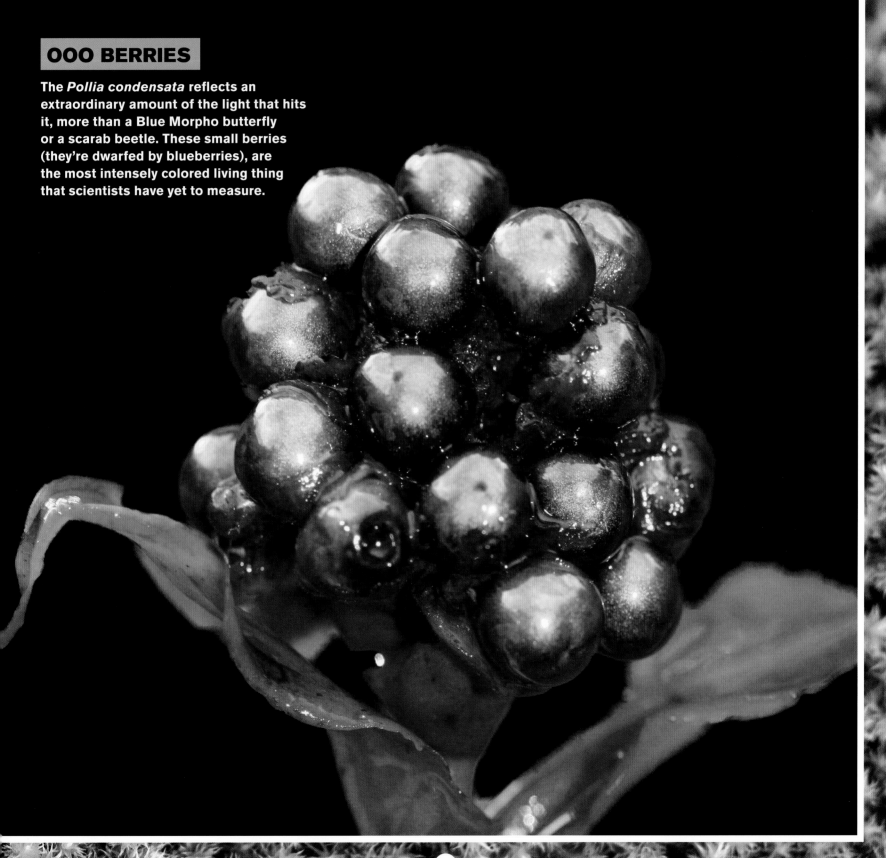

OOO BERRIES

The *Pollia condensata* reflects an extraordinary amount of the light that hits it, more than a Blue Morpho butterfly or a scarab beetle. These small berries (they're dwarfed by blueberries), are the most intensely colored living thing that scientists have yet to measure.

Amborella trichopada is one of the oldest living flowering plants, or angiosperms. Angiosperms differ from their predecessors, gymnosperms, not only in that they flower, but also because their seeds are covered. It is believed that covered seeds are more easily dispersed, allowing them to diversify and propagate quickly.

Algae comes in all shapes and sizes from microscopic diatoms to voluminous kelp forests. Clockwise from the top: Ceramium red algae, Synura algae, Bull kelp (*Nereocystis luetkeana*), and giant kelpe (*Macrocystis pyrifera*).

For a long time, color was not particularly abundant in plants. Blooms developed while dinosaurs were still walking the earth but also after mammals and birds populated the planet, some hundred and forty million years ago. Scientists hypothesize that pigments originally evolved in plants as protection against ultraviolet light from the sun; that is, they acted as sunscreen. Once animals came into existence, color became a means of attracting animals to the plants to pollinate them and disperse their seeds.

Biological pigments are made up of molecules housed within a plant's cells. The particular chemical structure of a pigment reacts to light in its own unique way, absorbing certain wavelengths and reflecting others. You might have heard of a couple—carotenoids or flavonoids, for instance—because these plant pigments, among many others, are known for their health benefits in humans, which range from boosting our immune systems, reducing allergies and inflammation, ameliorating the toxicity of contaminants and pollutants, and helping to prevent cancer. These pigments are the reason we're encouraged to "eat the rainbow," but there is one particular pigment that is responsible for life on earth.

THE IMPORTANCE OF CHLOROPHYLL Chlorophyll is the mother of all plant pigments, and the reason green dominates plant life on planet Earth. Why is green the particular by-product of chlorophyll? The energy it absorbs comes from long (what we perceive as red) and short (what we perceive as blue) wavelengths of visible light. Plants that contain ample quantities of chlorophyll, which is almost all of them, reflect the leftover medium wavelengths—those we perceive as green. Not just any old green, though. Plants use two kinds of chlorophyll, blue-green chlorophyll A, which absorbs violet-blue and orange-red light, and yellow-green chlorophyll B, which absorbs blue and orange light. This handy variance is rooted in the plants' absorption patterns, the result of

Walk into a forest and you'll get a better idea of what the world looked like before flowers became abundant.

Chlorophyll is stored in chloroplasts, pictured above, which live within a plant's cells.

energy in the form of carbohydrates, which they feed off as they continue to grow, repair, and reproduce.

Plants are not the only beneficiaries of chlorophyll. Animals eat plants, either directly or indirectly (by eating other animals that eat plants), and use the energy stored in these plants for their own growth, repair, and reproduction. We really must eat our greens, and our ancestors knew this. The evolution of living beings was dependent on the energy that plants provided.

Photosynthesis also emits a by-product crucial for humans and other life on earth: oxygen.

adaptability that allows particular plants to thrive in whatever light is prevalent in their environment.

Chlorophyll also happens to be the central ingredient to photosynthesis, the process that produces the fuel on which all of life runs. For those with only dim recollections of elementary school science, photosynthesis starts with sunlight. Chlorophyll molecules in plants take in energy from light and transform it into chemical energy. Plants store the chemical

IT'S A BIRD... IT'S A VEGETABLE

Carrots have long been another must-eat on the vegetable list; their high marks for health benefits are due to their richness in carotene, a kind of carotenoid. This pigment that colors carrots orange, absorbs light in the shorter end of the visible spectrum (greens, blues, and violets), and reflects longer wavelengths (reds, oranges, and yellows). You've probably heard that carrots are good for your eyes. This is precisely because carotene absorbs harmful blue and ultraviolet light, which can damage our skin and eyes or even ultimately be cancer causing.

SHAPE-SHIFTING CAROTENOIDS
Carotenoids assist in the process of photosynthesis, helping to break down the energy from sunlight and transfer it to chlorophyll molecules. They happen to be much more stable than chlorophyll, whose production is dependent on intense sunlight. As sunlight wanes and cooler weather arrives, chlorophyll production winds down, but carotenoid production continues apace. In addition to carrots, other fruits and vegetables rich in carotenoids include tomatoes, sweet potatoes, cayenne peppers, apricots, mangoes, and cantaloupes.

FLAVONOIDS TO THE RESCUE Although the word *flavonoid* derives from the Latin for "yellow," flavonoids can be found all over the color map, most commonly in red, purple, and blue blooms and fruits. And the colors that

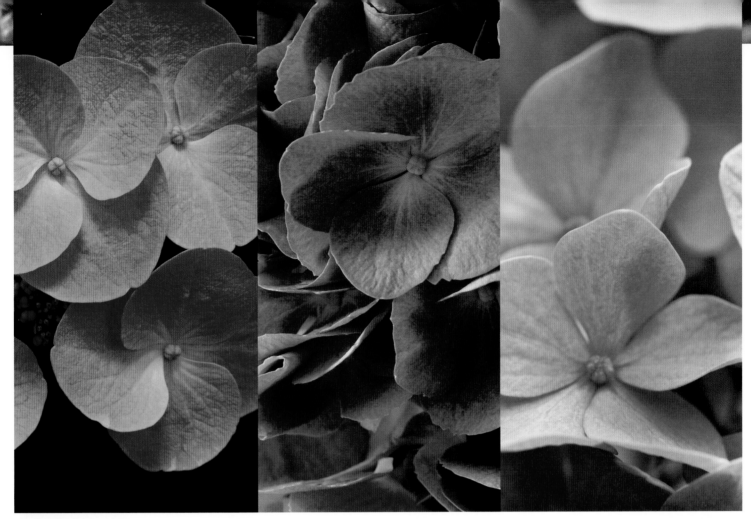

Hydrangeas can change color, from blue to pink, depending on the acidity and alkalinity of soil they are planted in.

result from the presence of a particular kind of flavonoid called anthocyanin help signal to animals that their fruit is ready to eat.

Flavonoids are responsible for some of the most vibrant plant colors, and they're abundant in the human diet as well. Cocoa and coffee beans, tea leaves, lemons, grapefruits, cranberries, blueberries, cherries, onions, and soy are just a few examples of foods rich in flavonoids. Red

and purple grapes are big in the flavonoid department, which is what accounts for the health benefits of red wine.

Anthocyanin has another benefit: a particularly strong pH gauge. If you've ever seen a "blue" hydrangea turn red or a "pink" hydrangea turn blue, you've been witness to anthocyanin's tricky chemical properties. If a soil is very acidic, blue hydrangeas turn pink. If the soil is very alkaline, the opposite occurs. In neutral soil, hydrangeas are a lovely shade of violet. The chemical structure of the anthocyanin present in hydrangeas and other anthocyanin-rich flowers changes as the acidity increases or decreases, resulting in the absorption and reflection of different wavelengths of light.

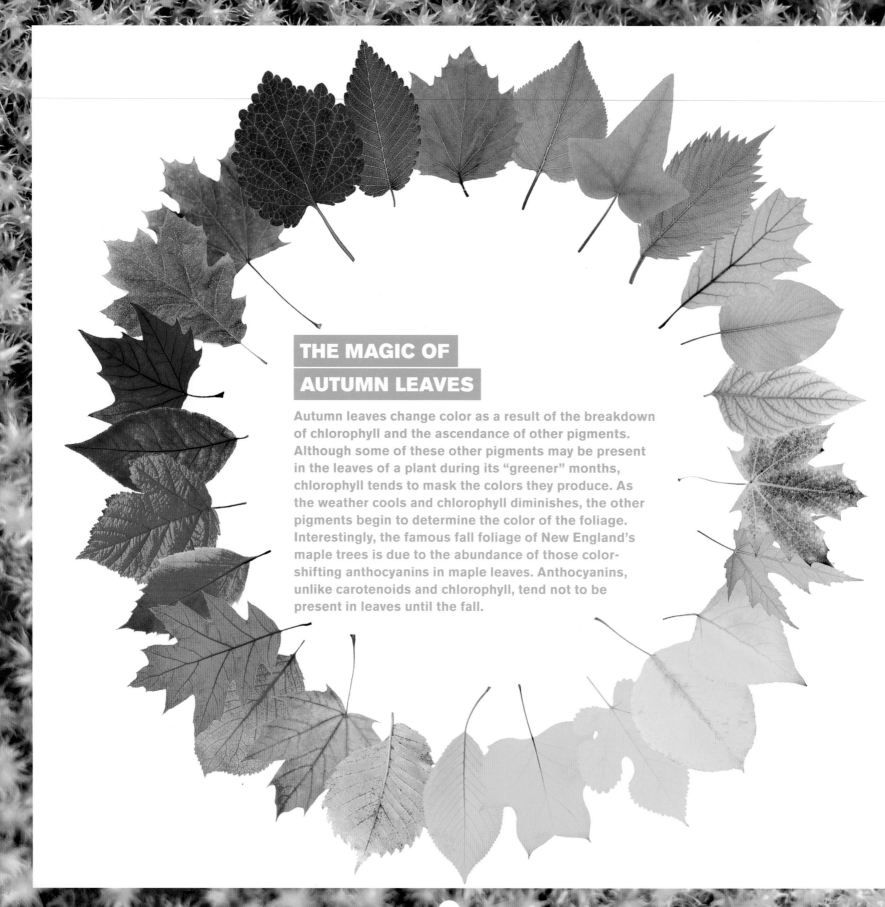

THE MAGIC OF AUTUMN LEAVES

Autumn leaves change color as a result of the breakdown of chlorophyll and the ascendance of other pigments. Although some of these other pigments may be present in the leaves of a plant during its "greener" months, chlorophyll tends to mask the colors they produce. As the weather cools and chlorophyll diminishes, the other pigments begin to determine the color of the foliage. Interestingly, the famous fall foliage of New England's maple trees is due to the abundance of those color-shifting anthocyanins in maple leaves. Anthocyanins, unlike carotenoids and chlorophyll, tend not to be present in leaves until the fall.

The spots on bananas, the flesh of a cut apple that's been left out uncovered, the plethora of "brown" mushrooms that span from pale beige to deep wenge, are all caused by melanin.

MELANIN IN PLANTS The most common pigment in animals—melanin—also plays a small role in plant life. The dark spots we see in ripe or overripe bananas and the brown flesh of cut or bruised apples are the result of melanin. Melanin also happens to be the pigment that colors our skin, hair, and eyes (see page 200). It's a great producer of browns and beiges, blacks and grays, and even brownish reds and yellow-blonds. Just don't expect any bright colors from this neutrals-friendly pigment.

POLLINATION AND SEED DISPERSAL AND THEIR LINK TO COLOR Plants cannot put on a show or fight their competitors to attract a mate—they are dependent on the forces of nature or other life for their own reproduction. Fortunately for all of us, water and wind are great mechanisms for spreading seeds. Plants that avail themselves of these helpful forces of water and wind tend to sport rather narrow palettes, but plants that require animals for pollination or seed dispersal tend to be much richer in hue and all over the color map.

For animals with sight, the color of a plant's blooms and fruits, contrasting with the greenery of its stems and leaves, can be a significant draw. Hence the development of fruits and flowers—plants' party dresses, disguises, and aphrodisiacs.

Plant colors have adapted over time to attract the particular insects, birds, or other animals that do the job best.

To lure the animals to their blooms, plants have recourse to three primary methods: food, aggression, and sexual deception. Once a plant has been pollinated or its seed dispersed, it takes a well-deserved rest. It takes energy to produce energy, and it takes a lot of energy to produce the colors present in blooms and fruits. So blooms soon fade or turn brown when the seduction ends.

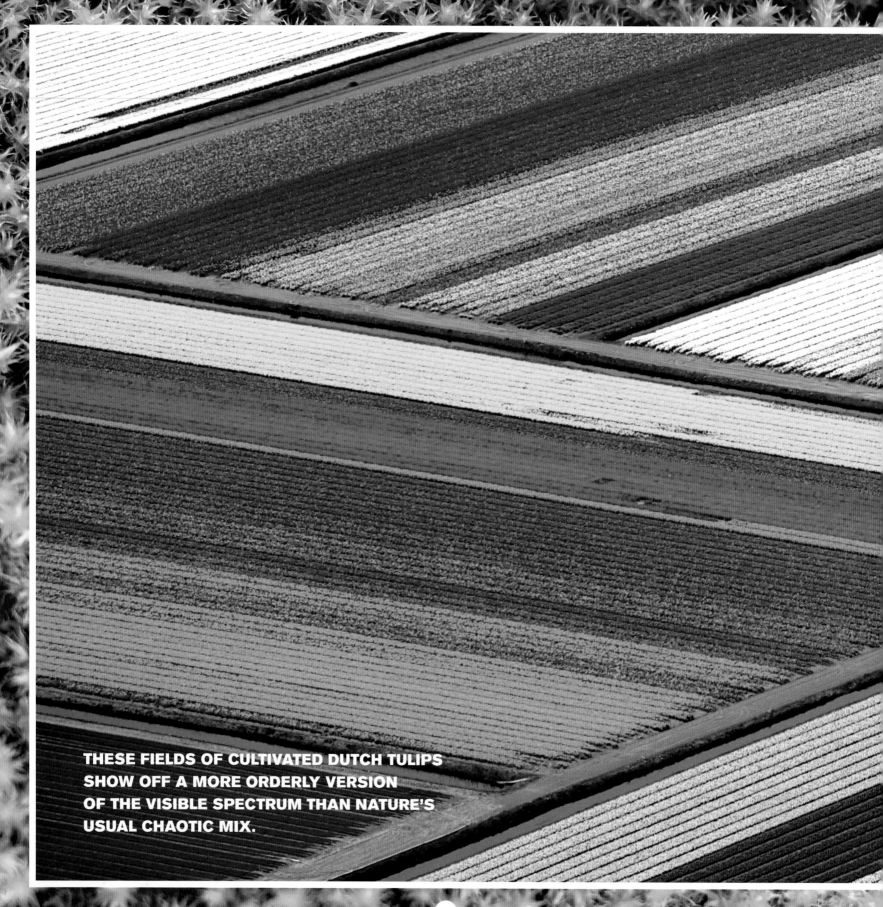

THESE FIELDS OF CULTIVATED DUTCH TULIPS
SHOW OFF A MORE ORDERLY VERSION
OF THE VISIBLE SPECTRUM THAN NATURE'S
USUAL CHAOTIC MIX.

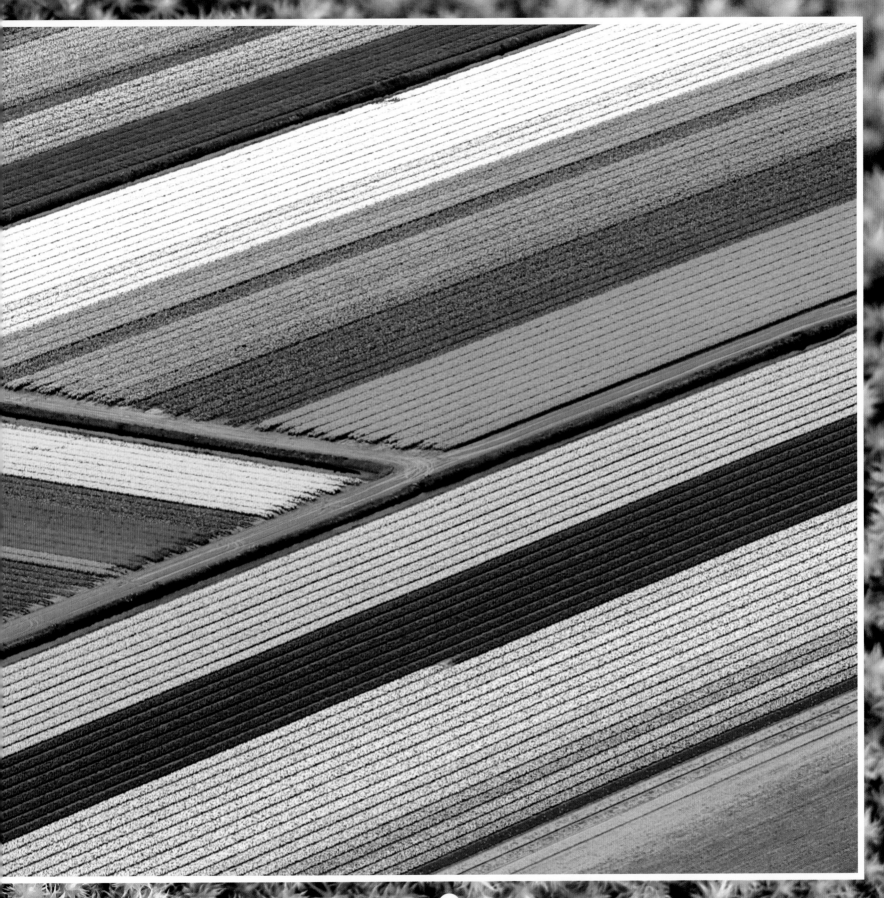

Arils in various forms, include, clockwise from the top right, mangosteen, *Ormosia amborea*, pomegranate, and lychee.

A FOOD-BASED SEDUCTION "Eat me!" is what pollen, nectar, fruits, berries, and flowers say to the species that feed off of them, but it's quid pro quo. The animal gets food, and the plant has its seed removed and dispersed (sometimes via the animal's digestion and then excretion).

Sometimes plants get tricky with their enticements. For example, if the seed itself isn't particularly attractive, some plants produce something called an aril. You'll find arils in the form of seed coverings or pretty-colored appendages on nutmeg, mangosteen, and pomegranate seeds; the arils on these last seeds are the juicy magenta flesh covering the seeds. Even trickier, plants like those in the *Ormosia* genus mimic these coverings via color alone, saving these plants from producing the arils themselves, which takes a lot of energy.

PROVOKING THE AGGRESSOR

The notion of aggression in the largely peaceable world of plants might bring to mind Venus flytraps or thorns, but aggression may come via the animal doing the pollinating. Some plants, like the *Oncidium* orchid (commonly known as the dancing lady), waltz, swing, and bebop (or more appropriately, *bee*-bop!) around in the wind. However, the solitary bees they need for pollination see something entirely different going on: They think these flowers are other male bees infringing on their territory! To defend their turf, they attack what they perceive to be the offending male bees—which

Oncidium orchid.

are really just the blooms of the orchid—and get laden with pollen in the process. Never ones to shy from a fight, they spend their days going from flower to flower in combat mode, which results in pollination for these tricky plants.

THE ART OF DECEPTION There's no denying it: The plant world stoops to some low-down dirty tactics to achieve pollination, often in the form of expertly designed disguises that involve both color and pattern.

Imitating the appearance of a female insect is often the name of the game. The orchid family provides another compelling example of a plant's sexual deception at its finest. The orchids of the genus *Ophrys* look like female bees and they even emit aromas similar to both bees and wasps, which is why they are commonly called bee orchids. The male bee lands on the flower thinking he

The bee orchid, *Ophrys apifer*, looks to a male bee just like a female bee. This deception tempts him to the flower where he is bathed in pollen.

is going to mate, gets covered in pollen and then takes this pollen with him onto the next Ophrys he lands on with plans to mate yet again. Named *pseudocopulation*, the orchid's mimicry may not help a bee reproduce, but it successfully causes the reproduction of the flower. It's no surprise that orchids are one of the two biggest families of flowering plants!

THE AMAZON WATER LILY Copulation and color are also the themes that dominate the relationship between the Amazon water lily and the beetles that pollinate it. The Amazon water lily blooms white its first night. Once fully bloomed, its temperature increases, which helps disperse its enchanting aroma.

When large scarab beetles catch wind of the perfume, they make a run for the closest flower. As they enter the white flower, it closes in over them, but fear not for the beetles. Once inside, they get food and sex in a warm discotheque. The food is in the form of modified, fleshy stamens, the sex is with each other (multiple males and females enter one flower), and the discotheque is due to the changing color of the flower. By morning, when it reopens, the Amazon water lily has changed to deep pink and no longer gives off an aroma. The beetles know that white means *come hither* and pink means *see you later*, and off they go to another first-night white flower.

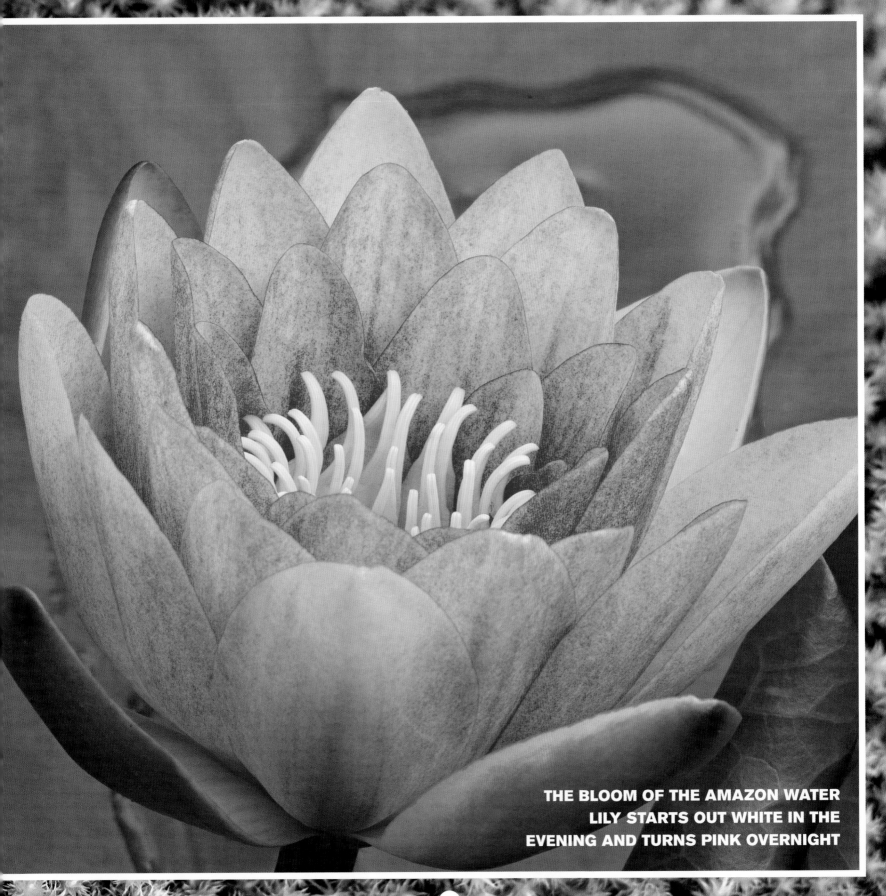

THE BLOOM OF THE AMAZON WATER
LILY STARTS OUT WHITE IN THE
EVENING AND TURNS PINK OVERNIGHT

THE RULES OF ATTRACTION Different colors attract different animals. Bright red flowers are pollinated almost exclusively by birds with excellent red color vision. Ultraviolet flowers are particularly attractive to bees that can see this far along the electromagnetic spectrum. Pinks and lavenders are favorites of butterflies. Strongly scented pale or white flowers are beloved by bats and moths, who have very poor eyesight but an excellent sense of smell. Other mammals—including our primate relatives—are also known to pollinate flowers similar to those that attract bats, although larger animals are far less efficient than their bird and insect counterparts (the petite beaks of the hummingbird or the proboscis of the butterfly yielding nectar from far more recessed parts). Some flowers, like phlox, actually change color while their blooms last to attract different insects at different times of the season.

Recent research has also shown that some plants that initially attracted insects have since evolved to attract birds by changing the colors of their flowers. These flower colors reflect longer

This hummingbird dips its beak deep into a red flower to extract the nectar inside.

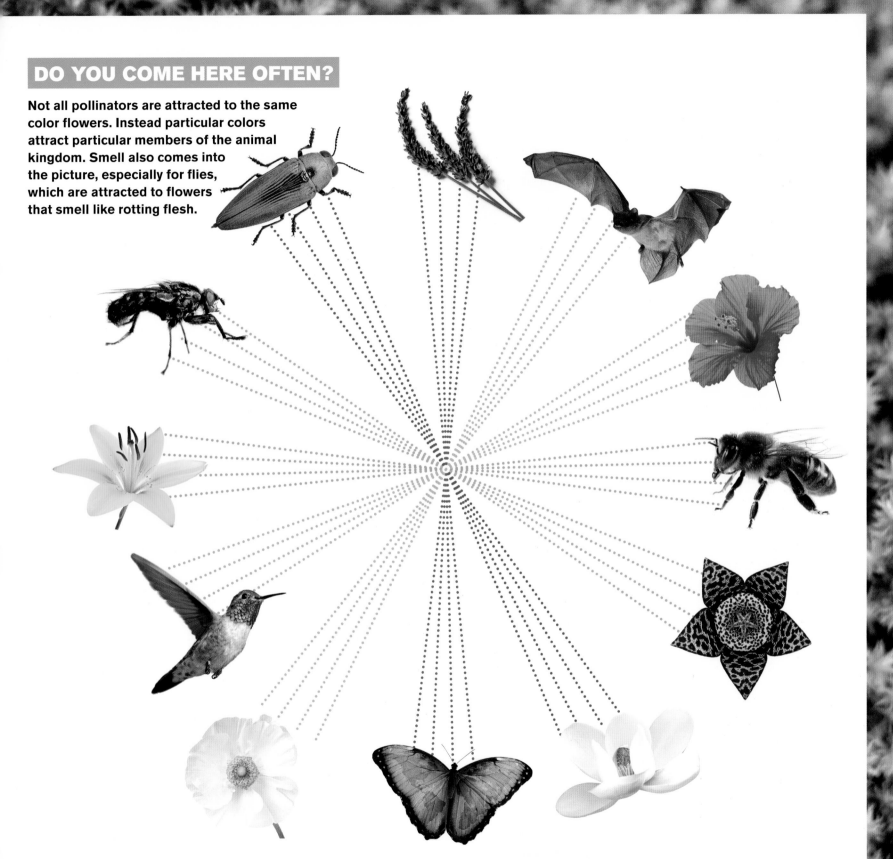

DO YOU COME HERE OFTEN?

Not all pollinators are attracted to the same color flowers. Instead particular colors attract particular members of the animal kingdom. Smell also comes into the picture, especially for flies, which are attracted to flowers that smell like rotting flesh.

Hard to believe that a bee sees a color in the middle of a flower where we see nothing. This approximation of what a bee sees when eyeing a cucumber flower (bottom) shows just how different bee vision is from our own (top).

The passion flower, *Passiflora incarnata*, has a bull's eye-shaped honey guide that leaves little doubt as to where its treasure of nectar lies.

wavelengths to which their bird pollinators are particularly sensitive, and to which certain insect pollinators that weren't so great at their jobs are not similarly sensitive. Roses may be red and violets blue, but only so long as their pollinators remain effective.

BULL'S-EYE! Many flowers have more than one color on their blooms, and very often the color shifts from one to another in a flower's center, where its nectar and pollen are stored. These bull's-eyes, called honey or nectar guides, provide yet another color map for the animals that pollinate plants. Some flowers

MUSHROOMS AND MOLDS

It may be thought by those unacquainted with the glowing colors found among the fungi that some of my drawings are the creation of fancy, but such is not the case. I invite the careful observation of the skeptical and they will find that their paint boxes hardly afford pigments bright enough to sketch those beauties of the woods.

—*Mary Banning*

First things first: Fungi are not plants, nor are they animals. They are a kingdom unto themselves; fungi are a strange hybrid of plant and animal, and yet they are also neither of these things. Fungi contain no chlorophyll, so they are unable to undergo photosynthesis. They are unable to eat food directly, like animals. Instead, they grow inside their food source—be it dead plant material or soil—secrete enzymes into their environment, then reabsorb the molecules once they have broken down. This digestion process is similar to that in animals, but it takes place outside the organism rather than inside of it.

We most commonly find fungi in the form of mushrooms and molds, both of which come in a surprisingly vibrant array of colors. Why the need for these reds, yellows, browns, blacks, blues, and greens? Are they there to warn insects and animals that they are poisonous or to urge, "Eat me," like the mushroom in Alice's wonderland? Most fungi are not pollinated via animals. Fungus spores (the mechanism by which fungi reproduce) differ from seeds, which contain embryonic plants. A spore is just a cell with a nucleus, or at least a small number of cells with a small number of nuclei that can germinate and grow into a new fungus. Spores also happen to be very tiny—so small they can float in air as easily as algae can float in water and can be seen only under a microscope.

Most fungus spores are dispersed through the air. A few are distributed by water or by insects and other animals. In the air, these spores are subjected to the sun's ultraviolet rays, which are potentially damaging to the vulnerable contents of the nucleus. Many spores are protected from ultraviolet rays by the presence of pigment in their cell walls. The typical brown color that we associate with supermarket mushrooms comes from melanin, the very same substance that protects our own skin. The same goes for the other pigments that make

even bear the equivalent of arrows—darker lines that direct the insect right into its center—pointing to just the spot where it would go to find the goods.

Some of these honey guides are invisible to humans. A cucumber flower that looks completely yellow to us will appear to a bee to have another, highly contrasting color at its core. Because bees can see short wavelengths of ultraviolet light, they are sensitive to what is known as "bee purple," a color that combines wavelengths of light that appear yellow and ultraviolet to bees. Since we can't see ultraviolet light, we see only the yellow wavelengths.

A RAINBOW OF FUNGI...

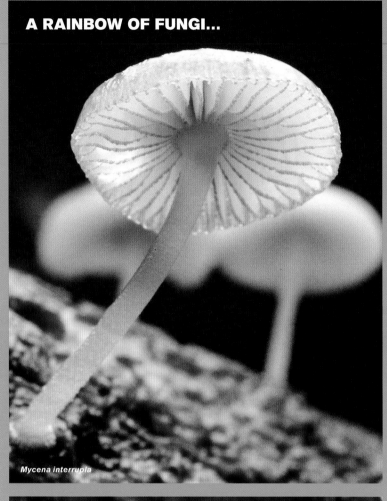

Mycena interrupla

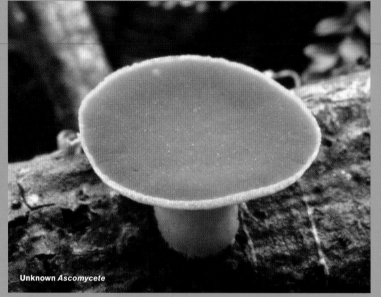

Unknown *Ascomycete*

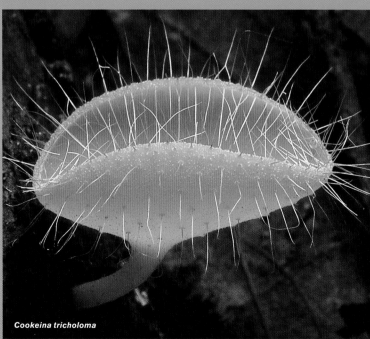

Cookeina tricholoma

Cortinarius iodes

Hygrocybe psittacina.

Podostroma cornu-damae

Leotia viscosa

Unknown *Lepista sp.*

Mucronella sp.

CALOPLACA NAMIBENSIS, A LICHEN
WHICH IS FOUND ON STONES AND
ROCKS IN THE NORTHERN NAMIB DESERT,
SKELETON COAST PARK, NAMIBIA

up the fungi family rainbow. As tantalizing as that mushroom was to Alice, in all probability, mushrooms wear their colors for their own protection, not for the enticement of little girls or animals of any other kind.

THE STRANGE CASE OF LICHEN Our multihued journey through the plant kingdom takes another odd twist at lichen, for lichen is a sort of plant, sort of animal, but it is not a single organism. Half fungi and half algae or blue-green algae, lichen is a living, breathing example of symbiosis. The alga half of the partnership undergoes photosynthesis, and the fungi half provides a nice home.

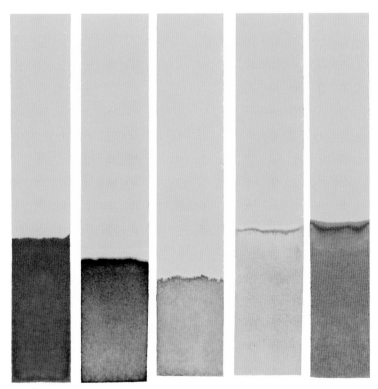

Roccella is the genus of lichen most commonly used for the litmus test. The papers used in a litmus test present different colors depending on the pH of the substance being tested. More alkaline substances result in purple and blue, more acidic substances result in orange or red.

Found in environments as diverse as frozen tundra and blazing hot desert, lichens are some of the oldest organisms on earth and, yes, they come in an amazing array of colors.

Like hydrangeas, they are also keen readers of pH. Indeed, lichen is at the root of the litmus test, the go-to method for reading the acidity or alkalinity of a substance. In days of yore, the recipe went something like this: grind lichen into a powder, add urine, and test away! Today a modified formula (thankfully involving no urine), is soaked into paper strips used for testing.

Lichens undergo a change in their chemical structures when they are exposed to acidic or alkaline substances. When dipped in the lichen solution, acidic substances reflect long wavelengths of light, and we see red; basic substances, on the other hand, reflect short wavelengths of light, and we see blue.

Lichen dyes have also had a rich and identifiable history. Dyes ranging from greens to oranges can be created simply by boiling lichen in water. Add a little ammonia, and reds and purples can appear as well. These purples were coveted for themselves, but they were also used as base dyes to heighten the effects of Tyrian purple, the most famous purple dye in history (see page 223). Dyes made from lichen were not only used to color wools and silks, but they were also turned into body paint by Native Americans.

Foliose lichen on Manitoulin Island, Ontario, Canada.

GREEN

Money. Inexperience. Paradise. Jealousy. A penchant for recycling. A knack for gardening. All of these we identify with the color green. And yet, green is so much more fundamental. From the Amazon jungle to the concrete jungle, it's nature's greenery that supplies us with the ability to live and breathe. Chlorophyll, the pigment responsible for the greenery that surrounds us, although the term sounds scientific, is simply derived from the Greek words for *green* and *leaf.* And it's this chlorophyll that produces the oxygen that we need to survive. Green is the essence of life.

The intersection between civilization, religion, and the natural world is abundantly apparent in the Islamic faith. The green domes atop Islamic mosques, along with the green flags of many Islamic countries, speak to a special relationship between Islam and the color green. For Muslims, the color's meaning is grounded primarily in its associations with paradise, resurrection, and the Prophet Mohammed.

Throughout the Islamic world, the word paradise means "garden," whether it's derived from ancient Persian, Greek or Arabic. The Qur'an (or Koran) also makes reference to the green robes worn in paradise and to the green silk couches with which the eternal garden is furnished. In keeping with the flora theme, references throughout the Qur'an indicate that heavy rains come down—even in the desert—resulting in a sudden greening of the world. Resurrection is symbolized in these seeds of possibility, unknown until the rain falls, sprouting new shoots throughout the land.

Reigning over it all is the Prophet Mohammed, who wears only green, white, or green and white.

In medieval Islamic poetry, green is ever present. Mount Qaf, the celestial mountain, is green. The sky is green (some say because it reflects Mount Qaf). Even water is green. As the great

Sufi poet Rumi wrote:

Everyone talks about greenery, not with words,
but quietly, as green itself talks from inside,
as we begin to live our love.

—"Green from Inside *Rumi": The Big Red Book* by Coleman Barks

THE GREEN MEN Sufi prophet, Al-Khidr, who teaches Moses about the importance of patience in the Qur'an (18:60–82), is yet another example of the connection between green and Islam. When Mohammed's companions ask him about the stranger's provenance, he responds simply that the man is Al-Khidr, the Green One. To inquiries about the origins of this moniker, Mohammed replies that when Al-Khidr sits on barren soil, the ground sprouts green shoots.

Al-Khidr represents renewal, understanding, and patience. Often, when he appears to Sufi masters, the Green One initiates them via prayer. He gives them a teaching or practice to ponder and, as a result, resuscitates their faith.

Rumi, the thirteenth-century Sufi poet, is buried in Konya, Turkey, in an exquisite tomb known as The Green Dome.

Clockwise from the top-left, the flags of Iran, Bangladesh, Pakistan, Saudi Arabia, Palestine, and Turkmenistan all incorporate green into their design.

The green man with special powers is by no means exclusive to the Qur'an. Green men have been making an appearance throughout history in cultures around the world. They peek out from the cornices of august stone buildings or from the pages of catalogs for garden lovers: elaborate stone carvings of men with leaves encircling their faces.

Anthropologists call these strange sculptures representations of "The Green Man." Who is he? There is no single answer. Some say Osiris, the green-skinned Egyptian god of the afterlife, fits the profile. Avatar

Rama, avatar of Vishnu.

Rama, by way of the Hindus, is usually portrayed as green. The Tibetan Buddhist mystic singer Milarepa was said to turn green after subsisting solely on green nettles. Then there's a whole host of green characters from English folklore, including the Green Knight, the fourteenth-century character of the Arthurian poem *Sir Gawain and the Green Knight;* Puck, the woodsy sprite from English folktales and Shakespeare; Robin Hood, the forest-dwelling archer with an unforgettably green getup; and Peter Pan, the boy from an enchanted forest called Never-Never Land.

Green men are, predictably, known to have a profound connection to the earth; some of them even seem to spring directly from its loins. Others embody the transformational powers of nature, owning the power to bestow its magical qualities onto everyday mortals. Many speak to the idea that after death, there is rebirth; others possess the gift of eternal life. And sometimes these green men dip a green toe into the dark side; maybe this is why we sometimes even see the devil depicted in green.

In this illustration of Al Khidr, c. 1700s, he's standing on a fish that carries him over water.

GREEN-EYED MONSTER Although the green men pepper English literature and folklore, we have Shakespeare to thank for the lasting connection between the color green and the feelings of envy and jealousy. The first reference comes from *The Merchant of Venice*, in which Portia exclaims:

How all the other passions fleet to air,
as doubtful thoughts, and rash-embraced despair,
and shuddering fear, and green-eyed jealousy!

In Othello, the villainous Iago warns:

O, beware, my lord, of jealousy;
It is the green-ey'd monster, which doth mock/
The meat it feeds on.

Milarepa.

IS THE GRASS ALWAYS GREENER?

Perhaps Shakespeare chose to equate green with deadly sin number six because the grass really is greener on the other side of the fence. This is due to the fact that when you look down at the grass right around you, you're close enough to see the details hiding in that green expanse—dirt, pebbles, sticks, small flowers, leaves, maybe a gum wrapper or two. Look across to your neighbor's yard, and you'll be viewing the grass not from above but from an angle. Optical laws remove all the extraneous matter from your sight—hence greener grass! So the next time the green-eyed monster takes hold of you, remember that your neighbor's greener grass is just an illusion.

SO VERY VERDIGRIS The Statue of Liberty, an old penny, and the roof of the Hofburg Palace in Vienna all share a blue-green patina, the beautiful result of the exposure of copper, bronze, or other similar metals to oxygen, water, carbon dioxide, or sulfur. The chemical reaction produces a copper carbonate whose vivid color is quite close to that of mala-

Verdigris can span a wide range of color from true green to a turquoise blue.

chite, the coveted green mineral. This is no coincidence, as malachite, too, is made of copper carbonate.

For centuries, copper carbonate was intentionally produced and then scraped off to form the pigment known as verdigris. The Greeks hung copper sheets over vats of vinegar or wine to hasten the patina, which would then be scraped off. Verdigris' beauty wasn't its only asset. The Greeks, Romans, and Egyptians also availed themselves of its natural antibacterial properties to ward off infection.

During the Renaissance, as artists became concerned with painting realistic representations of the natural world around them, verdigris became a particularly important pigment. Not only was it the most vibrant and stable of all green pigments used

The Arnolfini Marriage by Jan Van Eyck, 1434.
One of the most memorable uses of verdigris in the history of painting.

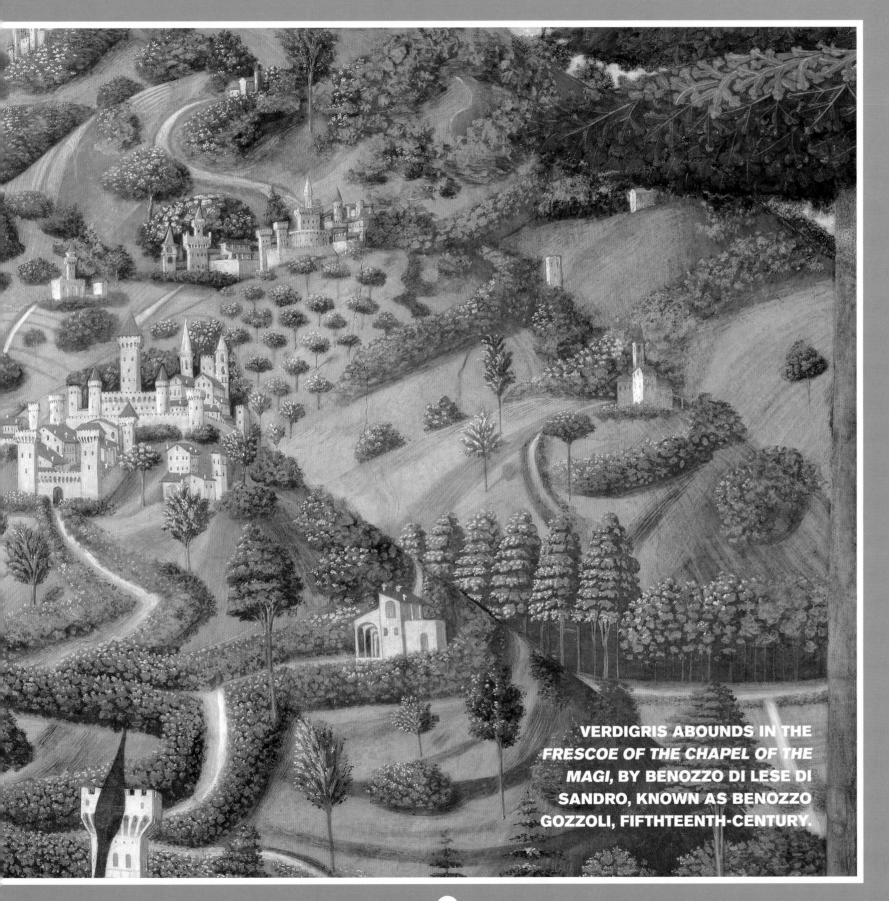

VERDIGRIS ABOUNDS IN THE
*FRESCOE OF THE CHAPEL OF THE
MAGI*, BY BENOZZO DI LESE DI
SANDRO, KNOWN AS BENOZZO
GOZZOLI, FIFTHTEENTH-CENTURY.

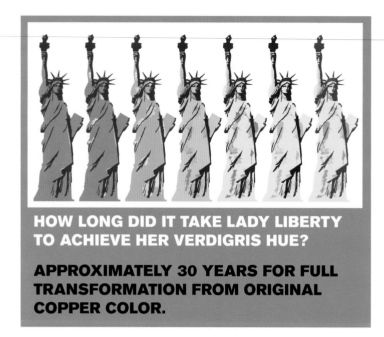

HOW LONG DID IT TAKE LADY LIBERTY TO ACHIEVE HER VERDIGRIS HUE?

APPROXIMATELY 30 YEARS FOR FULL TRANSFORMATION FROM ORIGINAL COPPER COLOR.

for painting, when used in combination with oil, it was also prone to a unique chemical reaction: It would turn from an aqua green to a mossy grass green and then stabilize, verdant nature seemingly coming to life on the canvas. Unfortunately for painters who did not mix their verdigris with oil, another chemical change was in the works: their beautiful aqua would eventually turn to brown.

At the end of the eighteenth century, verdigris made another stunning appearance. Based on his study of copper carbonate, the French chemist Joseph Proust coined the law of definite

The blue-green copper coins pictured here were no doubt oxidized or exposed to sulfides, the result of which is verdigris.

proportions. Each substance, states the law, is made up of a fixed proportion of elements by mass. Take water, for example. Nine grams of water, taken from any source, will be composed of 1 gram of hydrogen and 8 grams of oxygen. Unbeknownst to its author, Proust's hypothesis would be the precursor to modern atomic theory, which similarly showed that every element is made up of different types of atoms in fixed proportions.

VENI VIDI VERDIGRIS

For centuries in Roman times, verdigris has served many different purposes ranging from bright green paints to medical applications.

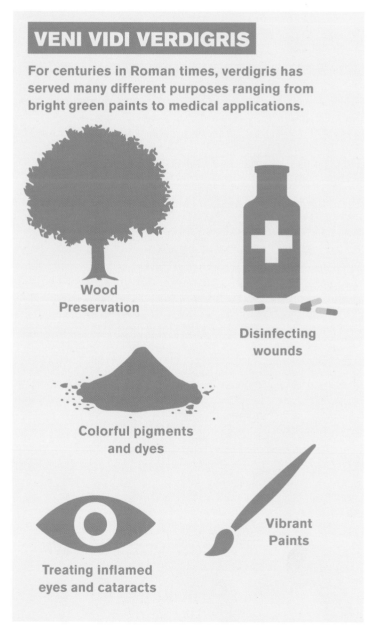

Wood Preservation

Disinfecting wounds

Colorful pigments and dyes

Treating inflamed eyes and cataracts

Vibrant Paints

Also known as Paris green, Emerald Green, was likely used in the wallpaper pictured here as well.

DEATH BY GREEN While Joseph Proust was beginning to change the course of modern chemistry, another decorative—and dangerous—green was finding its way into well-appointed homes beginning in the last quarter of the eighteenth century.

How far would a true aesthete be willing to go for the right hue? Would she take a few years off her life for a gorgeous green wallpaper or for the most fetching emerald gown? Shave a few years off a child's life to give him the immediate pleasure of an adorable green toy? Sadly, many men and women unknowingly did just these things.

First came Scheele's green, a pea green that hadn't previously been achieved in a fast dye. The problem was that Scheele's green was made with arsenic. In dry conditions, tiny particles of the poison would become airborne. Bad as this was, in damp conditions, the situation was far worse; the dye would form a mold that released larger amounts of arsenic into the atmosphere, giving off a smell that was variously described as "eau de garlic" and "mouse." We now know that arsenic can cause diabetes, heart disease, and a whole host of cancers; but when Scheele's green was put on the market, none of these health risks was known.

In 1814 emerald green came on the market, the electric shade we love so well to this day, a shade that was even more popular than Scheele's green—and similarly laced with arsenic. It was brighter and lasted longer and so found its way into the wallpaper in drawing rooms, the fabric of gowns, and the wax of candles, not to mention pharmaceuticals and confections. It also made a terrific rat poison.

You'd have thought all the dead rats would have been a clue to emerald green's deadly effect, but it wasn't until 1861 that one smart doctor deduced arsenic's toxicity and did his best to send out a warning call. But the people loved their green, and dye manufacturers were too enamored of their profits to quit their arsenic-loving ways. Not until the end of the nineteenth century, when it was definitively proven that the substance could kill, was the fatal ingredient finally eliminated from green dyes.

Napoleon Bonaparte on his deathbed, with the infamous green wallpaper behind him.

For decades, many believed that Napoleon died of arsenic poisoning; his blood betrayed high levels of the substance at the time of his death. One theory placed the blame on the Scheele's green wallpaper in his room.

This plausible theory proved to be false. Although Napoleon's arsenic levels were indeed high by our standards, many of his contemporaries would have had similarly high exposure levels, thanks to the pervasiveness of dyes like Scheele's, among other sources. It is certainly possible that the wallpaper in the damp room where he lived his final days might have sped things along, but the emperor was far from unique in his exposure to the poison.

THE GREEN MUSE Vincent Van Gogh, Mark Twain, Ernest Hemingway, Paul Gaugin, Edgar Degas, Edouard Manet, Guy de Maupassant, Pablo Picasso, Edgar Allan Poe, Henri de Toulouse-Lautrec, Oscar Wilde, even Theodore Roosevelt—all were said to have had at least one thing in common. At some point in their lives, they sat down to a drink (or several drinks) with the "green muse." No metaphorical creative force, this muse was in fact a potent liquid: absinthe, the drink that rocked the world.

Also knows as "the green fairy" or simply "the green," absinthe was actually quite sober in its ancient medicinal beginnings. The combination of anise, fennel, and wormwood (and sometimes other herbs) was used by the Greeks, Egyptians, and Romans for everything from an antiseptic to a cure for worms to an insect repellent. At the close of the eighteenth century, absinthe laid down its roots as a recreational drink.

It may well have been malaria that brought absinthe into the mainstream. French soldiers in Africa were given the drink to

ward off the disease and then were hooked by its sweet licorice taste and high alcohol content. Absinthe quickly made the transition from medicine to social lubricant. In France circa the 1860s, five o'clock came to be known as "the green hour," the time when cafes and bistros came alive with absinthe drinkers.

Absinthe's greenness came from the chlorophyll released by its muddled plant leaves. To the mixture were added water and sugar, for a brew that was innocent enough, it would seem, but those who drank the green fairy claimed they hallucinated. Some were even said to lose their minds when the green grasp took hold. Because of these extreme reactions,

in 1907, absinthe was rebranded as a danger and banned in Switzerland. A domino effect ensued, and in 1915, France banned its favorite drink.

It wasn't until the 1980s that absinthe re-emerged. Once the drink had been studied by chemists, it became clear that the true cause of the hallucinations were simply drunken hallucinations! There were no hallucinatory chemicals in the basic recipe of absinthe—just a sizeable alcohol content. However, makers of cheap absinthe may be partially responsible for its reputation. In cheapening the process, they eliminated absinthe's natural green color and replaced it with a food coloring made from copper salts.

A rare poster advertising Absinthe designed and printed by Nover, 1895.

Once Absinthe was deemed dangerous, posters like this one, by Frederic Christol, 1910, replaced the old advertisements.

3 PARTS WATER

1 PART ABSINTHE

CORIANDER
ANGELICA ROOT
WORMWOOD
FENNEL SEEDS
GREEN ANISE SEEDS
STAR ANISE

WHAT MAKES
THE GREEN, GREEN?

The chlorophyll contained in the leaves of the muddled herbs used to create Absinthe give it its green hue. Wormwood, anise, and fennel are typically found in Absinthe, but other herbs such as star anise, angelica, and coriander can also be added to the mix.

These salts *were* toxic and could have been the culprits of the madness that so many reported experiencing.

Although absinthe came back into vogue once its name was cleared, its infamy will never quite be forgotten. Because some of the greatest writers, poets, and artists of all time enjoyed the green muse, their odes to absinthe live on like an endlessly flowing green river. As Baudelaire wrote, "Where instead of blood flows the green waters of Lethe. The green waters of forgetfulness, with their lethargy-inducing effect, could only be absinthe."

Wormwood, a main ingredient in Absinthe.

Aesthetics aside, white actually impeded the surgeon's ability to perform surgery. When the eye dwells on an object of a particular color and then shifts to something white, it tends to perceive the complement of that first color floating in the white background (complementary colors are those that sit opposite each other on the color wheel). To see this process in action, turn your attention to the red circle below. Stare at it for 30 seconds straight, and then look to its right at the white circle. You should see a greenish blue shadow over the white circle.

These floating phenomena are distracting, but the presence of red in the operating room caused an even bigger problem. When the human eye gets an overdose of a particular color, it begins to become desensitized, to ignore the color essentially. And gory, bloody red is one color to which we want a surgeon's eyes to be extremely sensitive.

Starting in the 1960s, the problem was solved via an elegant solution: bluish green scrubs. Because blue-green is the complement of red, when red blood hits bluish green scrubs, it turns brown, like all complementary colors, when mixed together. And if the color that is bouncing around as a result of visual desensitization—bluish green, in this case—is actually present in the room, the bouncing color seems to disappear, allowing the eye to rest. Yes, it's true, we have those unglamorous blue-green scrubs to thank for the fact that our surgeons can concentrate on our emergency bypass surgeries.

THE SCRUB EFFECT Even several decades into the twentieth century, surgeons commonly operated in their street clothes. It was only once hygiene was embraced as a means of preventing infection that they adopted white clothing as a bow to cleanliness. But the practice was short-lived, as the presence of so much white in the operating room caused a couple of problems. For one, blood really shows up on white fabric. Picture a surgeon emerging from duty with blood spattered everywhere, its very redness speaking to the carnality of the work he's just performed. Not a very comforting scene.

From the bark brown of an African twig mantis to the iridescent brilliance of a blue morpho butterfly, the color of an animal can protect it from getting its head bitten off or help it put on a wild show for a mate. Colors can express signals as opposite as "Stay away!" and "Come by and see me sometime."

One of the first things you'll notice when looking at the animal kingdom through the lens of color is that insects, fish, and birds display a rainbow of magnificence. Mammals, on the other hand, display only a rainbow of neutrals: browns and beiges, black and grays, and a few "reds" and "yellows."

No matter their appearance, color helps most animals decide what to eat and who to mate with; it helps them hide from or scare the daylights out of fellow living creatures.

Whether it bats a blue eye, swishes a turquoise tail, or tosses a golden mane, color is a significant clue to each animal's place in the ecosystem: its habitat, its behavior, even its chances of getting a little love.

The hues, shades, and brightness of the animal kingdom help nurture and protect its species. Nature has done a magnificent job of color-coding animals to help them thrive and survive.

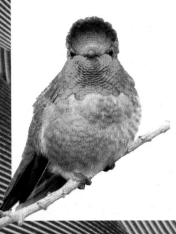

The color of skin, scales, fur, and feathers comes from two different sources: pigments and structural color. Most animals have one type of color, but a few, like the hummingbird, have both.

A PIGMENT PLAY Much of what we've discussed in relation to plants and pigments comes into play with animals as well. As with plants, the pigment contained in an animal's skin, fur, feathers (or whatever kind of outer layer protects it) causes certain wavelengths of light to be absorbed and others reflected.

One of the most plentiful pigments in the animal world, particularly in mammals, is melanin. Melanin account for a vast array of color that spans from pale gray to black, from beige to dark brown, from auburn to blonde. Melanin is not, however, responsible for the very bright colors we see in nature.

Chlorophyll, the most important pigment in the plant world, plays only a secondary role in the animal world; animals are unable to manufacture chlorophyll on their own and can only eat it. The same is true for carotenoids, the pigment most commonly associated with bright reds, oranges, and yellows.

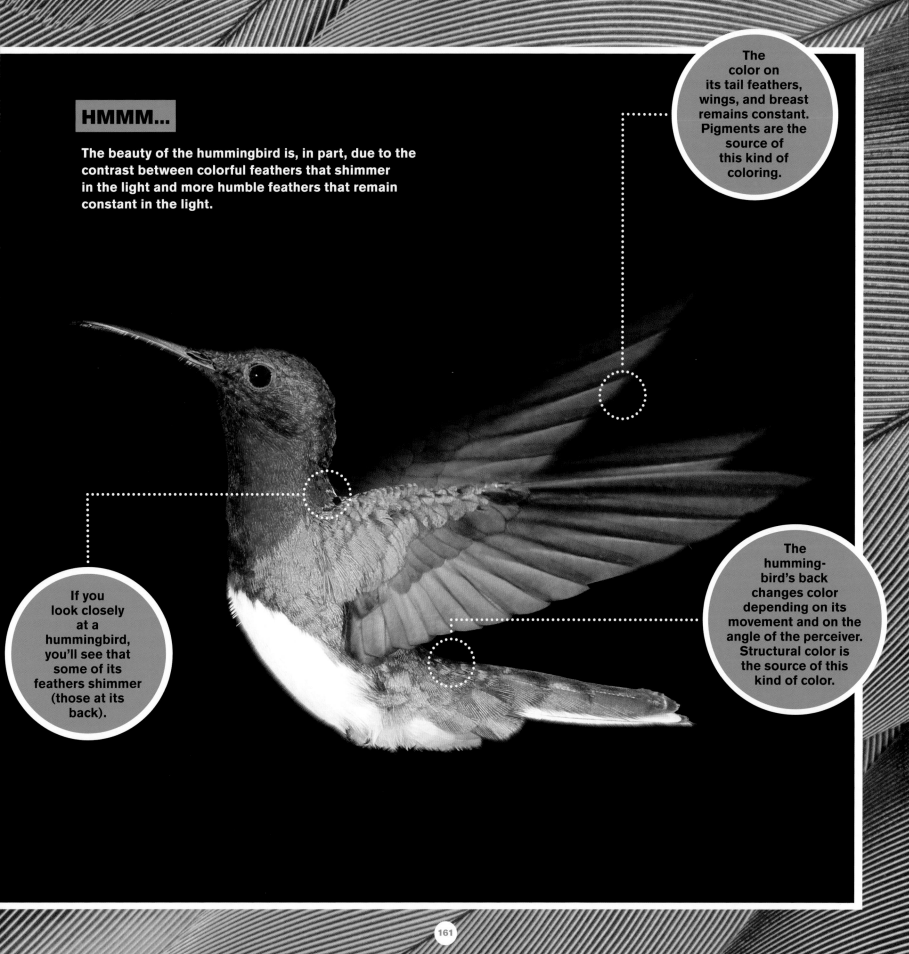

HMMM...

The beauty of the hummingbird is, in part, due to the contrast between colorful feathers that shimmer in the light and more humble feathers that remain constant in the light.

The color on its tail feathers, wings, and breast remains constant. Pigments are the source of this kind of coloring.

If you look closely at a hummingbird, you'll see that some of its feathers shimmer (those at its back).

The hummingbird's back changes color depending on its movement and on the angle of the perceiver. Structural color is the source of this kind of color.

IF YOU'VE EVER WONDERED HOW CANINES
COULD POSSIBLY BE ONE SPECIES WITH THEIR
VARIOUS SHAPES, SIZES, AND COLORS, IT
MIGHT HELP TO KNOW THAT ALL THESE COLORS
ARE CREATED BY ONLY ONE PIGMENT: MELANIN.

MELANIMALS

Eumelanin and pheomelanin are the most common forms of melanin. The latter is responsible for the brightest manifestations of melanin, including "red" hair and fur.

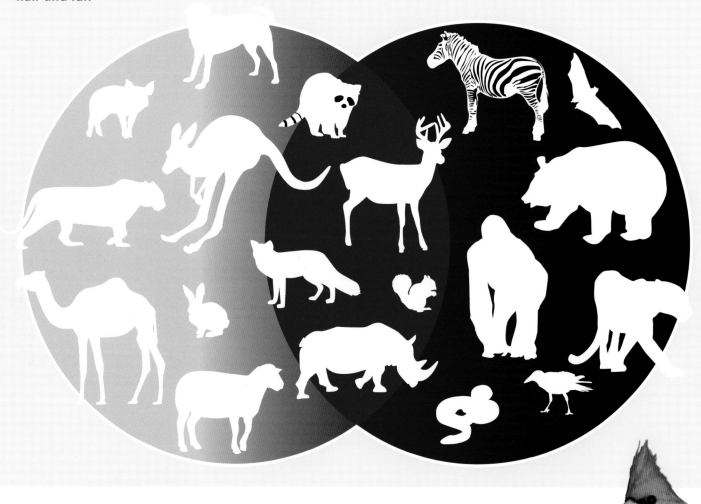

As with plants, animals were first endowed with pigment as protection against the sun's ultraviolet radiation, but the colors of these pigments had another beneficial effect: to help animals mate and survive. One thing that separates animals from plants is that for many animals, the plants they eat and the pigments these plants contain have a direct effect on their own colors.

SOME ANIMALS ARE (COLORED BY) WHAT THEY EAT It's hard to believe that eating a red berry could change one's coloring, but for some animals, this is the case. The berries a cardinal eats in the summer are stored in its feather follicles to keep them

bright red. If you held a cardinal in captivity and fed it only seeds, you would see its feathers fade with each molt.

Salmon ingest a lot of carotenoids in the wild, but when they are farmed, they don't have access to this pigment. The same is true for flamingos, who love shrimp and eat much of it in the wild. What happens to shrimp in a flamingo's stomach is similar to what happens to these crustaceans in boiling water: Shrimp go from a bluish gray to bright salmon pink, and this pink influences the color

light through the structure of their scales, shells, and wings, creating their colorful displays through interference and diffraction.

The blues and violets of the male morpho butterfly, for example, are caused by thin-film iridescence. Thin layers of air are sandwiched between thin layers of cuticle on the butterfly's wings—up to ten to twelve layers for some species of the *Morpho* genus. Because air and cuticle bend light slightly differently, the interference between these thin films refracts light in a specific way that enhances its color; a whopping 70% to 75% of the short wavelengths we perceive as blue will be reflected—far above what can be achieved by pigments alone—lending the morpho its particular brilliance.

Our eyes can only see the glittery play of intense blue on the wings of the morpho butterfly, but an extreme closeup reveals the thin layers of cuticle that create this breathtaking color and iridescence.

It's remarkable how closely the flamingo's feathers reflect what it eats.

of the flamingo's feathers. But shrimp are expensive and are not plentiful in zoos. This is why farmed salmon and captive flamingos must have doses of carotenoids added to their diets: so their flesh and feathers stay nice and pink.

THE SHIFTING WORLD OF STRUCTURAL COLOR The shimmering tones of the shell of the jewel beetle, the plethora of blues on the morpho butterfly's wings, the glittering green of the green bottle fly—they all shift as you look at them. The extraordinary colors of these animals and many others reflect

FINE FEATHERED FRIENDS

In the world of ornithologists, their subjects can vanish in the blink of a feather. Bird identification requires both a quick eye and a sophisticated system of color shorthand, which is why, joining references to more ordinary colors like chestnut, emerald, and fawn, birders use some of the following tongue-tying nomenclature:

RUFOUS
A rusty, reddish brown.
RUFOUS-HEADED HORNBILL;
GREAT RUFOUS WOODCREEPER

VIOLACEOUS
Anything from a deep french blue to vibrant purple
VIOLACEOUS TROGEN;
VIOLACEOUS JAY

OLIVACEOUS
A dull yellowy green.
OLIVACEOUS WOODCREEPER;
EASTERN OLIVACEOUS WARBLER

CINEREOUS
An ashy gray, sometimes with a dash of copper.
CINEREOUS VULTURE; CINEREOUS TINAMOU

GLAUCOUS
A bluish to turquoise gray.
GLAUCOUS-WINGED GULL;
GLAUCOUS MACAW

FULVOUS
A wide-ranging brown that can go from butterscotch to cinnamon.
FULVOUS WHISTLING DUCK;
FULVOUS BABBLER

OCHRACEOUS
An intense earthy yellow-orange.
OCHRACEOUS WREN;
OCHRACEOUS-BREASTED FLYCATCHER

ROSEATE
An intense pink to rose red.
ROSY BEE EATER ROSEATE;
SPOONBILL ROSEATE TERN

BUFFY
A pale, tannish yellow. Think undyed leather, the stuff from which this color got its name.
BUFF-NECKED IBIS;
BURNISHED-BUFF TANAGER

The striations in these peacock feathers create the effects of structural color.

Other species, such as peacocks and jewel beetles, have not evolved to reflect one specific color but rather reflect many colors. Their feathers and shells exhibit the same kind of thin-film iridescence as the morpho butterfly but spread out over more of the spectrum, causing a rainbow effect.

THE WHYS AND HOWS OF ANIMAL COLOR The shimmering green of a hummingbird's back is a come-on as well as an indicator of good health to lure the opposite sex. It's also a sign of a male hummingbird's dominance over other males and a warning to them that they shouldn't pursue the same female. That wasp's black and yellow stripes also lure and warn simultaneously, although wasps are a little stronger on the warning than on the luring. A cuttlefish's changing shades and patterns help both to

The incredible multi-hued irridescence of this 80-million-year-old ammonite fossil is the result of millions of years of high temperatures and pressures acting on the animal's shell.

and adaptations to the animal kingdom. Today, some animals excel at seeing millions upon millions of colors, others at getting around in the dark.

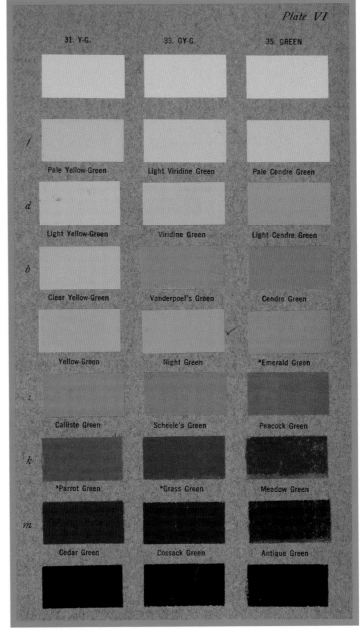

Plate VI

31. Y-G.	33. GY-G.	35. GREEN
Pale Yellow-Green	Light Viridine Green	Pale Cendre Green
Light Yellow-Green	Viridine Green	Light Cendre Green
Clear Yellow-Green	Vanderpoel's Green	Cendre Green
Yellow-Green	Night Green	*Emerald Green
Calliste Green	Scheele's Green	Peacock Green
*Parrot Green	*Grass Green	Meadow Green
Cedar Green	Cossack Green	Antique Green

Robert Ridgeway (1850-1929) was an American Ornithologist who developed a complex color system in order to identify the colors of birds. This color system included 1,115 colors. Here are just 27 of those colors from Ridgeway's classic book, *Color Standards and Color Nomenclature*.

disguise this vulnerable fish from abundant predators and communicate with his own species.

For animals that have extremely colorful skin, feathers, or scales, there is also a cost in the amount of energy they need to expend to keep these colors vibrant. Given this cost, color needs to provide a big benefit to a species in terms of its survival. Sexual selection is the main reason animals expend all this energy because its results offset the costs, which can also include drawing the eye of predators in addition to mates.

ANIMAL SURVIVAL AND LIGHT Because the earth is bathed in sunlight, living creatures developed eyes as a way to navigate their world. The first creatures to develop eyes could not perceive much. Memories of introductory college biology class might recall cutting in half a planarian, a flatworm that still has primitive versions of eyes called "eyespots." Eyespots are pretty much just light detectors, but millions of years' worth of evolution brought an astounding and diverse array of visual processes

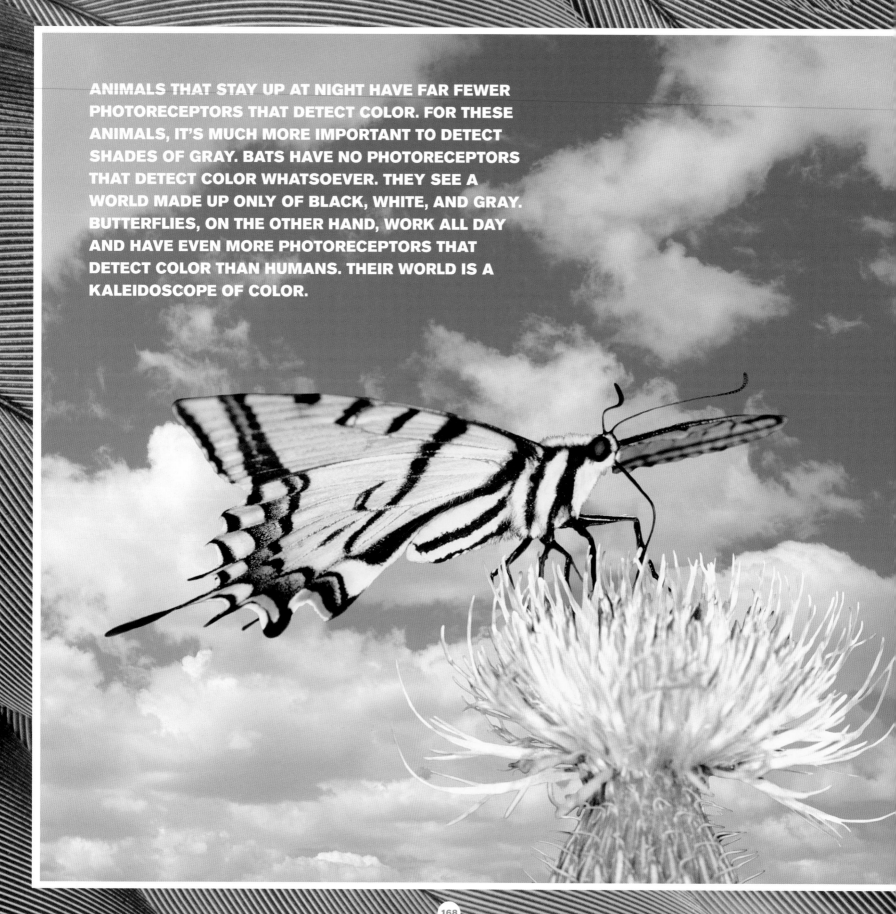

ANIMALS THAT STAY UP AT NIGHT HAVE FAR FEWER PHOTORECEPTORS THAT DETECT COLOR. FOR THESE ANIMALS, IT'S MUCH MORE IMPORTANT TO DETECT SHADES OF GRAY. BATS HAVE NO PHOTORECEPTORS THAT DETECT COLOR WHATSOEVER. THEY SEE A WORLD MADE UP ONLY OF BLACK, WHITE, AND GRAY. BUTTERFLIES, ON THE OTHER HAND, WORK ALL DAY AND HAVE EVEN MORE PHOTORECEPTORS THAT DETECT COLOR THAN HUMANS. THEIR WORLD IS A KALEIDOSCOPE OF COLOR.

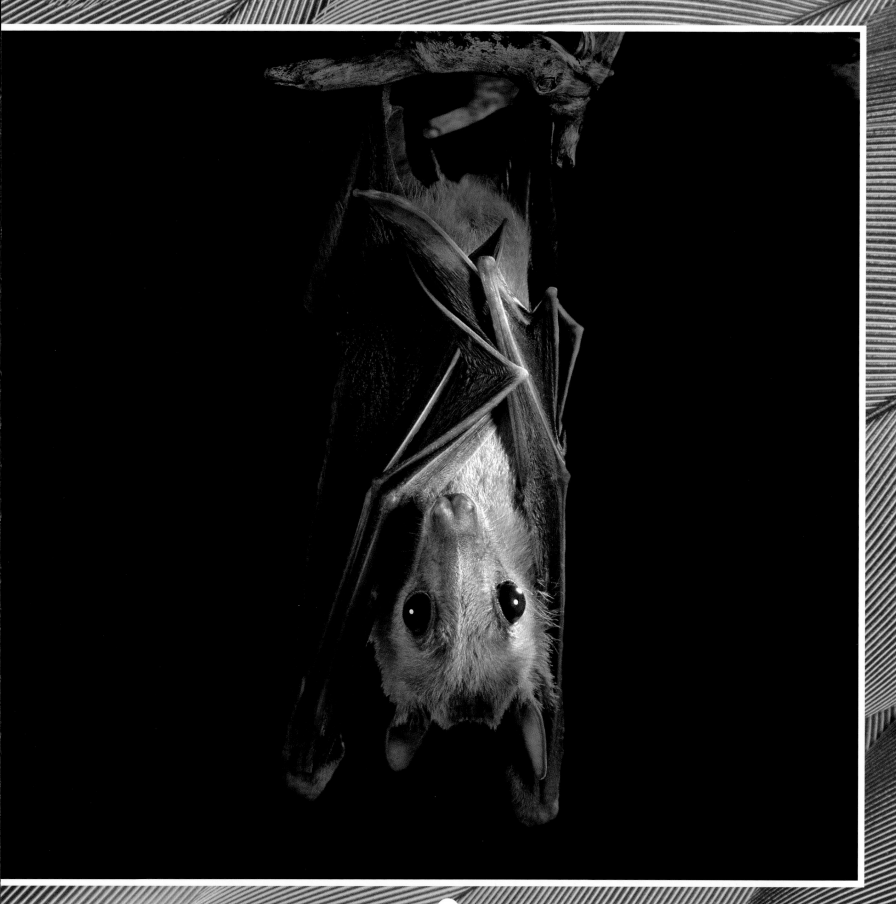

For animals that evolved to stay awake during the day, light is a major survival tool. Daytime is when bright colors are on display, and many animals that are awake at this time are adorned with them and flaunt them.

For those animals that evolved to stay up at night, a lack of light during their waking hours is equally important. These nocturnal animals must distinguish only between shades of grays, and their own colors typically reflect this nighttime world.

The same is true for aquatic creatures. Animals that survive in waters that the light penetrates shimmer with color, whereas those in deeper waters won't be able to show off much. Interestingly, though, there are a lot of red fish in deep water, although they don't appear red until they're brought into the light. This is because long wavelengths of light (the kind we and many other animals see as red) are the first to disappear from vision in very deep water. At 30 feet below sea level, only yellows and blues are visible to animals with cones that are able to see these colors. Go even farther down, and only blue is visible. So, unlike in most environments on land where red makes an animal stand out, in water, being red helps make fish disappear.

SURVIVAL AND COLOR There are three primary reasons for color in the animal world: To find food, to find a mate, and to survive. Every animal calls on its senses to cope with each of these necessities of life, but depending on the species, one sense tends to dominate the others. Some animals rely on their sense of smell, some on their hearing, some on sight.

For those who can perceive long wavelengths of light, color can be particularly helpful when trying to discern whether fruit

Damselfish and wrasses show off their colors in the beams of light that penetrate the shallow waters above staghorn coral in Borneo.

MR. BROWN BIRD ON MY SHOULDER

Vertebrates have no blue pigments. Blues in vertebrates result from either structural color or from the scattering that causes the sky to turn blue (see page 62). If you do the following experiment, you'll see for yourself that this is so: Take a feather from a blue bird, and put a light source behind it. Watch the feather go from blue to brown! Backlighting does not allow for scattering to take place, so the blue disappears.

At left is a blue jay feather in daylight. At right is a blue jay feather backlit with a flashlight.

Scattering is behind–or rather in front of–blue eyes as well. The fine particles in the fat and proteins in our irises scatter the light that hits them. The shorter the wavelength–the colors that appear blue to us–the more scattering that occurs, causing us to see more blue than any other color. Sometimes there is also yellow pigment in front of the iris and the blue combines with the yellow. The result? Green eyes.

The cat's blue eye has no pigment. The blue is the result of scattering. The other eye contains yellow pigment, which in combination with scattering results in a green eye.

With color vision that can differentiate ripe fruit from foliage, finding and eating delicious and nutritious food becomes much easier for animals, including humans!

is ripe or not. With color vision, animals can tell not only ripe from unripe, but they can also discern the stages in between and after, like once a fruit has rotted and gone bad. Mold, bad meat, and poison berries are also color-coded so animals know to avoid them.

When it comes to mating in the animal world, the male is often more heavily and colorfully adorned to attract the female. Some male birds, for example, are more colorful than the females, and they use their colorfulness to attract mates, fanning out their

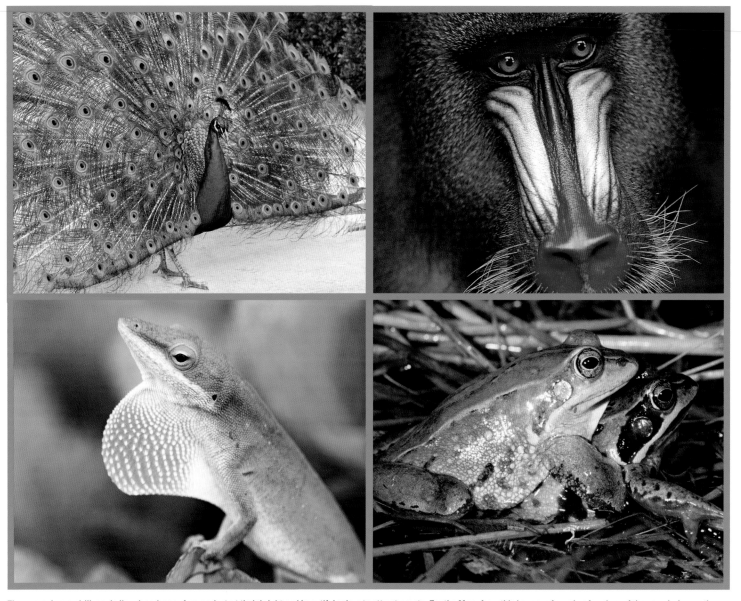

The peacock, mandrill, anole lizard, and moor frog each strut their bright and beautiful colors to attract a mate. For the Moor frog, this happens for only a few days of the year during mating season. The rest of the year, he's the brown color of the female frog he's impregnating in this photo!

feathers for a full display when there's a prospective partner in sight. Just think of the male peacock with his dramatic ornamentation and arrays of blues and greens.

The blue face of a male mandrill, the pink throat of the male anole lizards, and the orange spot on Trinidadian male guppies are just a few other examples of how color adornment on a male is used to attract a mate. New research suggests that the beauty and color variations of female animals are also important, although this topic has long been ignored. Although usually more subtle, such adornments on female animals influence their male partners, too.

It takes so much energy to produce color, that for many animals, the colors don't last past the mating season. Birds, for example, shed their feathers annually, and some birds change color

completely in the process. In the fall, the scarlet tanager, whose name refers to the male's color in the spring when it's ready to mate, isn't scarlet at all. It's a greenish yellow, as is its female counterpart year round.

As the male tanager molts, his red feathers are replaced with green ones, which take less energy to produce.

COLOR SHIFTERS Emperor angelfish have an interesting way of signaling their sexual maturity: they change color and pattern. Except for their shape, young emperor angelfish look like an entirely different fish compared with their sexually active elders.

The mandrill monkey, on the other hand, exhibits a phenomenon called bimaturism: Some members of the adult male mandrill population look completely different from their brethren.

THE AVIAN WORLD'S INTERIOR DESIGNER

We tend to associate birds' colorful mating rituals with their feathers, but there's more to the bowerbird than just his outfit. Colorwise, bowerbirds are a wide-ranging family. Some are a shimmering, violet-black; some are black with splashes of school-bus yellow; others are a tawny brown. What all male bowerbirds have in common is the beautiful "bowers" they build out of sticks to attract their mates. The bowers alone are a sight to behold, but it's the decorations with which the birds surround their homes that may inspire your next decorating purchase.

Bowerbirds seem to settle on an array of palettes: some that are all within one hue, like all blues; some that include close colors, like yellows and oranges; and some that are opposites, like greens and magentas.

They collect petals and berries, leaves and stones, and a myriad of human trash: bottle caps, random pieces of plastic, and even duct tape (yet another use for the product). These are all meticulously gathered and expertly laid out. Females then come by for a visit and assess the bowers for quality, beauty, and how the males present them. These are the greatest open houses real estate has never seen!

It's not just the mandrill's face that attracts a mate, his bottom is also one of the most extraordinarily colorful in the animal kingdom.

HIDING IN PLAIN SIGHT To survive, every animal on this planet has figured out some way to ward off predators and attract prey. Color can be an essential part of this evolution. Some animals blend into their environments, so they can appear to disappear when it's convenient. Some like to mimic animals more dangerous than themselves to confuse their predators, and some find ways to warn their predators to stay away. Color comes in handy with all these approaches.

Camouflage is one of nature's most stunning and cunning uses of color. It is also a vivid demonstration of the way animals evolve in tandem with their habitats. Such thorough disguise can help the animal hide from view; through the use of patterns and colors, camouflage can appear to make skin, scales, or fur fully fade into a background. Some camouflaged animals, like the peppered moth, retain the same colors throughout their lives. Others, like the ermine, wear one color in the summer and slowly shift to a completely different color in winter as the seasons change the landscape. Still others, like the peacock flounder, change moment to moment.

This small percentage of mandrill males will develop iconic multicolored faces (and big pink and blue butts) and will grow to be twice as large as adult males who lack colored visages, but nothing is forever. If a colored male loses his stature through a fight, he will also lose much of his fabulous coloring; all the pinks and reds go away, but the blues remain. Likewise, if a noncolored male takes him down, the victorious male will develop the special coloring and suddenly grow to twice his size—even if he's already reached adulthood. That is some crazy monkey business, indeed!

WHY DO BIRDS HATCH DIFFERENT COLORED EGGS?

WHILE SCIENTISTS HAVEN'T YET FIGURED OUT EXACTLY WHY EGGS ARE THE COLORS THEY ARE, DIET AND CAMOUFLAGE ARE LIKELY PART OF THE EQUATION. BUT WHAT NEITHER DIET NOR CAMOUFLAGE EXPLAIN IS THE PREPONDERANCE OF WHITE EGGS, WHICH REVEAL NO PARTICULARITIES OF DIET AND WHICH APPEAR TO SCREAM OUT "HERE I AM…EAT ME!"

An immature emperor angelfish (left), and a mature emperor angelfish (right) look entirely different from one another. You'd never guess they're the same species.

Sharks are perfectly countershaded to hide them from their prey.

this trick is evolution's response to the fact that in water, light comes from above. If fish A from deeper waters is looking up at fish B above, fish B's pale or silvery undercarriage will disappear into the beams of light around it. Likewise, if fish B is looking down at fish A, fish A's darker upper half will blend into the dark waters below. It makes sense, then, that bottom dwellers are the exception to this type of camouflage.

THE CASE OF THE CHROMATOPHORES What do chameleons and octopuses have in common? Chromatophore cells that allow them to change colors rapidly—as quickly as in a fraction of a second, in some cases.

Long misunderstood, chameleons do not in fact use their superhero-like shape-shifting abilities for camouflage. They use their powers to endure temperature changes, to ward off predators and attract mates. When it gets too hot, a chameleon lightens its hue to reflect more sunlight and cool down; too cold and it becomes darker to absorb more light and warm up. When it comes time to mate, like many other animals, chameleons want to strut their stuff.

Don't think for a second that animals camouflage themselves only to hide from predators. Both the ermine and the peacock flounder use their camouflage to hide, yes, but from their prey— so they can sneak up on their dinner without being noticed.

Almost all fish share a kind of camouflage: Their undersides are lighter than the rest of their bodies. Known as countershading,

Pepper moth, ermine in summer and winter, and peacock flounder in three different states of camouflage.

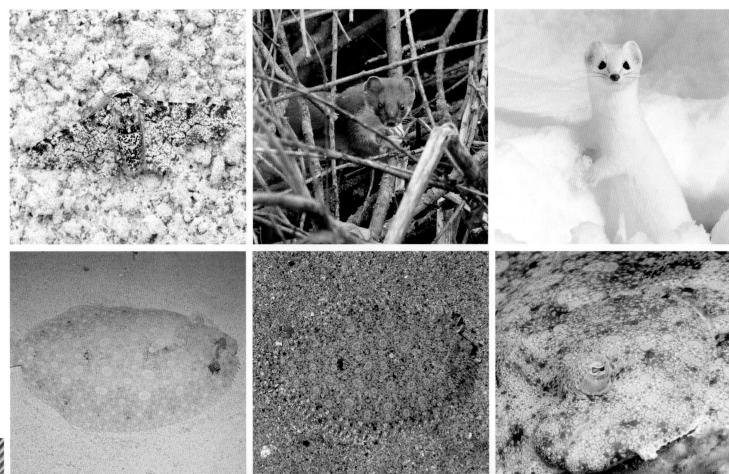

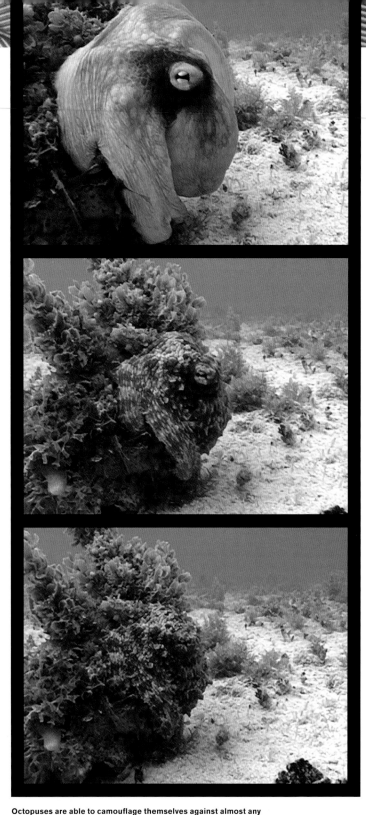

Octopuses also demonstrate rapid color and pattern changes, but they are quite susceptible to predators; so, unlike chameleons, they *do* use this ability for camouflage. As they move across the ocean floor, their chromatophore cells seem to morph instantaneously from color to color and pattern to pattern.

The many-limbed ocean-dweller has one additional color trick up its sleeve: To surprise and confuse its predators, it can discharge a blast of black ink. Despite being color-blind themselves, octopuses seem to have the dark art of color deception all figured out.

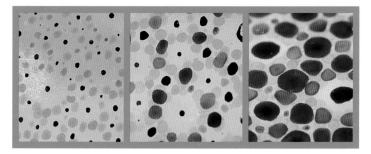

These ultra closeups, taken through a microscope with a *live* animal under it, show what's happening to chromatophore cells as a cephalopod, such as an octopus, changes color and pattern.

COPYCATS AND TOP DOGS Mimicry is another weapon in the struggle for survival in the animal kingdom. It always helps if your predators think you have the power to kill them, which is why certain nonpoisonous animals have cannily evolved to look similar to poisonous ones. Take the non-venomous milk snake and its near lookalike, the (venomous) coral snake, for example. Both have yellow, red, and black stripes; but look closely and you'll see that the order of their stripes is not exactly alike. Red bands touch yellow bands if the snake is venomous, and red touches black if it's a mimic. You'd think evolution would have granted predators some pattern lessons, but sure enough, they're wary enough about taking the risk that they generally refrain, just in case they are wrong. And the milk snake lives on.

As the harmless milk snake mimics the venomous coral snake, the coral snake has its

Octopuses are able to camouflage themselves against almost any background; coral reefs, kelp forests, mud plains. They can change instantaneously—in 2:02 seconds from image 1 to image 3—and blend seamlessly into the environment.

In the case of the nonvenomous milk snake, red bands adjoin black bands.
In the venomous coral snake red bands adjoin yellow bands.

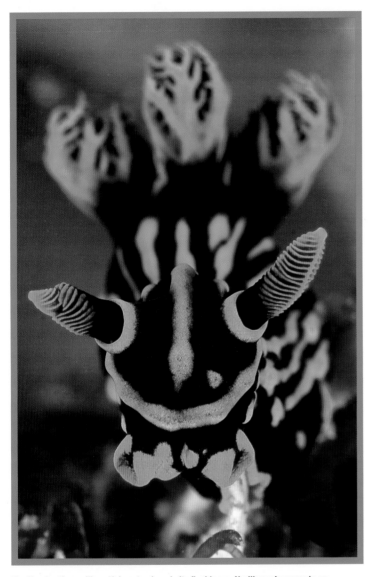

The Nembrotha nudibranch is not unique in its flashiness. Nudibranchs come in an assortment and combination of colors, so bright they give the illuminated Empire State Building a run for its money.

distasteful, as it stores toxic chemicals given off by sponges. One bite of a nudibranch and a predator will fear these plant-like sea creatures.

The poison dart frog secretes its poison through its brightly colored skin. The correlation of its color to the intensity of its poison hammers home the importance of color when it comes to warding off predators: the more intensely colorful this frog became as it evolved, the more poisonous. Just how poisonous are poison dart frogs? Just one is said to be able to kill ten humans or 20,000 mice!

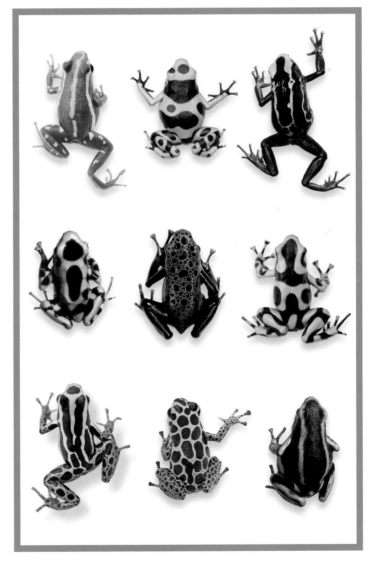

Rainbow of poison dart frogs

own color-coded survival technique. It's called "Stay the bleep away from me!" For coral snakes, their brightly colored stripes are a warning sign in and of themselves; and they are not alone in using their bright color as a warning. Many animals like to let others know that if attacked, they will bite, sting, or send their predators' taste buds on a truly unpleasant journey.

The nudibranch, a kind of mollusk that sheds its shell early in life and displays a circus of color in its stead, is particularly

YOU'RE POSITIVELY GLOWING!

Deep-sea creatures, as we've seen, don't enjoy much, if any, light, which is why many of them create their own. These creatures manufacture their bioluminescence via chemical reactions within their bodies. Although it must be nice for them to have a little light, the main motivation is believed to be survival: the glow can disguise its exact shape, causing confusion on the part of the predator or prey.

Aboveground examples of bioluminescence also exist, namely, the firefly. Like other bioluminescent animals, fireflies use their ability to light up as a warning to say, "We can be poisonous to predators!" They also use their light to excite their mates, flashing their bright lights or letting their light shine to let their lovers know to "come on over."

The sea sparkle is a bioluminescent creature.
Japanese firefly squids displaying bioluminescence. (inset picture)

HOW ANIMALS SEE COLOR Some animals can see wavelengths of light farther along the electromagnetic spectrum than what we humans can perceive. Many birds, for example, see all the colors that we see plus ultraviolet. This is nature's handy way of ensuring that flowers that reflect all different wavelengths of visible light are pollinated and their seeds dispersed. But it all depends on to whom these wavelengths are visible. Red flowers, in particular, are favorites of birds, which works out nicely because insects, their main competition for pollination and dispersal, cannot see red at all.

The only color to which humans are possibly more sensitive than birds is blue. Indeed, because birds spend so much time in the sky (and because Ray-Ban hasn't yet come out with a pair of aviary sunglasses), a sensitivity to the color would not bode well for them.

On the other end of the spectrum, a number of snakes can perceive wavelengths of infrared light. This ability comes in handy as it allows them to see the heat emanating from their warm-blooded prey.

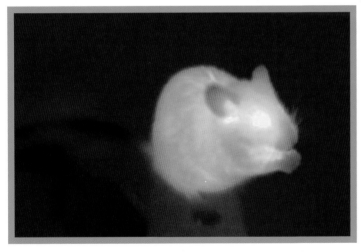

Here's what a mouse looks like to a snake, adjusted for human vision.

Some animals can only see a narrow band within the spectrum of visible light. Some can see no color at all.

Whether it's big- or peewee-brained, an animal's command center is what allows it to see (or not see) color; but before the brain perceives color, the color data must first pass through the animal's photoreceptors. The two types of receptors are rods and cones. Cones are the receptors that turn a wavelength of light that enters the eye into an electrical signal that is passed onto the brain, which tells the animal it's looking at a particular hue. Cones are most active in daylight and other forms of bright light. Their ability to distinguish color diminishes as the environment grows darker; that's when rods take over. Rods are the photoreceptors responsible for an animal's ability to see in the dark, as well as to distinguish contrast. They can distinguish dark and light and shades of gray but not one color from another.

Rods and cones are the primary method by which animals perceive color, but they're not the only means. With its rapidly changing palettes and patterns, the "color-blind" octopus—because of its lack of cones—appears to have a different relationship to color. Octopuses can sense an entirely different kind of light. They can perceive the polarization of light, which has to do with how waves oscillate in electromagnetic fields.

Some animals—especially those that are entirely nocturnal, like bats—also have no cones and are entirely dependent on their rods. Other animals, like the Chinese yellow swallowtail butterfly, have five kinds of cones, allowing them to see colors that we humans, with our paltry three cones, cannot even conceive. Dogs, like many other mammals, have only two cones and can perceive wavelengths that translate to yellow and blue; reds and greens don't color their world. And the gold medal for best color vision goes to—drumroll—stomatopods! These coral-reef-abiding crustaceans have an astounding sixteen different kinds of photoreceptors (eleven or twelve of which are cones). They also happen to have eyes on top of their heads. When it comes to vision, stomatopods have it locked up.

Primates are all over the map. Old World monkeys and apes have trichromatic color vision (like humans), whereas nocturnal prosimians can see only black, white, and gray. Some species of lemurs and nearly all New World monkeys have polymorphic color vision. Males are dichromats (meaning they have two kinds of cones). Some females share the same two kinds of cones as males, and to complicate matters, some don't. Some females are trichromats. Why all this diversity of color vision? Each kind has its advantages and disadvantages. Dichromats are great at breaking up camouflage, which allows them to spot predators and prey better than some of their trichromat sisters; but those sisters are much better at spotting ripe fruit. It's great to have a family in which everyone has different skills!

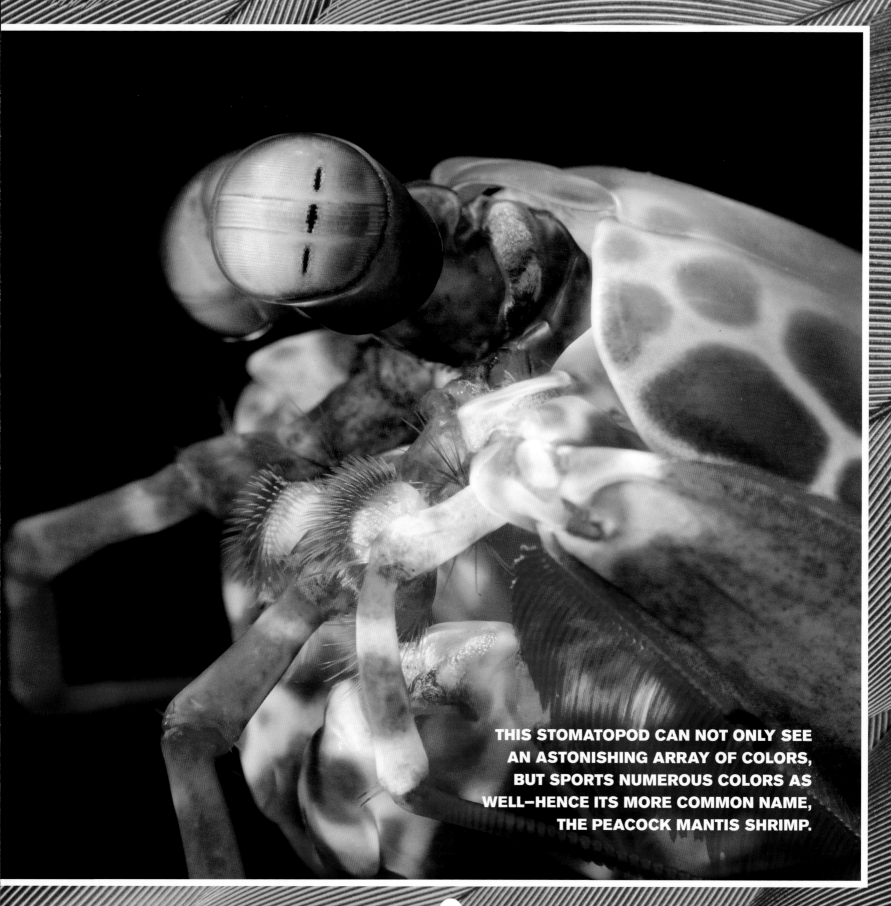

THIS STOMATOPOD CAN NOT ONLY SEE
AN ASTONISHING ARRAY OF COLORS,
BUT SPORTS NUMEROUS COLORS AS
WELL—HENCE ITS MORE COMMON NAME,
THE PEACOCK MANTIS SHRIMP.

BLUE

From a nighttime sky to a deep blue sea, the color blue expands our horizons and blankets our dreams. We trust blue (bestowing its authority on our men and women in uniform), depend on blue (granting blue chip stocks their fiscal reliability), see blue as masculine (bundling up our baby boys and decorating their nurseries), and perceive it as both calming and cooling. On the other hand, we all get the blues at one time or another, and blue can be the moody underside to our otherwise rosy dispositions.

For centuries, blue has remained unique in its polarities. It represents both the working class (whether they're clad in denim or blue collar) and the very rich (outfitted in royal blue, with blue blood running through their veins). It's a color ever present in our sky and seas—hence our "blue planet"—but rarely present in more earthbound plants and beings.

Very little blue existed in the ancient world. Blue fruits were virtually nonexistent; truly blue flowers rare; and blue clothing very difficult, if not impossible, to come by. Perhaps this is why it took nearly all cultures, regardless of geography, so long to name the color. You'll see the evidence of this lack of blue by searching the *Odyssey* and the *Iliad.* Homer makes not a single mention of the word blue, nor is it named in ancient Indian Vedic poems, Icelandic sagas, and the early works of numerous other cultures that span the globe.

In the second century AD, the ancient scholar Rabbi Me'ir wrote about why the Torah requires a thread of "blue" in the fringes of ritual Jewish prayer shawls. The word *blue* here is actually a translation of the Hebrew word *Tekhelet,* a word that has been variously defined as everything from turquoise

As with our "blue," techelet emcompases many shades.

to purple. Here is how Rabbi Me'ir described it: "Tekhelet resembles the color of the sea, and the sea resembles the color of the sky, and the sky resembles the color of a sapphire, and a sapphire resembles the color of the Throne of Glory." If you look at representations of these three on the previous page, you'll see very different colors, but the colors fall within a range, a range we recognize.

SACRE BLUE

In modern European languages, the origin for the word *blue* is usually derived from black and sometimes from green. And in these languages, prior to a name for blue, you'll find the things we would describe as blue, instead described as black or green. Blue provides a great example of the fluidity of our color language.

And what about the color of the sky? It seems impossible that one of the most omnipresent colors in our day-to-day existence—a color that hasn't changed—would go unnamed. But there are reasons to believe this is so. Some scholars suggest that to our ancient forefathers, the sky was a psychic nonentity. It was just *there* and thus wasn't thought of as a color. Additionally, if ancient humans didn't have much exposure to the color blue beyond the sky and lacked a concept that encapsulated "sky," *blue sky* would have been quite a stretch. This is not to say there were no descriptions of the sky, but like other "blue" things, it tended to be described as green or black.

A Jewish prayer shawl (or tallit) with its techelet fringe.

There is a cultural exception to the lack of blue in early civilizations: Ancient Egypt. Egyptians not only noticed the blues around them, but they also placed a high value on the color. Lapis lazuli and azurite were rare but present, and the Egyptians set to work on producing a substance that reflected the beauty of the natural minerals they adored. The result was one of the first, if not *the* first, synthetic pigments. The color was blue, and the Egyptians felt compelled to name this unique and beautiful color.

LOVELY LAPIS LAZULI Although for centuries the Egyptians cornered the market on a synthetic blue pigment, they weren't the only ones who adored the mesmerizing color of lapis lazuli. For the painters of the Renaissance, lapis lazuli was used to create the coveted pigment ultramarine (not to be confused with the synthetic pigment you can now find in art supply stores); coveted because lapis lazuli was imported from very long distances (it

From the tomb of Amon Khopechef, son of Ramses II.

with its unparalleled luminescence, intensity, and purity; and it also ensured its monetary value. Their paintings cost as much as precious gems in terms of materials alone. That's why the "blue bloods" who owned them showed them off as proudly as their diamond rings.

Detail of Leonardo Da Vinci's, *The Last Supper*, 1495-1497.

IF YOU LOOK CLOSELY, YOU'LL SEE THAT THE ROBES OF JUDAS—WHO IS IN THE FOREGROUND HERE—ARE A DIFFERENT COLOR THAN JESUS'. ACCIDENT? ART HISTORIANS BELIEVE NOT. LEONARDO USED THE CHEAPER AZURITE, NOT LAPIS LAZULI, AS THE PIGMENT FOR THIS TRAITOR'S CLOTHES.

was mostly mined in Afghanistan), it required an extremely labor-intensive process to turn it into a pigment, and it had a vibrancy unlike any other blue.

Leonardo da Vinci and other great painters of the time demanded that their clients and patrons supply this precious pigment as part of their contracts, and the shade was so expensive that unscrupulous sellers would sometimes try to pass off azurite as ultramarine. Although similar in look, these minerals differed in their chemical makeup. Once ground up, azurite was greener and more translucent. From an aesthetic standpoint, it lacked the prized essence of lapis lazuli: the latter's deep purplish blue. Azurite was also worth a fraction of the price.

The test of authenticity was no small undertaking; the minerals had to be heated until red hot. Azurite turns black once it's cool, whereas lapis lazuli does not. For the painters, though, it was a worthwhile process. Ultramarine transported their work

ACCIDENTAL BLUE Jump to the beginning of the eighteenth century, German painter, Heinrich Diesbach created the first synthetic blue pigment to go down in the history books since the Egyptians. And this one—like its natural predecessor ultramarine—didn't fade. Unlike lapis lazuli, Diesbach's Prussian blue was a fraction the price and easy to produce. As an added bonus, it didn't kill—a trait that wasn't shared by many subsequent synthetic dyes.

Diesbach was in the middle of mixing together iron sulfate and potash for another pigment called red lake. But in what historians assume was an attempt

Lapis lazuli.

to save some cash, Diesbach bought subgrade potash, which was contaminated with animal oil. The pigment came out way too pale, and in his effort to concentrate it to improve the color, he invented a whole new one: a vibrant, exciting blue that got its name from its use as a dye for Prussian military uniforms.

INTO INDIGO The Tuareg of North Africa have a deep affection for the color blue—indigo to be precise. Unlike many of their Muslim neighbors, it is the Tuareg men who wear headscarves—called *tagelmousts*—covering everything but their eyes. Boys first don their tagelmousts during a ceremony that marks their transition to manhood.

For men of wealth or status, this headscarf is certain to be blue. The darker the color of the indigo and the higher the fabric's sheen (virtues accomplished through multiple rounds of dying and beating), the more prestigious the wearer. This plant-based dye is a quick signifier of wealth for the Tuareg as well as in other parts of West Africa, which has a centuries-old tradition of dying with indigo.

But for the Tuareg, donning blue isn't merely a matter of wealth and prestige: It is their belief that the color carries essential protective powers. White, the alternative tagelmoust worn by those of lesser standing, has no such claim. Given the color's pedigree, it's no surprise that the "Blue People" actually welcome the rubbing off of the dye from their flowing indigo garb onto their skin.

The blue in original blue jeans was also a result of indigo dye. But unlike with the Toureg, pants made of blue denim clearly identified a lowly laborer in the Western regions of the world.

BLUE TO THE RESCUE

Prussian blue also has an added benefit: it could mean the difference between life and death. Should you happen to ingest some thallium or radioactive cesium, Prussian blue can get you out of a jam. It sequesters these toxic radioactive substances in your intestines, allowing you then to excrete them via fecal matter tinted with a surprising hue.

BLUE IN KHAMUN

The use of Ultramarine dates back to ancient Afghanistan.

THE DAWN OF MAN

ANCIENT AFGHANISTAN
Ceramics

MESOPOTAMIA
Sculpture

EGYPT
Jewelry and Amulets

ROMAN
Aphrodisiac

MEDIEVAL
Illuminated Manuscripts

RENAISSANCE
Oil Paints

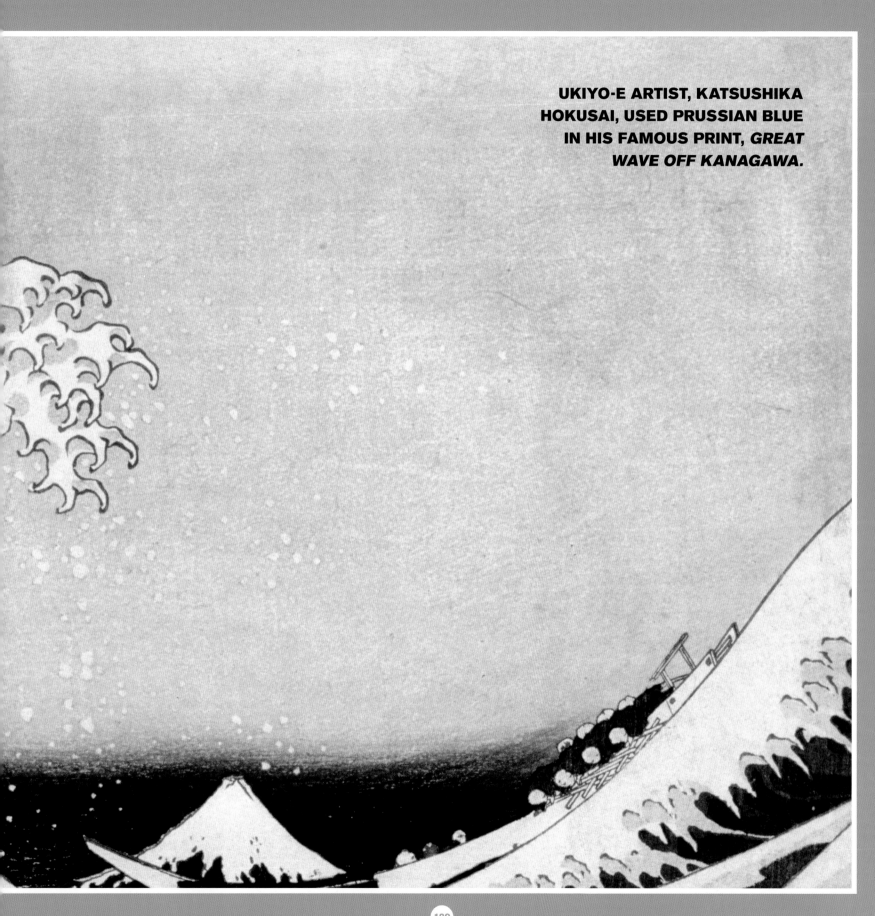

UKIYO-E ARTIST, KATSUSHIKA HOKUSAI, USED PRUSSIAN BLUE IN HIS FAMOUS PRINT, *GREAT WAVE OFF KANAGAWA.*

Tuareg man in indigo-dyed taglemoust.

Levi Strauss and his partner, Jacob Davis, received patent number 139,121 for the process of riveting pants from the U.S. Patent and Trademark Office in 1873. Their first pant was the original 501® jean but at the time it was just called "XX," the term for the high quality denim they used.

Blue jeans have come a long way from these hardy, workaday origins—and we have Levi Strauss, the man who created Levi's, to thank. Like many in the 1850s, Strauss went to California to seek his fortune, founding a dry goods business, where he carried the best American denim available. Made in a factory in New Hampshire, the cloth was superstrong, the fabric of choice for dirty, difficult work like gold mining.

Enter Jacob Davis, a tailor out of Reno, Nevada, who regularly bought denim from Strauss. Davis had devised a strategy that made his denim pants sturdier than his competitors' pants: He added metal rivets at the top corners of their pockets. The two men went in on a patent together, and Levi's were born.

The jeans were a smashing success, but for decades they were sold only on the West Coast. When they started showing up in Westerns and on movie stars like John Wayne, the hardy work pants began to turn into a cultural icon.

When America entered World War II, the raw materials, including cotton and copper used in making denim pants, were needed for the war effort and thus became scarce. Perhaps their scarcity is why post-war America embraced its denim enthu-

siastically, turning what for a century had been called "waist overalls" into "blue jeans." Although still largely considered work clothes, not the sort of thing you'd wear socially, mores were changing. Blue jeans were transitioning into a fashion statement, and the youth of America couldn't get enough of them. In the 1960s and 1970s, hippies started customizing their jeans. They turned them into art projects replete with peace signs and embroidery, even converting them into skirts, hats, and purses. In the 1970s and 1980s, designers like Calvin Klein and Gloria Vanderbilt embraced the blue jean and unabashedly emblazoned their logos on women's rear ends. In the 1980s and 1990s, jean smugglers created a black market explosion in the Soviet Union.

A couple centuries ago, you'd have been hard pressed to find a peasant wearing anything a royal would deign to wear—fabric, cut, and color separated the masses from everyone who was anyone. But today, jeans are worn the world over by homeless people and princesses. And although they now come in a plethora of colors, blue jeans remain the standard—the classic, never-out-of-style color.

HOW BLUE IS YOUR BLOOD? The mention of a "blue blood" is sure to conjure images of a wealthy, stiff-upper-lipped lady or gentleman from the highest echelons of society. But the term has more than classist origins. Originally, sangre azul—*sangre* meaning "blood" and *azul* "blue"—was meant to indicate race and religion.

In 1492, Ferdinand of Aragon and Isabella of Castille, who ruled most of Spain as we know it, conquered the Muslim kingdom of Granada in southern Spain as well. This victory put an end to a period of religious tolerance during which Muslims, Jews, and Christians lived peacefully. With the Spanish Inquisition in full force, Muslims and Jews were forced to convert to Catholicism or to leave their homeland. Skin color became a way of identifying and singling out Muslims and Jews, as many were of Northern African descent. Christians were generally far paler; their skin was fair enough to see their veins, which appeared blue through its layers. So to show your "blue blood" was a way to prove your pure Christian heritage.

In the nineteenth century, the class-conscious British adopted the identifier "blue-blood," and it came to mean, more specifically, a member of the aristocracy. Of course, our blood is not blue no matter what the color of our skin. It's simply the way pale skin absorbs and reflects light that makes our eyes perceive a bluish cast.

Scientists gather the very blue blood of these horseshoe crabs and use it to help detect bacteria in medicines before they contaminate us.

Courting blue-footed boobies.

Horseshoe crabs are also blue-blooded—but not in the aristocratic sense. Their blood, unlike the iron-heavy plasma common to many creatures, is rich in copper, which when mixed with oxygen turns the blood a beautiful blue.

These accommodating arthropods play an essential role in shielding us from biomedical mayhem. The blue blood of the horseshoe crab detects and clots around all sorts of bacterial toxins, allowing scientists to identify these biohazards and to ensure that our medicines and inoculations are free of lethal substances.

The use of horseshoe crab blood in medical research has also helped to save countless rabbits previously used as laboratory animals, often to their sad demise. The crabs suffer a less drastic fate. After their period of medical service, they are returned to their habitat, with 85% going on to live healthy lives.

A BLUE-FOOTED BOOBY TRAP The seabird called the blue-footed booby takes great pride in its extremities. Although the remarkable turquoise appendages are shared by both sexes, it's the male booby, smaller than his female counterpart, who makes the most of his assets. During their mating rituals, males lift their tails, wings, and heads dramatically into the air. Then, in a deliberate dance that vividly showcases their most exotic feature, up comes one foot, then the other—a blue-footed booby stomp of sorts.

Blue-footed boobies are mostly monogamous, so females choose their mates carefully. Males and females share the childcare duties, which means females are looking not just for long-term partners but also for great childrearing potential. As it turns out, those blue feet hold all the answers. An excellent foot color means a healthy booby, but a healthy looking foot has an even more primal significance to these future parents, as both the male and female bird will eventually use its feet to warm the eggs and the newborn baby boobies. Sadly, the color of booby feet starts to fade after the couple has been together awhile, when it's no longer necessary for either party to put on a show.

BLUE FOODS

Although not every blue food is poisonous—blueberries being a case in point—some, like the mushroom psilocybin, are psychedelic. Foragers beware (unless you intend to take a magical mushroom trip): Its stems are stained blue.

FOOD	GOOD FOR YOU	BAD FOR YOU	EFFECT
BLUEBERRIES	YES!		BOOSTS IMMUNE SYSTEM
VIRGINIA CREEPER BERRIES		YES!	DEATH!
FOOD MOLD		YES!	ALLERGIES, RESPIRATORY PROBLEMS
OLD MEAT		YES!	GASTRO-INTESTINAL PROBLEMS
MAGIC MUSHROOMS	YES! (IF YOU WANT TO TRIP)	YES! (IF YOU DON'T WANT TO TRIP)	WOAH!

The magical mushroom, psylocibe.

THE BLUE FOOD BLUES Rare though they are, both in the ancient world and today, blue foods generally portend sickness or death for humans. Toxic molds, bad meat, poison berries, and rare mushrooms all come in shades of blue; there are no blue apples, squash, or beans. The only edible blue foods are blueberries, blue corn, blue potatoes (with the latter two both leaning toward purple), and blue cheese (the name refers to the safe variety of mold growing on the cheese). Fittingly, studies have shown that most people find foods that are dyed blue the most unappetizing of any color. Because there are so few blue foods, and because most blue foods that do exist are likely to make us ill or even kill us, humans never developed an evolutionary appetite for the color.

SAVED BY THE LIGHT Blue light can play a key role in our mood, even when it comes to curing the "blues." Scientists have long known that light is essential to our circadian rhythms, which receive signals from the outside world and download them to our internal clock, which regulates when we're active, how and when we sleep, and the hormonal ebb and flow related to sleep. Scientists suspected a connection between circadian rhythms and blue light in particular for some time but were unable to prove it. Then in 1998 a previously unknown class of photoreceptor that is particularly sensitive to blue light was found in fish. These photoreceptors were unlike those believed to be the sole sensors of color and light in vertebrates, and it wasn't easy to convince the scientific establishment that such cells existed—especially in humans. After experiments with a genetically engineered mouse that showed a related kind of photoreceptor, it became an accepted fact that mammals' (including humans') color and light sensitivity was more complex than previously thought.

Blue light affects more than just our circadian rhythms, as it turns out. When blue light is detected by these new photoreceptors in the eye, they send messages, not just to our clocks, but directly to many different areas of the brain that control alertness, sleep, hormone release, and even our pupil size. It seems they give us an unconscious awareness of the overall brightness of environmental light and use this information to regulate much of our physiology and behavior.

So far, scientists have found that blue light can help treat a number of health problems, including seasonal affective disorder, depression, dementia, premenstrual syndrome (PMS), and eating disorders, to name a few. They are also exploring the use of blue light in schools to help children concentrate and stay alert, in nursing homes to help with memory loss and depression, and in factories for nightshift workers. Even after 20 years on the night shift, workers do not shift their body clock with the demands of working at night. They are locked onto the same light/dark cycle as the dayshift workers because in the factory the light is relatively dim, and they are exposed to bright natural light on the journey to and from work. As a result, a nightshift worker is always trying to work when the body clock is saying, "Sleep." This explains why the accident rate is so much higher on the night shift compared with the day shift. To counteract this, blue light is being introduced to increase alertness in the factory.

Maybe the most amazing aspect of the discovery of these new cells is that their existence has redefined our understanding of blindness. The visual cells in the eye can be lost as a result of genetic disease, but the new receptors can keep on working. People with visual loss, but with these blue-sensitive cells still working, can be encouraged to seek out daytime light to keep their body clocks aligned to the light/dark cycle.

Why are we so affected by blue light in particular? Scientists don't know for sure, but these new receptors are tuned almost exactly to the same blue as a cloudless blue sky, which makes sense because they help us detect overall brightness in the environment. It is also interesting that the blue light sensitivity shown by these receptors is the same in very different groups of animals, suggesting that they are all locking onto the same light signal in the environment, presumably the blue sky.

The animal kingdom presents a vast array of colors, with seemingly every hue and shade represented. In contrast to many other species, we humans are truly dull. We have skin ranging from barely pink to an array of browns, with no bright colors to be found. Even the bluest eyes and the reddest hair, alongside a butterfly's wing or a bird's feather, look comparatively "blah."

When it comes to color and humans, we are faced with two major conundrums: We are relatively colorless, yet we can see far more color than most other mammals, as well as many other creatures in the animal kingdom. Although we display only a small range of color in our skin, hair, and eyes, we think of ourselves as dramatically different, depending on what part of the planet we hail from and to which tribe we belong. In our world, a little color can go a long way.

A woman looks at a painting entitled *1024 Farben, 1973,* by the German artist Gerhard Richter, during the presentation of the exhibition *Gerhard Richter: Panorama* at the Centre Pompidou in Paris, on June 4, 2012.

These color conundrums can be at least partially explained by the large size of our brains. Our unique ability to see not only many colors, but also to perceive what we see, has an almost constant effect on how we take in the world. Although we are largely unaware of these perceptions, our world is mapped out for us through color, and at every moment these colors are helping to guide our very next moves.

We've used color, abused color, loved color, hated color, but we are always surrounded by it, always wrapped in it, even if it's only by our own skin.

We didn't always see all the colors we now can see. Our ancestral primates were primarily nocturnal, navigating the world with monochromatic or dichromatic vision. As their brains grew, and as they spent more time in the daylight, color became more important. Their visual cortexes enlarged enough to handle more complex information, and they developed a third kind of cone, thus evolving from dichromats into trichromats and exponentially increasing the number of colors they saw.

We also rely more heavily on our sight than on any other sense—so much so that we are more sight dependent than virtually

any other animal. We are almost always taking in information through our eyes. More than 80% of the neocortex (the part of our brain that deals with many of our more complex activities, like sensory perception and language) is involved in vision in one way or another.

So how many colors can humans see? 100,000 colors? 500,000? 1,000,000? The average human can see ten million colors!

THE HUMAN "RAINBOW" The range of human hair color goes from the wispiest white to the shiniest black. Eyes can be icy blue,

multihued hazel, or deep pools of brown. Skin can be the palest blush to the darkest brown. It's hard to believe, but only one kind of pigment—or the lack thereof—is responsible for the color of human hair, eyes, and skin. That one pigment is melanin. Dark-skinned Africans have more melanin in the outer layer of their skin than light-skinned Northern Europeans. People with brown eyes have more melanin than those with hazel, green, or blue. Blue and green

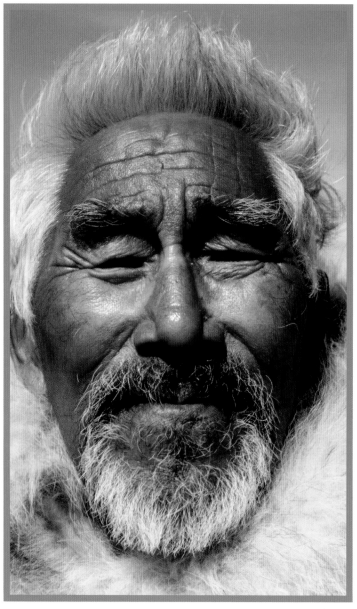

The Inuits of Alaska share a skin color similar to those from far more temperate climes.

French artist, Pierre David, has created a human skin rainbow that shows the minute increments of skin color, from "white" to "black".

eyes are the equivalent of pale skin, and as you may recall, they are colored not by some other nonmelanin-type pigment but by an illusion owing to the selective scattering of light. Blue eyes contain no melanin whatsoever. Green eyes result when a yellow-colored type of melanin in the eye mixes with the blue caused by scattering. Whereas melanin produces brown, black, red, and blond hair, white hair—like blue eyes-—contains no melanin at all (and gray contains very little). Its appearance is also an optical effect, the result of nonselective scattering.

As with plants and animals, there is a very good reason for the presence of pigment in our hair, eyes, and skin. Melanin is a natural sunscreen. We live on a planet awash in sunlight, and without this protection, we wouldn't be able to withstand the sun's ultraviolet radiation. The more sun our ancestors had in their environment, the more melanin they developed in the specialized cells that hold this salutary substance.

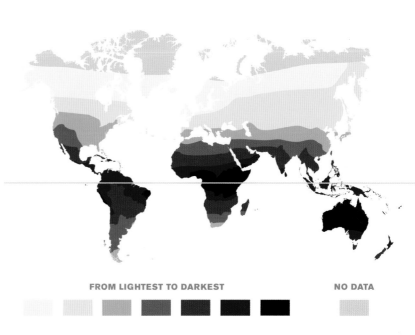

This skin map of the world shows how skin color changes depending on how far a population is from the equator.

Higher concentrations of melanin in the skin naturally boost one's overall immune system, helping to prevent not only cancer but other diseases as well. Studies have shown that Parkinson's, multiple sclerosis, and spina bifida rates are lower in those with darker skin. Darker skin also ages better because it is more resistant to damage from the sun.

The only significant drawback to high concentrations of melanin is that it prevents the absorption of vitamin D, an essential nutrient whose absorption is facilitated by the same ultraviolet rays that can damage our skin. Vitamin D, for example, allows us to absorb and utilize calcium. Everything from our bones to our brain to our immune systems needs vitamin D to survive and thrive. As humans moved from Africa into less sun-drenched places like Northern Europe, their melanin decreased as their skin color lightened, but their vitamin D absorption increased.

What the map above does not show is that humans from cultures with long-standing roots in places that are largely snowbound also tend to have darker skin. This is because snow is a tremendous reflector of ultraviolet radiation from the sun. Cold though it may feel outside, those rays can burn, and humans require darker skin as protection against this radiation.

HOW SKIN FITS IN Why do we see so many colors and yet display so few? The prevailing hypothesis is that we, like many of our fellow animals, developed a wide range of color vision to recognize ripe fruit. This makes sense, but a new hypothesis has emerged, and it's a compelling one: we see all these colors because of our skin.

Look at your skin. What color is it? Can you name that color? If you said peach or chocolate, submit your pick to a reality check. Put a peach or a piece of chocolate next to your skin, and we're pretty confident that you won't find a match. When you think about it, it's odd that we don't have accurate names to describe skin color. Given that many of our ancestors routinely showed a lot of skin, it seems they would have developed language to describe the birthday suit they could never take off.

The task of naming skin color is harder than it may initially seem, however; skin color is so difficult to define. It actually seems

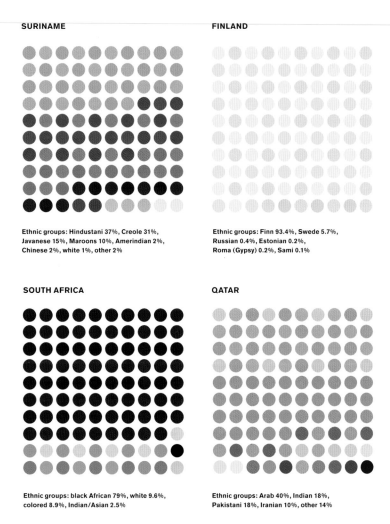

SURINAME

Ethnic groups: Hindustani 37%, Creole 31%,
Javanese 15%, Maroons 10%, Amerindian 2%,
Chinese 2%, white 1%, other 2%

FINLAND

Ethnic groups: Finn 93.4%, Swede 5.7%,
Russian 0.4%, Estonian 0.2%,
Roma (Gypsy) 0.2%, Sami 0.1%

SOUTH AFRICA

Ethnic groups: black African 79%, white 9.6%,
colored 8.9%, Indian/Asian 2.5%

QATAR

Ethnic groups: Arab 40%, Indian 18%,
Pakistani 18%, Iranian 10%, other 14%

Dutch designer, Reineke Otten, created these visually arresting skin color maps to reveal each country's link to its population, climate, economy, politics, and social practices. As she says, "Our planet is an unstable composition of complexions: through migration, intermarriage, cosmetics, war, trains, planes, and automobiles, the 'view from above' of the earth's skin tones is in a continuous state of evolution."

to color-shift. Depending on a host of external and internal variables, skin can take on different hues anytime of the day or night, which makes it extremely hard to name. When you're hot, cold, sick, angry, or scared, your skin reflects each state of being. We don't say that someone turned red with rage, white with fear, or blue with cold for nothing. We see these changes, and we note them; and although you don't actually turn bright red or true blue or white as a sheet, it is possible to register even a tinge of these colors in our skin.

As we go about our daily lives and interact with other humans, it's important to be able to perceive when someone is hot, cold, sick, angry, or frightened. So it makes sense that our color vision—even if it did initially develop to recognize a ripe fruit—would also evolve to note these differences in our fellow humans. If you're fighting with your enemy and his face takes on a red cast, it might be time to back down. If your infant's skin looks blue or yellow, it might be time to call the doctor.

In a similar vein, back when our ancestors wore little to nothing, it was their skin that gave them the critical first impression of a stranger. Biologically, differences in skin color simply indicate melanin levels. Although the ingredient is the same, we divide ourselves by race and have put considerable stock in the color of our skin. Skin color has started wars, ended love affairs, enslaved generations, changed the fate of entire populations, and carried the burden of assumptions that are ludicrous and shameful. What's even more distressing is that these assumptions still exist today, despite what we now know about skin and melanin and despite the fact that these days only a small percentage of our skin is displayed.

Yet given that color defines nearly everything in every corner of our universe, it's perhaps not too surprising that it has taken on this kind of significance. Animals ascribe a great deal of importance to the color of fellow animals, and we're not so different from our fellow animals as we'd like to think. Maybe if we hadn't been blessed with such abundant color vision, we'd be fighting wars over differences in smell, determining status via prolonged sniffing rituals, and falling in love at first whiff.

THE BUILDING BLOCKS OF COLOR VISION Whether our senses evolved to help us see a yellow fruit, care for a sick baby, or know when an enemy is furious, our trichromatic vision is the reason color is so plentiful to us humans. The "tri" in trichromats refers to the three different kinds of cones that are contained in our retinas. To refresh your memory from page 21, these three kinds of cones are sensitive to three different kinds of light in the visible spectrum. One kind senses short wavelengths (perceived as blues and violets). Another kind senses medium wavelengths of light (perceived as greens and yellows), and one kind senses long wavelengths (perceived as reds, oranges, and yellows). These cones are commonly referred to as red, green, and blue. Without our cones, these wavelengths of light would appear colorless.

WHITE, BLACK OR IN BETWEEN?

Although the rest of the world may have trouble coming up with the names of skin colors, there's one notable exception: Brazil—a country whose complex history has resulted in a vast array of skin tones and names for them.

Unlike colonization in the Americas, where European invaders were determined to keep themselves separated from the "natives" (and on keeping their skin white), Brazil's colonizers didn't draw the same line in the sand. Because they needed to keep the population growing, light-skinned Europeans were actually encouraged to marry darker-skinned natives.

By the seventeenth century, the colonialists encountered another problem: There weren't enough white women to go around—but there *was* a surplus of newly arrived African slaves. By the time social Darwinists, who propagated the idea that whites are a superior race, reached Brazil in the late nineteenth century, it was too late. The nation had so many people with so many skin colors that these "scientists" were stumped. They couldn't agree on where to draw the line between "superior" and "inferior."

Although postcolonial Brazil has never been blind to race, it certainly is more inclusive than multicolored societies like South Africa, India, or the United States. With this sense of acceptance come more than a hundred names for the various skin colors that abound. The term *mulatto* is one, and it doesn't carry the racist undertones it holds in the United States.

ALVERENTA
SHADOW IN THE WATER
PARÁBA
THE COLOR OF MARUPA WOOD
JAMBO
THE DEEP-RED COLOR OF A BLOOD ORANGE
COR-DE-CANELA
TINT OF CINNAMON
MORENA-CASTANHA
CASHEW-LIKE TAN
TRIGUEIRA
WHEAT-COLORED
ROSA-QUEIMADA
BURNISHED ROSE

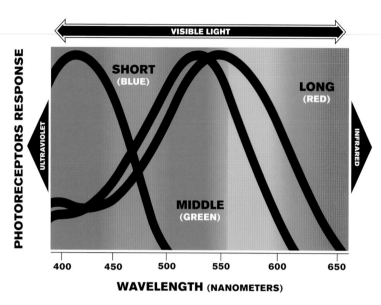

Even though our cones that sense long wavelength light are called our "red" cones, as you can see, their peak sensitivity is at yellow light, and they are least sensitive to red.

our senses are picking up from each kind of cone (or, just as important, what they're not). These comparative computations are what allow us to see colors from red to violet.

Equally amazing is the fact that we can see ten million colors with just three kinds of cones. Our brains' computing abilities are responsible for registering these subtleties, which could easily be overwhelming. It would be terribly confusing to be aware of all the activity in each of our cone types, so our brains simplify the sensations coming in so that we don't have to take up time and energy thinking "orangish red couch with a touch of blue." Instead, we group colors together and simply register the couch as red.

Unfortunately, some people don't have as finely tuned a computing system because they are color-blind. The genes responsible for the development of our photoreceptors live on our X chromosomes, which means that for men, who have only one X chromosome, a mutation in these genes is likely to result in color blindness. Men are much more likely to be color-blind than women. Women have a good shot at having at least one healthy X chromosome—which is all you need for normal color vision—so color blindness is rare in females.

Like many mammals, most color-blind people are red-green color-blind. However, in rare cases, humans can be blue-yellow

The colors we perceive are the result of electrical signals being sent from the cones to our brains. The brain then compares which cones are most active and settles on a color accordingly, brilliantly performing data analysis that computes what exactly

DO YOU SEE WHAT I SEE?

Deuteranopia is the most common form of color blindness. Deutrans and protans both do not see what we call "reds" and "greens," but for different reasons. Deutrans lack the cone sensitive to green light. Protans lack the cone sensitive to red light. Tritans on the other hand, do not see what we call "blues" and "yellows" due to a missing cone that is sensitive to blue light.

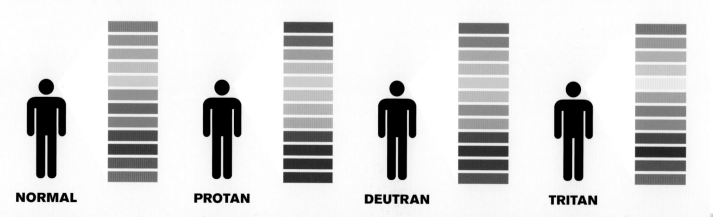

NORMAL PROTAN DEUTRAN TRITAN

Rene Magritte's *The Empire of Light II* perfectly illustrates our rods and cones at work. In the bottom half of this painting, our eyes can detect all sorts of shades of gray, but very few hues and no white (save for the whitish glow emitted from the streetlamp). The sky, on the other hand, seems to have no subtlety of dark and light, just vibrant blue and stark white.

color-blind or completely color-blind, with no functioning cones at all and only the ability to see shades of gray.

There's another possible genetic mutation relating to our cones—this one for women only—but it's an asset rather than a liability: a fourth cone type with extra sensitivity to reds, oranges, and yellows. If you're a woman who has ever gotten into an argument over a color being salmon rather than pink, you just might be one of these mutants.

A HOUSE BUILT ON MILLIONS OF RODS As we've said, rods don't excel at distinguishing between colors, but they are quite good at identifying contrast: what is brighter or duller, as well as the steps from dark to light. Humans are equipped with a far greater number of rods than cones, with approximately six to seven million cones to some 120 million rods. If you want to experience your rods at work, go outside on a clear night and look at the sky. Your cones won't be active because there's too little light

to perceive color, but your rods will be on alert. Search for a dim star, and look directly at it. It will appear dim, but if you look slightly away from it—putting the star in your peripheral visual field—it will appear much brighter. This is because your rods sit on the periphery of your cones and, as a result, gather information from the sides.

THE VISUAL CEMENT OF COLOR CONSTANCY Our rods and cones are continually taking in information, and our brains are continually processing it. For the world to make sense, sometimes our brains need to fill in gaps, do some inventing; the brain might even make up a color entirely if the brain believes the color should be there.

Imagine, for example, that every time you saw a lemon, you had to figure out what color it was. Without your brain's adjustments, this would surely be the case—for on each viewing, in a new kind of light, a lemon's color would change. In the dark, it might appear brown; in the blazing sunlight, it would look quite pale; and by a fire, it would look orange. Our brain knows to recalculate, however, so that we always register the lemon as yellow. This process is called chromatic adaptation or color constancy.

Look at photo (A) below, which has been overlaid with a turquoise filter. Look at the woman who is third from the left. What color would you call her sari?

If your answer is "yellow," you're correct. Here is the original photo without the turquoise filter:

To illustrate the "chromatic adaptation" that your eyes just performed, photo (C) below takes the woman's sari from the first photo and overlays it onto photo (B).

As you can see, the color of her sari in photo (A) is actually green. The reason it looks yellow is that your eyes adjusted to the fact that everything else in the photo looked greener. So in this particular context, the woman's green sari looked yellow.

Our eyes have a tremendous ability to recover from overstimulating experiences. For example, look at the photograph of the airplane below. See how the left side looks like it's been washed over with turquoise and the right with yellow? Now you're going to see how your eyes can make these washes disappear. Stare at the black spot in between the turquoise and yellow squares above the photo for 30 seconds. Then move your eyes down to the black spot on the airplane.

PILL POP OF COLOR

Our brains aren't interested only in keeping colors constant from one kind of light to another. They also like constancy when it comes to things like medication.

If you'd taken a blue pill every day for the past year and you found that your new prescription for the same medication contained pink pills, how would you react? In this situation, 53% of people stop buying the medication, even if their life depends on it—at least that's what a new study claims. Most consumers assume their pills are color-coded for a reason, and if the coding changes, they don't trust that it's the same pill.

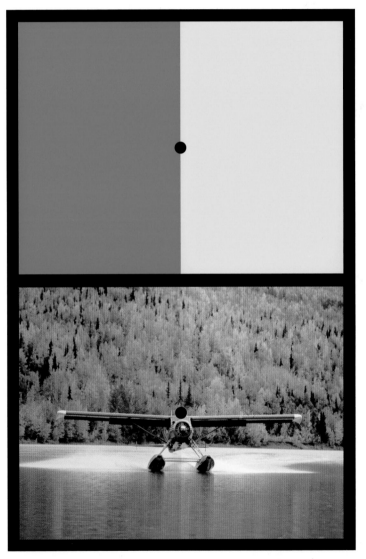

A similar phenomenon happens when you go from very little to very bright light, like when you turn on the light in your room in the middle of the night. At first, everything in the room will appear blindingly bright, but after just a minute or two, your eyes will adjust and everything will look normal again. The same experience occurs when your eyes are bombarded with a lot of color.

If the photo now appears the same on the left- and right-hand sides, your eyes have completed their chromatic adaptation.

THE LANGUAGE OF COLOR

We see in essence not with two eyes, but with three: with the two eyes of the body and with the eye of the mind that is behind them.

—*Franz Delitzsch, 1878*

Our brains are not only taking in all information via our rods and cones, not only interpreting this information based on what they've seen before, not only making adjustments based on the lighting conditions, but also using the language we have for color to help us perceive what we're seeing.

Although every color we see is unique, our brain helpfully groups colors into categories—hues and shades—so we don't have to learn millions of other words to describe them. This way, we're able to communicate quickly and easily what we see to other humans and have them understand what we mean.

The fact is that most humans—and this is true for men even more than for women—lump an uncountable number of colors into a few small groups: turquoise, teal, royal, navy, cornflower. A vast majority of us would describe these as simply blue. Our brain's ability to tease out these shades is simply not evidenced in our language.

Part of the problem is that we didn't always have names for even the basic hues we use today as descriptors. It took humans a long, long time to name the colors of the "rainbow," and not all cultures agree on these fundamental hues. Depending on where you live, the language of color differs. There are still tribes that don't name colors beyond black and white. Instead, they refer

> WE HAVE A SHOCKINGLY SMALL VOCABULARY FOR COLOR CONSIDERING THE SUBTLETIES OF COLORS WE ARE ABLE TO SEE. WRITE DOWN EVERY SINGLE COLOR YOU CAN THINK OF. TAKE ONE MINUTE TO DO IT NOW. GET ANYWHERE CLOSE TO TEN MILLION COLORS?
>
> YOU PROBABLY FOUND IT HARD TO COME UP WITH EVEN TWENTY!

to texture and sheen, as do the Japanese when describing many colors. Do these cultures see less color? Throughout the nineteenth and twentieth centuries, vociferous debates focused on whether language (or lack thereof) revealed a difference in biology. Did the fact that someone described the sky as black mean he couldn't see blue? We now know the answer is a definitive *no*; but what is true is that once we add a color name to our lexicon, the hue seems to come to life. It seems that if we name it, then we talk about it and even see it more often than we ever did before.

We use color imprecisely in language. "Red cabbage" is positively purple. "White wine" is golden. "Black skin" can be any shade of brown.

If you look at the order in which colors got their names, you'll get a sense of how the world was colored in during the time of our ancestors. Black and white are always the first to be named across all cultures. Red comes next. After that, it's a bit of a free-for-all, but typically yellow or green follows, then blue or violet/purple. Colors like orange and pink come much later. Before a new color is named, it is simply grouped with a color that already exists. For example, in the case of blue and green, usually green first served to describe both.

The history of art reveals much about the relationship between language and what we see, especially where paintings of rainbows are concerned. As late as the twelfth century, the arc is portrayed only in red and green, with a band of white running through its center. It wasn't until the Renaissance that rainbows took on additional hues and not until in the eighteenth century—post Newton—that they acquired the bands we name today. Part of this had to do with the availability, or lack thereof, of specific pigments, but it works the other way around, too: awareness of a color was developed partially based on what language was available.

As we said in chapter 1, how the rainbow is broken up, that is, how many hues it is composed of—is an arbitrary human construction. This arbitrariness is particularly evident when you look at the Russian language. In Russian, there are two separate words for

Compare this twelfth-century tri-hued rainbow with Ellsworth Kelly's multi-hued version from his Spectrum series.

They were asked to identify which square, 1 or 2, was the same color as the Master Square. If the color of Square 1 and Square 2 were very different, the subject was easily and quickly able to identify which was the same as the Master Square. If the squares were very close in color, however, it took the subject longer to decide.

Where things got interesting was when Russian subjects participated in the same experiment. If the color of the Master Square and the matching square was in the medium-blue range, it took Russian subjects longer to identify the matching square even if the non-matching square was a much lighter or darker shade of blue.

the "blue" found in most textbooks describing the rainbow today: голубой (*goluboi*), which is light blue, and синий (*sinii*), which is dark blue. This distinction is similar to that between pink and red in English (which, in turn, many cultures do *not* distinguish). Can we prove that language actually influences what we perceive? Might a Russian "see" a different color than an American sees? It turns out that this is probably the case. Recent simple but profound experiments have shown that if we have a name for a color, our brain processes the color differently than if we have no name for it. For example, in one experiment, people were asked to look at three squares like the ones to the right:

Since the shade of the matching squares fell somewhere between *goluboi* and *sinii*, Russian subjects seemed to be confronted with the double-task of making a purely visual choice while also trying to name the color they were seeing.

NAME THAT COLOR

Even those of us who work with color every day don't have anywhere near hundreds of names—let alone thousands or millions—at the tip of our tongues to describe all the colors with which we work. The truth is, color naming has become the realm of the advertising industry. A clever name for a particular shade can activate the parts of our brains that process language to help us "see" and ultimately "buy into" the color.

 The naming of colors became particularly important once the chemical industry took off in the nineteenth century and paint colors of every variation were created. The few words we have for color simply wouldn't suffice for selling all those shades of paint. Pull out a deck of paint swatches today, and you'll see everything from the inspired (chopped dill) to the ridiculous (cat's meow), the latter being a particularly unfathomable shade that neither inspires nor informs.

HOPE SPRINGS? **BRATWURST?** **SCHNAPPS?** **TERRARIUM?** **DOG'S BREATH?** **CUPID'S ARROW?**

Clearly, something more was going on in the brains of the Russians in this experiment. They were "seeing" something that the others were not seeing and this delayed their decision making.

Related experiments have shown similar results. Naming and seeing are interconnected. What we see changes according to whether the language centers of our brains are activated in the seeing.

COMMUNICATING THROUGH COLOR As with our fellow animals, color perception works in tandem with other brain processes to help us decide what to eat, whom to fear, and to whom to be attracted. We humans have been diligent students of nature, learning from nature's example how to use color in our own maps—literal and figurative—and allowing color to guide us so

we can know where we're going, when to stop, when to go, even what to buy. We've created our own color codes, ones that influence nearly every step we take.

MAPS AND DIAGRAMS From subway maps to weather maps to maps of the human genome; from traffic lights to road signs to terrorist alert systems; from Venn diagrams (which reveal the relationships between illustrated objects or concepts) to pie charts (which reveal the relative proportions of various objects or concepts) to flowcharts (which break up projects into steps); from safety color codes to knitting patterns to reflexology charts—we are constantly using color to break down intellectually and reconstruct the world around us.

We've been mapping and diagramming with color since we

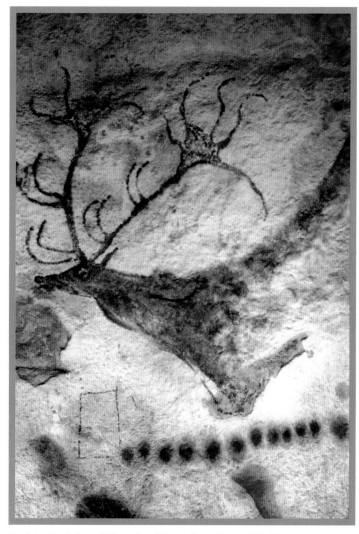

The dots at the bottom of this replica of the paintings of the prehistoric Lascaux cave are an ancient representation of the cosmos.

When few colors were available, or when they were too expensive to use, maps and diagrams weren't as easy to understand as they are today. Color printing truly changed the world of mapping and diagramming forever. With personal computing (not to mention the invention of PowerPoint!), there was no holding anyone back from trying his or her hand at color-coding.

129° IN THE SHADE

A recent example of a color-mapping hurdle drives home how quickly color can communicate a piece of information.

Australia was experiencing record-breaking heat, so record-breaking, the country had no color on their weather maps to represent the span of temperatures it was enduring. We've all seen weather maps that graduate from one part of the rainbow to another to represent hot and cold. The Australian weather forecasters had already used every kind of red to show increasing heat. So they turned to purple—a proper representation of their bruising temperature index, indeed!

first put charcoal to rock. Maps and diagrams have helped us understand how to navigate not just a city or an ocean, but the universe. Even the cave paintings of Lascaux, dating back to before 16,000 BCE, show dots mapping out or diagramming the stars.

Color is a natural component of maps and diagrams. In the history of cartography, it has had two primary purposes: to inform and to decorate. Color allows the viewer to understand what's water, what's land, and how territories are separated. It can transform a diagram from virtually impossible to decipher to clear as day; and it also draws the eye, engaging the viewer aesthetically.

STADIUM TICKETS

MALL OF AMERICA. FIELD

PRICE LEVELS	2013 SEASON TICKETS (PER GAME)	2013 SEASON TICKETS (9 GAMES)	2013 SINGLE GAME TICKETS
	133	1,197	150
	127	1,143	150
	123	1,107	135
	112	1,008	135
	105	945	120
	99	891	120
	82	738	99
	75	675	83
	68	612	78
	54	486	64
	44	396	54
	31	279	41

EULER/VENN DIAGRAM

Yohji Yamamoto

Emilio Pucci

BRIGHTS

NEUTRALS

PASTELS

BLACKS

Vivienne Westwood

Calvin Klein

Alexander McQueen

Georgio Aramani

WANT TO BUY CHEAP SEATS AT A SPORTING MATCH? GET ON THE RIGHT LINE OF THE LONDON UNDERGROUND? LEARN TO TYPE FAST? COLOR IS YOUR GUIDE. THESE COLOR MAPS SHOWS HOW PREVALENT THE USE OF COLOR IS TO EXPLAIN, ELUCIDATE, AND NAVIGATE AT A GLANCE.

TRANSPORTATION MAP

© Transport for London

TOUCH TYPING

† Check before you travel

Bank
Waterloo & City line open between Bank and Waterloo 0621-2148 Mondays to Fridays and 0802-1837 Saturdays. Between Waterloo and Bank 0615-2141 Mondays to Fridays and 0800-1831 Saturdays. Closed Sundays and Public Holidays

Camden Town
Sunday 1300-1730 open for interchange and exit only

Canary Wharf
Step-free interchange between Underground, Canary Wharf DLR and Heron Quays DLR stations at street level

Cannon Street
Open until 2100 Mondays to Fridays and 0730-1930 Saturdays. Closed Sundays and Public Holidays

Edgware Road
Bakerloo line station closed from 25 May until late December 2013

Emirates Greenwich Peninsula and Emirates Royal Docks
Special fares apply. Open 0700-2100 Mondays to Fridays, 0800-2100 Saturdays, 0900-2100 Sundays and 0800-2100 Public Holidays. Opening hours are reduced by one hour in the evening after 1 October 2013 and may be extended on certain events days. Please check close to the time of travel

Hammersmith
No lift service on the District and Piccadilly lines from 12 May until late December 2013

Heron Quays
Step-free interchange between Heron Quays and Canary Wharf Underground station at street level

Hounslow West
Step-free access for manual wheelchair users only

Turnham Green
Served by Piccadilly line trains until 0650 Monday to Saturday, 0745 Sunday and after 2230 every evening. At other times use District line

Waterloo
Waterloo & City line open between Bank and Waterloo 0621-2148 Mondays to Fridays and 0802-1837 Saturdays. Between Waterloo and Bank 0615-2141 Mondays to Fridays and 0800-1831 Saturdays. Closed Sundays and Public Holidays

West India Quay
Not served by DLR trains from Bank towards Lewisham before 2100 on Mondays to Fridays

Key to lines

- Bakerloo
- Central
- Circle
- District
- District open weekends, public holidays and some Olympia events
- Hammersmith & City
- Jubilee
- Metropolitan
- Northern
- Piccadilly
- Victoria
- Waterloo & City
- DLR
- London Overground
- Emirates Air Line

This diagram is an evolution of the original design conceived in 1931 by Harry Beck
Correct at time of going to print, May 2013

SAFETY GUIDE

EMERGENCY
Use **RED** for fire protection equipment and apparatus, danger and stop.

WARNING
Use **ORANGE** for dangerous parts of machines or energized equipment.

CAUTION
Use **YELLOW** for caution and for marking physical hazards.

SAFETY EQUIPMENT
Use **GREEN** for safety and First Aid equipment.

SAFETY INFORMATION
Use **BLUE** for safety information used on informational signs and bulletin boards.

TRAFFIC/HOUSEKEEPING
Use **BLACK & WHITE** to designate traffic and housekeeping markings.

RADIATION
Use **PURPLE** to designate radiation hazards.

MECHANICAL DIAGRAM

A Petrol Circuit

B LPG High Pressure Circuit

B1 LPG Low Pressure Vapour

C Vapouriser Heating Circuit

D LPG Electric Circuit

1 LPG/ Petrol Switch
2 LPG ECU
3 LPG Tank
4 LPG Vapouriser
5 Petrol Tank
6 LPG Filler Valve
7 Petrol Filler
8 LPG Control Relay
9 Petrol Injectors
10 LPG Distributor
11 Petrol ECU
12 LPG Inlet Solenoid
13 LPG Fuel Gauge
14 LPG Outlet Solenoid

PIE (THAT PEOPLE LIKE) CHART

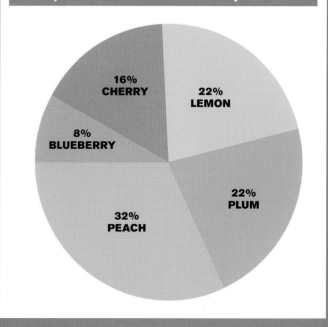

- 16% CHERRY
- 22% LEMON
- 8% BLUEBERRY
- 22% PLUM
- 32% PEACH

RED STATES AND PINK STATES

When using color to map concepts, it matters how the color is implemented. As a completely hypothetical example, a gradient map (left) is a much better way to represent degrees of the same thing–like whether people like pie a little or a lot. The shades of color correspond to the amount of enjoyment people can have for pie. The map becomes less clear at a glance when the degree of pie appreciation is represented by a spectrum of color (right).

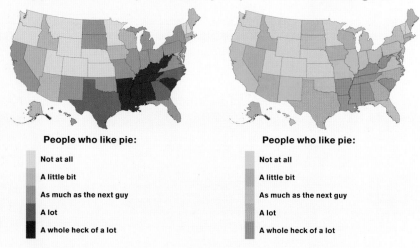

People who like pie:

Not at all

A little bit

As much as the next guy

A lot

A whole heck of a lot

People who like pie:

Not at all

A little bit

As much as the next guy

A lot

A whole heck of a lot

By contrast, it can be more effective to use a spectrum map (left) to represent the various types of pie that people enjoy most by state. Here the colors correspond to different kinds of pie. We can see at a glance in which states lemon pie (yellow) is the favorite. With a gradient map (right) the shades are less intuitive and the viewer may have to refer to the key more often.

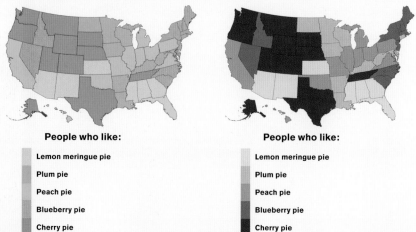

People who like:

Lemon meringue pie

Plum pie

Peach pie

Blueberry pie

Cherry pie

People who like:

Lemon meringue pie

Plum pie

Peach pie

Blueberry pie

Cherry pie

Medievalist/artist Hilarie Cornwell recreates medieval flags using the tinctures that populated battlefields back when these colors were one of the only ways to identify friend or foe.

FLAGS Color as a tool became even more widespread in the Middle Ages when flags became a part of the culture. Their function in medieval heraldry was to differentiate enemies on battlefields that were plagued with smoke, mud, and fog that tended to obscure all but the boldest and simplest of designs. In the interest of clarity, only seven tinctures were used: red, green, blue, purple, and black (known as the "colors"), plus yellow/gold and white/silver (known as the "metals"). This simple color palette worked to everyone's advantage because it allowed for a variety of colors that couldn't be mistaken for other colors. Translation: You didn't end up dead.

In the years since, academics have attributed all sorts of meaning to the colors used in heraldry, but no one can agree on these meanings or on whether they really meant anything at all. Possible hidden meanings aside, the primary purpose of these flags was to inform—but their beauty makes it clear that artistry was on the flag-makers' minds as well.

Since those times, flags have been used to represent countries, sport teams, religions, and political affiliations. Some are coded for information, as on football fields, ships, and railroads.

Others are used for unifying purposes, as in country flags or the flags of political movements.

THE COLORS OF OUR SECOND SKINS In the Middle Ages, not only were flags used to define or identify, but clothing played this role as well. Dyes for clothing could cost a fortune. The more expensive colors, as logic would have it, were limited to the upper classes, but some members of the upper crust weren't satisfied with this level of exclusivity. Roman and Chinese emperors and African nobility had been decreeing for centuries who got to wear what, but it was the medieval Europeans who developed sumptuary laws (laws related to personal expenditure) that defined who got to wear what color, how much of it, and when. These were serious, not-to-be-messed-with laws, laws that, if trifled with, might result in your head on a plate. Laws regarding color and fashion were equal to laws against treason, murder, or other grave crimes.

The color of clothing helped establish not only class but also occupation. If you were a member of a particular clergy, the color of your dress communicated what position you held in the church. The same was true for the military, where the color of your uniform was determined by the division in which you served and sometimes your rank as well. The striking red of a cardinal's robes or the solid navy of a sailor's uniform gave information that helped guide how they were greeted and treated when encountered by others.

Our clothing remains an important expression of who we are. We continue to map out how we see ourselves in the world and how we want others to perceive us through our second skins.

The colors of military uniforms—from their overall hue to their colored details—clearly differentiate everything from military divisions to rank.

There's nothing like color to signal brand. Whether the colors of these logos signal particular psychological states (dependability, fun, environmentally-friendly) has yet to be scientifically proven (contrary to claims you'll find on the internet). But we certainly come to know a brand by its color, which is why so many brands spend so much money trying to find that perfect hue.

THE COLOR MAKES THE BRAND Most of the time when you reach into a cooler at your local supermarket, you don't even have to look at the name on the soda can to know that you've gotten what you want. How important is color to a brand? Ask Coca-Cola, Tiffany's, or United Parcel Service, companies that have spent bundles trademarking and protecting the color they consider theirs and theirs alone. For each of these companies and many others, color defines its brand.

As with all other color-coding, the use of color on products and logos is part informational, part aesthetic. On the purely informational side, the color of a can of soda might indicate the flavor contained within: yellow = lemon, orange = orange, red = cherry. Or it might indicate the size of a container: yellow = small, orange = medium, red = large. Color is also used to

Carnival, The Parade of Bands, Port of Spain, Trinidad, West Indies

Pentecostes Festival, Ollantaytambo, Peru

Tang Dynasty Performance, Willow Dance, Shaanxi Province, China

Heilala Festival, Tongatapu Island, Tonga

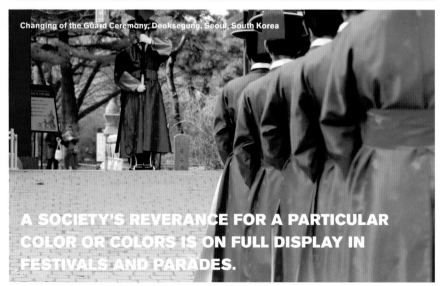

Changing of the Guard Ceremony, Deoksegung, Seoul, South Korea

A SOCIETY'S REVERANCE FOR A PARTICULAR COLOR OR COLORS IS ON FULL DISPLAY IN FESTIVALS AND PARADES.

Lent, Antigua, Guatemala

Grand Durbar Parades of Horsemen, Kaduna, Nigeria

Mudmen at Goroka Highland Show, Papua New Guinea

Feria de Abril, Sevilla, Spain

Royal Palace Changing of the Guard, Gamla Stan, Stockholm, Sweden

Holi Festival, Mathura, Uttar Pradesh, India

Arirang Festival, Pyongyang

express more general information—the brown of the Hershey's wrapper (indicating chocolate inside) or the green of John Deere's logo (indicating the green pastures you'll be sowing). In the aesthetics department, color is used to attract a potential buyer's eye and to fill that potential buyer with brand-appropriate associations—think of Tiffany's iconic and elegant aqua. Often, colors fulfill all of these functions simultaneously.

How do you choose a color for a mobile phone company? A national retailer? A new sports team? How does a women's clothing company pick the colors for its fall line? Why does it even matter? Won't any nice color or colors do? If history tells us anything, it's that certain powerful people make decisions about color and consumers follow along like colored sheep. Therefore, companies are terrified of making a wrong decision about color. The wrong color of a car could mean a balance sheet that's in the red. The right shade of red, and you're in the black. Everything from Prada's new line of handbags to a bag of M&Ms has a palette. And while the highest end of fashion has always created its own palettes (which then trickle down to mainstream stores like JCPenney and Target a lot faster than you might think), numerous industries are dependent on a twentieth-century creation: the color forecaster. These are individuals or groups who sit down months in advance of when a product will come to market to figure out the next big colors; the ones that are going to elicit that flocking response that a perfectly pink flower does for butterflies, which leads us right back to those amazing maps nature has laid out for us—to help us find food, find a mate, and survive. Only now, in contemporary life, this translated to finding the right soda, a husband or wife who dresses in a way that doesn't embarrass you, and surviving a car salesman's attempt to get you to buy the only color left on the lot when you want the color that sold out first. Color keeps informing, and we continue to take its cues.

PALETTES THROUGH THE AGES

If we look at palettes through a historical lens, we are given a code to that particular culture. Color palettes can speak to the nature of a place, to the people who inhabited it, and to the values they held.

GRECO ROMAN, POMPEIIAN

This palette was borrowed from a fragment of a painted wall of the Casa delle Suonatrici, in Pompeii, Italy and dated 69-79 AD in the House of Marcus Lucretius room.

MEXICAN

Although the spanish decimated native art, Indian palettes survived. Their rich and complex tones live on.

INDIAN ILLUMINATION

Inspired by The Illumination of Krishna Lifts the Mount Govardhan, from Razmnamah in the Mugha period of Jabangir (1605 – 1627), this palette incorporates the bright jewel tones we associate with Indian culture–whether via the silks used for saris or the flying powders of Holi Festival.

SWEDISH ROOTS

Sweden's rural roots show off in this naturalistic and clean palette. Balance and coolness paired with the colors that shape the Swedish landscape evoke the kind of practicality and elegance the Nordic people are known for.

ENGLISH VICTORIAN

Queen Victoria was not known for her sense of humor or bright colors. She and her kingdom preferred more subdued tones. But, mauve made its debut during Victoria's reign and made its mark on the palette.

AMERICAN SAMPLER

Children chose the colors for most American samplers in the eighteenth and nineteenth centuries. These happy, utilitarian tones seem to speak to the overall American spirit of the time.

FROM THE CAPS ON JUICE CARTONS TO THE LABELS ON YOGURT CONTAINERS, COLOR CODING HELPS US DECIPHER WHAT'S INSIDE EVEN IF WE DON'T KNOW THE LANGUAGE.

Is there any color more extraordinary, exquisite, exalted, delicious, delectable, desirable, more *je ne sais quoi?* The color just seems to call for prose that's purple.

Purple speaks of high places; it's been associated with royalty for centuries—and for good reason. Nature did not provide an easy means of dying fabric purple. Historically, the production of the dye was one of the most noxious, laborious, time-consuming, and expensive processes around. Only the rich could afford it, and aside from Kings' robes and priests' stoles, the hue was hard to attain. Those who wore it certainly did so with pomp and circumstance. No shrinking violets in the courts.

You say purple, we say violet. In everyday use, the words *purple* and *violet* are interchangeable. But in the world of color, violet and purple are not one and the same.

Purple isn't a mixture of blue and red light. Violet is a spectral color unto itself—a wavelength in the form of visible light—and the shortest wavelength visible to humans. It lies at the opposite end of the visible spectrum from the color we perceive as red, which boasts the spectrum's longest wavelength.

This perplexing concept is best explained via metaphor. Imagine a city block comprising six connected townhouses. Townhouses one and two share a wall, as do two and three,

three and four, and so on. The townhouses are all connected, but townhouse one and six are not connected, in the same way that red, at one end of the visible spectrum is not connected to violet, at the other end.

It's easy to show this by watching light pass through a prism and land on a surface. You will see red-orange, orange-yellow, yellow-green, green-blue, and blue-violet hues reflected onto the surface. Unlike on a color wheel, you will not see red-violet in the form of visible light. Red sits all the way at one end of the spectrum and violet on the other. If they're not next to each other, they can't mix.

Sadly, this recipe, which uses a mere thousand mollusks, will dye only one cloak; you'd need approximately 250,000 mollusks to make just one whole ounce of Tyrian purple dye. With a process this complicated, this time-consuming, this outrageously expensive (Tyrian sold for 10 to 20 times its weight in gold), and this putrid, it's no wonder the color was reserved for royalty and alternatively named "royal purple."

TYRIAN PURPLE

Ingredients:
1,000 MOLLUSKS
WATER
WOOD ASH
WHITE CLOTH FOR DYING

Directions:
Preheat hearth.

One by one, hit each mollusk with a hammer to open its hypobranchial gland. (This gland contains the precious drops of liquid from which the dye will take its brilliant color.) Make sure to hit the shell hard enough so that the liquid is exposed to air, allowing it to oxidize and preparing it for the dye-making process.

Place pigment into large pot.

Add water and wood ash (for alkali). Cover tightly, ensuring that no light can enter and break down the dye. (Light would remove all of the red and turn the dye blue.)

Place over the stove, and allow the mixture to ferment for 10 days.

Remove lid. Place cloth in dye.

Watch cloth magically turn from white to green to a brilliant shade of purple.

Tyrian purple dyes span a wide range of "purple." As you can see, it can even create a very bright blue.

A wide, and beautiful, variety of the Murex species.

HOW TO MAKE TYRIAN PURPLE The ancient Greeks credit the Phoenician god Melqart for the magnificently purple Tyrian dye. The myth goes something like this: Melqart finds his dog lapping up mollusks on the beach. Startled, he notices that his dog's mouth has turned a brilliant shade of purple. At the sight of the beautiful color, Melqart's nymph, Tyrus, demands something just as lovely—in exchange for her hand. So Melqart dutifully gathers mollusks and has them turned into a dye he applies to a piece of silk as a gift for Tyrus. Named for the nymph herself or for Tyre, the Pheonician port town where she lived (now part of Lebanon), Tyrian purple is truly mythic and has been mentioned in writing as early as 1600 BC. To the right, is what the dye's ancient recipe might have looked like.

Seeing the value of their invention, Phoenicians kept the origins and recipe of their dye a secret for centuries. Then, in 60 AD, Pliny the Elder described the source and the method of the dye in his *Natural History*. The secret was out, and the Roman Empire wasn't happy. So in the first century, Emperor Nero decreed that only he could wear the color. The punishment if you were found wearing purple? Death.

PURPLE REIGN

After Nero's reign, the law loosened up, but the amount of purple one could wear was still restricted and depended on one's rank. Generals who had won a battle sported purple and gold robes. Senators wore broad stripes of purple on their tunics. Knights and other luminaries wore thinner purple stripes. Among the great purple wearers of history, you'll find Egyptian Pharaohs, European royalty, and Alexander the Great.

Then, in 1453, an unfortunate event occurred: Constantinople fell to the Turks, and in the fall the recipe for Tyrian purple was lost. It wasn't until two centuries later that the instructions were rediscovered, and kings and queens took up their purple cloaks once again.

THE ART OF PURPLE PROSE The connection between royalty and the color purple was so strong that the very word *purple* became a descriptor for all things aristocratic, opulent, or even overdone, as in the case of the expression *purple prose*. The Roman poet Horace coined the term back in 18 BC, and his definition survives to this day: writing that is over-the-top flamboyant, that uses ornate language when simplicity is called for. Of course, Horace put this much more poetically in his book *The Art of Poetry*:

> *Your opening shows great promise,*
> *and yet flashy purple patches; as when*
> *describing a sacred grove, or the altar of Diana,*
> *or a stream meandering through fields,*
> *or the river Rhine, or a rainbow;*
> *but this was not the place for them.*
> *If you can realistically render a cypress tree,*
> *would you include one when commissioned*
> *to paint a sailor in the midst of a shipwreck?*

Today, purple prose abounds in romance novels and tabloids, but the broader meaning of purple as an adjective has faded from our vocabularies. As purple became available to the masses, its associations with all things elite and sumptuous became obsolete.

Gentian violet is used here to stain cells infected with the Polio virus.

A SPRINKLING OF GENTIAN VIOLET Gentian violet helps cure everything from thrush to athlete's foot, from abrasions to indigestion. As a stain, it can make cells come into focus and

fingerprints magically appear or even reveal the pH balance of a substance. And should you decide to get your tongue pierced, your choice of location may be marked by this multifaceted gift of nature so that the piercing ends up exactly where you want it.

Gentian violet (aka crystal violet for its crystalline form) comes from the *Gentiana lutea,* a plant with a bright green leaf and a clustered yellow flower. It's hard to believe that a violet color so intense could come from this sweetly yellow plant's root. But indeed, the root supplies the electric purple-blue that you'll find in this part-time medication, part-time dye.

Perkin's original mauve dye.

A dress dyed with Perkin's mauve dye.

THE ALCHEMY OF MAUVE In 1856, chemist William Perkin made a mistake that changed the world forever. A teenager at the Royal Academy of Chemistry, he was charged with creating synthetic quinine, the substance that gives tonic water its antimalarial qualities and bitter taste. But his experiment went awry: All he ended up with was some purplish-pinkish-brownish sludge.

Perkin started over, this time using an organic compound called aniline. Once oxidized, his aniline turned into a black mass. Dissolved, the resulting solution had taken on a purplish hue. Curious, Perkin dipped in a piece of cloth; to his delight, the color not only took but retained it over time.

In a world beholden to natural dyes that were expensive to create and prone to fading, Perkin knew he was onto something, and he set out on the project of producing this new dye cheaply and in large quantities. Before long, chemists all over Europe were using aniline as a base for all kinds of new dyes, including lovely

magenta. Within a few decades, approximately two synthetic dyes were available, taking the place of comp expensive and difficult-to-produce natural dyes tha used for centuries.

Because mauve had the honor of being the produced synthetic dye, it made waves. The dour b Queen Victoria wore it to her daughter's wedding. British humor magazine, *Punch,* diagnosed a case o measles" taking over London. Unlike the color cr owned by the courts and the aristocracy, this tren sible to the masses.

The creation of this synthetic dye would have plishment enough for young Perkin, as would h of the next mega-dye, the synthetic alizarin re cidentally made him far richer than mauve had, he missed his patent deadline by a single day) or

cents, which led to the modern
ork led to something far greater
successes: a new kind of alche-
modern chemistry. Because of
onomic success (which proved
e), scientists who followed in
te a whole host of medications
edicine, including Novocain,
name a very few. Unfortu-
cientific discoveries, its sub-
ientists were not always for
arfare, and life-threatening
mauve. When World War II
ere at the disposal of the
the chemical industry and
t to enhance the color of
heir scents, but to kill via
ds.

thousand
arably few
t had been

first mass-
t imposing
The famous
the "mauve
azes of yore,
was acces-

been accom-
is discovery
d (which in-
even though
his discovery

Perkin did not live long enough to see the seeds of his work
planted and cultivated by the evil hands of Nazis. But hopefully
he was able to foresee the good his lovely purple dye did not just
for the eyes, but for the health and wealth of future generations.

THE ULTRAVIOLET EFFECT Ultraviolet isn't actually a form of
violet; its wavelength lies somewhere between that of violet
and x-rays. Although it is invisible to humans (many birds
and insects can see it), it plays an important role in our lives.

There are ultraviolet rays in the sunlight that beams down on
us. We absorb these rays to the detriment of our DNA, particularly
for those with lighter skin, as sensitivity to ultraviolet rays can
lead to skin cancer. Evolution has endowed people in sun-rich
countries like Africa with the pigment melanin, which turns
more of the rays into harmless heat. Regardless of skin color,
we all develop a suntan in reaction to ultraviolet exposure,
temporarily increasing our melanin to help dissipate the damage
caused to our skin cells by the sun's rays.

endors offering UV body painting. From dragons to butterflies to the 7-Eleven logo, you'll light up under the moon.

Ultraviolet light not only heightens the mood of a party, but also comes in handy in genetic research. These vials are filled with fluorescent dyes that help detect DNA.

persistent smell of cat pee is coming from? You might want to run out and buy a black light.)

A PILLAR OF AMETHYST The mineral quartz comes in many colors, but amethyst is considered the most beautiful of all its varieties. The six-sided prismatic crystal is *vitreous*—the word gemologists use to describe a stone that reflects light like glass—with a structure that calls to mind a cityscape, low-lying clusters of small buildings interrupted by the occasional skyscraper.

Amethyst's color is determined by the quantity and structure of the iron impurities it contains. Its "purpleness" can become more or less intense, and it can even turn a green hue, at which point it is called citrine, depending on how the impurities are distributed; amazingly, heating amethyst to a high enough temperature reorganizes the impurities, turning the green back to purple. Today this heating technique is used to darken pale amethysts to increase their value.

Amethyst owes its names to the Greeks, who called the mineral *Amethustos,* "not drunken." God of wine Dionysius, the Greek myth goes, was infuriated by a mortal who had had the temerity to insult him. So angry was he that he declared he would take revenge on the next mortal who came his way. Enter Amethyst, an innocent girl who strays into Dionysius's path on her way to honor the goddess Diana. Diana, sizing up the situation, knew she had to make a quick move to save Amethyst from the tigers Dionysius had planted to kill her. She used her powers to turn Amethyst into a statue made out of magnificent purple quartz. When Dionysius sees Amethyst's beauty, he cries tears of wine for his bad behavior. And for centuries, Amethyst was honored by the Greeks as one of nature's most amazing creations.

The mythic stone was prized across many other cultures and religions as well. Amethysts were worn by ancient Israeli high priests; buried with Anglo-Saxons, who cherished amethyst beads; and held up as the prize of all stones by Catherine the Great. The Greeks believed that if you drank wine out of an amethyst cup, you couldn't get drunk. Medieval Europeans thought amethyst would protect you in battle and keep you calm, cool, and collected, and New Age philosophy claims that the stone opens the mind and shifts consciousness.

Sadly, this beautiful mineral, once considered a precious gem in the same class as diamonds, rubies, and emeralds, has taken a fall. In the nineteenth century, amethyst was downgraded to semiprecious status when vast reserves of the stone were discovered in South America.

The ultraviolet ray isn't one-dimensional, however. It also has health benefits, spurring the creation of vitamin D, a substance that helps our bones, our immune system, and possibly our longevity.

Ultraviolet rays have other beneficial qualities, one particularly helpful example of which is found in black light, which emits ultraviolet radiation and a small amount of purplish visible light. Readers whose memory banks stretch back to the 1970s will recall a preponderance of groovy glowing posters that were visible only when exposed to a happening black light, with all nongroovy incandescent and fluorescent lights turned off. That glow will also be familiar to anyone who's been to a club or concert and had his hand stamped with "invisible" ink—invisible, that is, until a bouncer shines a black light and the stamp suddenly appears. Black light has daytime uses, too: a number of medical ailments can be detected through a similar application of its rays, among them ringworm, scabies, alopecia, and many other skin problems.

In the forensic world, it's a star. Art authenticators use black light to determine whether a work has been attributed to the right period and artist—and in some cases, whether it's a fake. Black light is used to authenticate money: Shine it on a hundred-dollar bill and ferret out the counterfeiters. At crime scenes, it can be used to detect blood. In homes across the land, it can be used to sniff out urine. (Can't tell where the

ONCE CONSIDERED AS PRECIOUS
AS DIAMONDS, THE ABUNDANT
AND EASILY-MINED AMETHYST
IS NOW, WHILE STILL BEAUTIFUL,
ONLY A SEMIPRECIOUS GEM.

WHY LENT IS PURPLE

They put a purple robe on Jesus, made a crown out of thorny branches, and put it on his head.

—Mark 15:17

Many Catholic churches, during Lent, drape their altars in purple. Yet, in the Bible, purple is often associated with the rich and profligate. So it's an interesting twist to find Lent, a holiday that asks its observers to fast and give up luxuries, represented by the color purple.

Scholars have come up with a number of explanations for this conundrum, among them the notion that purple has been associated with mourning and bruising. In light of purple's royal connotations, one explanation is particularly intriguing: In the Bible, Pontius Pilate and his minions cloak Jesus in a purple robe before he is crucified. They do this to mock Jesus, to show how far he is from being next in line for the throne of David, to dethrone him as Messiah. But, following a tradition in which religions, minority groups, and even nations have reclaimed dark symbols from traumatic historical events, the Christian church embraced purple.

Pope John Paul II on Ash Wednesday, which marks the beginning of Lent.

Today's Purple Heart.

PURPLE-HEARTED Created by General George Washington in 1782, the Purple Heart was the first medal of honor awarded to enlisted men and noncommissioned officers in the American army regardless of their rank; up until this time, medals were reserved for the high-ranking, and Washington created the medal for "any singularly meritorious action." He designed the medal as a "Figure of a Heart in Purple Cloth or Silk edged with narrow Lace or Binding." In other words, the first Purple Heart looked like a nice patch.

New criteria, introduced in 1932, stated the qualification most of us associate with the award: the soldier must have been wounded by the enemy. Eligibility was expanded through the years to include the navy, marines, and coast guards, and finally by the order of President Kennedy, "any civilian national of the United States."

Today the Purple Heart is indeed a medal made of metal, bronze, to be exact, with a purple enameled George Washington head and a purple ribbon. Why purple? There is no historical record, but one can only suspect that the color's royal bearing, its majestic, noble qualities made it the natural choice to honor those who acted so bravely and honorably.

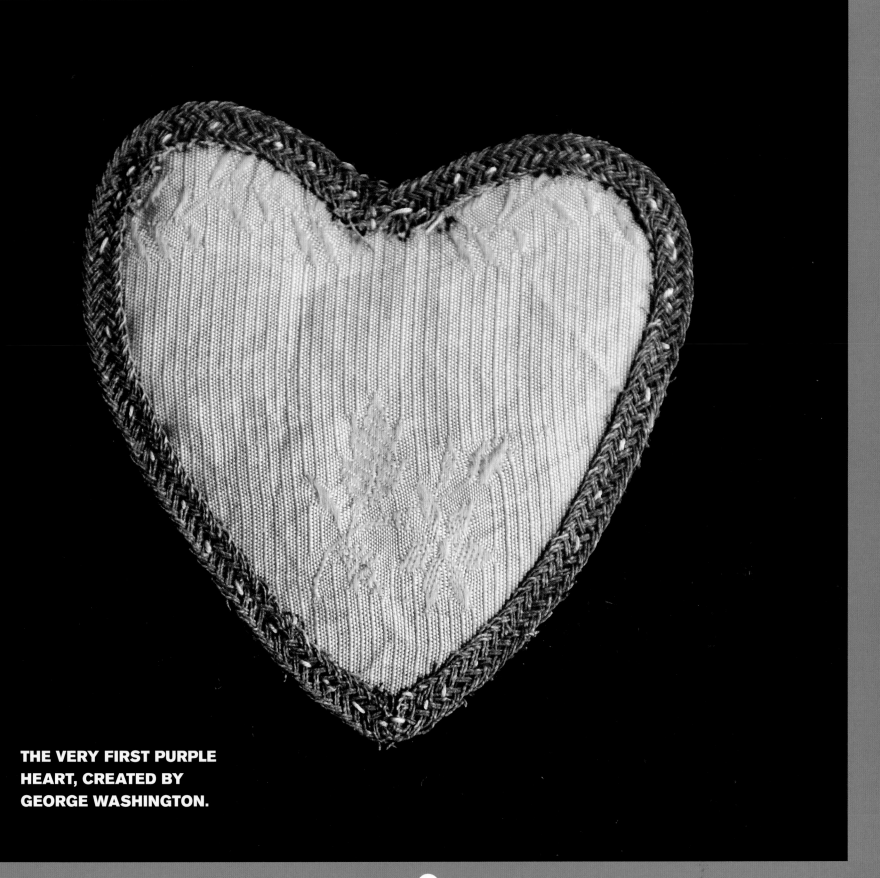

THE VERY FIRST PURPLE
HEART, CREATED BY
GEORGE WASHINGTON.

AFTERWORD

THE FUTURE OF COLOR The history of art and artists, and their relationship with color, has appeared throughout this book, and if there's one group of people who have a particularly intimate relationship with color, it's artists. Not only do they actively use color, but throughout history, they were often the ones creating it as well. As we mentioned in chapter 1, artists were the chemists who invented new pigments that allowed them to mirror and recreate the world through their art. From the very beginnings of art as we know it, where the palette was probably limited to only charcoal, red ochre, and yellow ochre; to the palettes developed throughout ancient Greece and Egypt, China, and India; to the blossoming of color in the Renaissance; and the explosion of color in the nineteenth century, artists did their best to depict the world by using color as an essential tool.

It is through the use of color in art and design that we came to write this book. So it might seem strange that we haven't devoted at least an entire chapter (let alone an entire book!) to the subject. What we came to realize in the process of writing *The Secret Language of Color* is that art is the first place most people go when talking about color. Much has been written about the subject and just walking in an art museum can be an education unto itself; but the science, nature, history, culture, and beauty of color are not obvious. Most living artists do not even know how or why color works. Scientists have taken over the realm of color science, and there's not a lot of conversation going on between the two disciplines.

We also began to see art as another kind of map—not so different from the maps nature has provided for us or from those we have created for ourselves. Think of those caves at Lascaux, where a map of the stars sets alongside those prehistoric animal drawings. The art and the map share the same space, are part of the same message. Look at Egyptian hieroglyphics, in which art and information forge a perfect bond, or Chinese calligraphy, where the information contained in the written word itself became art.

Eventually, the disciplines of art making and mapmaking branched off from each other; but one could argue that the desire to make sense of the world, to map it out, is still at the root of our art. And color remains an extraordinary tool to express this desire—a tool, we may add, that is now accessible to anyone with a computer or anyone with a few bucks in their pocket and access to an art supply store.

Today, with our knowledge of how and why we see color, art and science can once again be fused. We hope that by writing this book, we have helped to bridge the gap. We hope artists have appreciated the science and scientists the art. And we hope that no matter what brought you to this book—a love of art, a love of nature, a love of the color blue—we've helped broaden your color horizons, that we've shined a light on a select number of the uncountable things that color encompasses, that we've given an idea of why and how this narrow band of electromagnetic radiation has such a profound effect on how we communicate with each other and how much we share with our fellow animals, plants, earth and universe. We hope you'll see how much our at once amazingly abundant and ridiculously limited human vision has colored our worlds (for better and for worse!). As Paul Cezanne so perfectly said, "Color is the place where our brain and the universe meet."

Neo-Realist Yves Klein shocked the world by painting just a field of color—one color and that's all—but this field was composed of a pigment Klein the chemist created himself.

ACKNOWLEDGMENTS

Writing this book was a crazy wonderful experience. Crazy because it took so much more work and time than we ever expected. Wonderful because the generosity of those we worked with and interviewed was beyond anything we ever expected. For that reason, we have a long list of people to thank. Here goes:

We'd like to start by thanking the person who has clocked in too many hours to count on behalf of our book and ourselves; the person who has been there to guide us, assist us, champion us, cheerlead us; and who has helped make this book far better than it would've been without her savvy, attention to detail, and big brain. That person is our fabulous editor, Becky Koh. J.P. Leventhal, our publisher, saw a potential in this book that we didn't even see and had the wisdom to team us up with Becky. His vision and experience have been instrumental not just in the scope of this book, but also in its beauty. Savannah Ashour, our overly talented and laugh-out-loud funny line editor added beauty, grace, fluidity, and love of language into these pages. Patrick DiJusto, our editorial closer, not only made sure we got our science right, but also that we made it readable and engaging. Bonnie Siegler, founder of Eight and a Half, her lead designer Andrew Capelli, along with Kristen Ren, Bryan Lavery, and Lucy Andersen, turned our manuscript into an exquisite book whose pages beg to be turned. Their ingenuity, aesthetic prowess, imagination, funny bones, and creativity are unrivaled. Jim Levine, our agent and dear friend, was there for us from idea onward. Stephanie Sorenson is the rare publicist who is both a joy to work with as well as a creative force. Pamela Schechter handled the production of this behemoth with calm and grace. Maureen Winter was a sales dynamo. Steven Pace and the rest of the sales team at Workman Publishing can never be bowed down to enough. They are the best in the biz. Dudley Reed and Betty Reed somehow managed to make us both look not just decent but inviting in our author photo. Dudley is a master photographer whose work constantly surprises and delights us. Masayo Ozawa created original—and stunning—design concepts that helped us and the Black Dog & Leventhal team envision what this book could be. Jennifer Jeffries guided us through the vast Getty archives. Wendy Missan took on her photo research like a bloodhound on a trail. Many of the beautiful and informative photos in this book are due to Wendy's mad research skills. Doug Hill's early edits helped us get a clear handle of what was working as well as what wasn't. Don Smith, Associate Professor of Physics at Guilford College, gave us the class on astrophysics we should have taken in college—and what a teacher he is! John Goldsmith, physicist/laser jock at Sandia National Laboratories, took us through the basic laws of physics as they relate to light, enlightening us as he did so. Matthew Kissel who is getting his Ph.D. in Optical/Electrical Engineering at UC Santa Cruz took the time to explain key optical concepts. Robert Hurt, a Spitzer Visualization Scientist at IPAC/Caltech, elegantly framed key color concepts and shared his amazingly accessible explanations of true and "false" color in photographs of space. Chemist Eric Thaler helped us understand the chemical nature of color. Scott Swartzwelder, Professor of Psychiatry and Behavioral Sciences at Duke University, helped us understand how the brain senses and perceives color. Geologist William Rowe helped us understand the world of minerals and color. John Haines, mycologist and Curator Emeritus at The New York State Museum, helped us understand the world of fungi and color. William Bryant Logan, author of one of the most extraordinary books on the natural world—*Dirt: The Ecstatic Skin of the Earth*—helped us understand the world of soil. Scott Mori, the Nathaniel Lord Britton Curator of Botany at The New York Botanical Garden, helped us understand the world of plants, birds and insects as they relate to color. Our wonderful niece/cousin Mallory Eckstut, who just completed her Ph.D. in Evolutionary Ecology and Biogeography helped us understand the world of animals and color (all her childhood pet rescues clearly paid off). John Endler, Professor of Sensory Ecology and Evolution at Deakin University, kindly, patiently, and so generously explained the world of guppies (and hung in there until we got everything just right). Paul Sweet and his team of ornithologists at the American National Museum of Natural History helped us understand the world of birds and color. Gary Williams, Curator, Department of Invertebrate Zoology and Geology at the California Academy of Sciences, helped us understand the world under water as it relates to color. Colleen Schaffner, a primatologist at the Instituto de Neuroetologia at the Universidad Veracruzana in Xalapa Mexico, explained the primate relationship to color as well as read and edited our animal pages. Entomologist Stephen Lew got out his fine-tooth comb and his poet's aesthetic to help us refine our take on the animal world. Joan Grubin, an artist who is doing revolutionary work with color, helped us hone our words and thoughts on color and art post-Chevreul. Talat Halman, Associate Professor of Religion at Central Michigan University, taught us all about green men, as well as about Islam and the color green. James and Hilarie Cornwell, author of *Saints, Signs and Symbols: The Symbolic Language of Christian Art,* explained the world of heraldry and color. Katie Caprio proves that everyone needs a great librarian in her life. Thanks to Katie and the Rensselaerville Library we got access to rare and valuable books from all over the country. Burt Visotzky, Appleman Professor of Midrash and Interreligious Studies at The Jewish Theological Seminary, elucidated techelet and the meaning of blue in the Hebrew Bible. Jeff Watt, Director of Himalayan Art, taught us about color and Buddhism. Russell Foster, Head, Nuffield Laboratory of Ophthalmology, University of Oxford, explained how blue light affects our brains (and edited our text to make sure we got the science just right). Ellie Rose, M.D., William Parker, M.D. and Melissa Resnick, Msn, CNM made sure we had our bilirubin facts checked. Leslie Harrington, Executive Director of The Color Association of the United States, opened up her amazing library and was wonderfully supportive throughout the process. Margot Sage-El and Gayle Shanks—two of the shining stars of independent bookselling—helped us get our cover right. Grace Grund and her team at Terra Tea Salon fed us delicious, Fair Trade lunches and teas as we conceived of, wrote, and launched this book.

Last, but definitely not least, David Henry Sterry, husband and son-in-law extraordinaire, not only helped with every stage of this project, but put up with months and months of nonstop work on this book and did more loads of laundry than any writer ever should.

There are many, many others who helped us with this book. But if we went on and on, we'd have a book unto itself. So here's a shout out to some of the great folks who steered us in the right direction. Apologies for anyone we missed.

Tamim Ansary, Chris Butler, Ginny Carter, John Cloud, Joe Durepos, Bob Durst, Bob Fosbury, David Frail, Richard Goldstein, Theodore Gray, Greg Grether, Roger Hanlon, Jenny Herdman Lando, Kimberly Hughes, Paula Krulak, Taylor Lockwood, Ayesha Mattu, Kalpana Mohan, Jim Myers, Ruth Pardee, Judy Rich, Michael Rockliff, Steven W. Roth, Melissa Rowland, Laura Schenone, Kerry Sparks, Baruch Sterman, Helen Tworkov, Silvia Vignolini, Michael Walker, Aaron White, Susan Wooldridge, Chris Wojcik, Kirsten Wolf.

BIBLIOGRAPHY

Adams, Jad, *Hideous Absinthe: A History of the "Devil in a Bottle,"* Tauris Parke Paperbacks, London, New York, Melbourne, 2003.

Agosta, William, *Thieves, Deceivers, and Killers: Tales of Chemistry in Nature*, Princeton University Press, Princeton, NJ, 2009.

Bainbridge, James, and McAdam, Marika, *A Year of Festivals: A Guide to Having the Time of Your Life*, Lonely Planet Publications Pty Ltd, Melbourne, 2008.

Bakalar, Nicholas, "The Confusion of Pill Coloring," *The New York Times*, December 31, 2012.

Ball, Philip, *Bright Earth: Art and the Invention of Color*, Farrar, Straus and Giroux, New York, 2002.

Balfour-Paul, Jenny, *Indigo: Egyptian Mummies to Blue Jeans*, Firefly Books, Ontario, 2006.

Batchelor, David, *Chromophobia*, Reaktion Books Ltd., London, 2000.

Bhattacharjee, Yudhijit, "In the Animal Kingdom: A New Look at Female Beauty" *The New York Times*, June 25, 2002.

Bechtold, Thomas, and Mussak, Rita, *Handbook of Natural Colorants*, John Wiley & Sons, Inc., New York, 2009.

Berns, Roy S., *Billmeyer and Saltzman's Principles of Color Technology*, John Wiley & Sons, Inc., New York, 2000.

Birren, Faber, *Color: A Survey in Words and Pictures*, University Books, Inc., New Hyde Park, NY, 1963.

Blaszczyk, Regina Lee, *The Color Revolution*, MIT Press, Cambridge, MA, 2012.

Bloom, Jonathan, and Blair, Sheila (eds.), *And Diverse Are Their Hues: Color in Islamic Art and Culture*, Yale University Press, New Haven, CT, 2011.

Bok, Michael, *Arthropoda*, http://arthropoda.southernfriedscience.com , Ronald Louis, *Rock and Gem: The Definitive Guide to Rocks, Minerals, Gems, and Fossils*, Dorling Kindersley, New York, 2005.

Bradshaw, John, *Dog Sense: How the Science of Dog Behavior Can Make You a Better Friend to Your Pet*, Basic Books, New York, 2011.

Brodo, Irwin M., Sharnoff, Sylvia Duran, and Sharnoff, Stephen, *Lichens of North America*, Yale University Press, New Haven, CT, 2001.

Burris-Meyer, Elizabeth, *Historical Color Guide*, William Helburn, Inc., 1938.

Cahan, David, *Hermann Von Helmholtz and the Foundations of Nineteenth-Century Science*, University of California Press, Berkeley, CA, 1993.

"Causes of Colors," Web Exhibits, http://www.webexhibits.org/causesofcolor

Centers for Disease Control and Prevention, Prussian Blue Fact Sheet, 2010.

Chaline, Eric, *Fifty Minerals and Gems That Changed the Course of History*, Firefly Books, Ontario, 2012.

Changizi, Mark, *The Vision Revolution: How the Latest Research Overturns Everything We Thought We Knew About Human Vision*, Benbella Books, Inc., Dallas, TX, 2009.

Chapman, Reginald Frederick, *Insects: Structure and Function*, Cambridge University Press, Cambridge, MA, 2012.

Chevreul, Michel E., *The Principles of Harmony and Contrast of Colors: And Their Applications to the Arts*, Kessinger Publishing, LLC, Whitefish, MT, 2010.

"Color," *All About Birds*, The Cornell Lab or Ornithology, http://www.birds.cornell.edu/ AllAboutBirds/studying/feathers/color/document_view

Corfidi, Stephen S., "The Colors of Sunset and Twilight," NOAA/NWS Storm Prediction Center, Norman, OK, 1996.

Le Couteur, Penny M., and Burreson, Jay, *Napoleon's Buttons: 17 Molecules That Changed History*, Penguin, 2004.

Cromie, William J., "Oldest Known Flowering Plants Identified By Genes," *Harvard Gazette*, December 16, 1999.

Deutscher, Guy, *Through the Language Glass: Why the World Looks Different in Other Languages*, Metropolitan Books Henry Holt and Company, New York, 2010.

Echeverria, Steve Jr. "The Appeal of 'The Green Fairy,'" *Herald-Tribune*, September 18, 2008.

Fairchild, Mark, *The Color Curiosity Shop*, http://www.cis.rit.edu/fairchild/WhyIsColor

Farrant, Penelope A., *Color in Nature: A Visual and Scientific Exploration*, Blandford, London, 1997.

Finlay, Victoria, *Color: A Natural History of the Palette*, Random House Trade Paperbacks, New York, 2002.

Forbes, Jack D., *Africans and Native Americans: The Language of Race and the Evolution of Red-Black Peoples*, University of Illinois Press, Chicago, 1993.

Fox, Denis L., *Biochromy: Natural Coloration of Living Things*, University of California Press, Berkeley, CA, 1979.

Frazer, Jennifer, "Bombardier Beetles, Bee Purple, and the Sirens of the Night," *Scientific American*, August 2, 2011.

Gage, John, *Color and Culture: Practice and Meaning from Antiquity to Abstraction*, University of California Press, Berkeley, CA, 1999.

Gage, John, *Color and Meaning: Art, Science, and Symbolism*, University of California Press, Berkeley, CA, 1999.

Garfield, Simon, *Mauve: How One Man Invented a Color That Changed the World*, Norton, New York, 2002.

Lanier, Graham, F. (ed.). *The Rainbow Book*, The Fine Arts Museums of San Francisco in association with Shambhala, Berkeley, CA, 1975.

Gray, Theodore, *The Elements: A Visual Exploration of Every Known Atom in the Universe*, Black Dog & Leventhal, New York, 2009.

Greenfield, Amy, Butler, *A Perfect Red: Empire, Espionage, and the Quest for the Color of Desire*, Harper Perennial, New York, 2005.

Guineau, Bernard, and Delemare, Francois, *Colors: The Story of Dyes and Pigments*, Harry N. Abrams, New York, 2000.

Hall, Cally, *Gemstones: The Most Accessible Recognition Guides*, Dorling Kindersley, New York, 2000.

Harley, R. D., *Artists' Pigments C. 1600-1835: A Study in English Documentary Sources*, Butterworth Scientific, 1982.

Harré, Rom, *Pavlov's Dogs and Schrödinger's Cat: Scenes from the Living Laboratory*, Oxford University Press, Oxford, UK, 2009.

Hoffman, Donald D., *Visual Intelligence: How We Create What We See*, W. W. Norton & Co., New York, 1998.

Hutchings, John B., *Expectations and the Food Industry: The Impact of Color and Appearance*, Kluwer Academic/Plenum Publishers, New York, 2003.

Jablonski, Nina G., *Living Color: The Biological and Social Meaning of Skin Color*, University of California Press, Berkeley, 2012.

Keoke, Emory Dean, and Porterfield, Kay Marie, *Encyclopedia of American Indian Contributions to the World: 15,000 Years of Inventions and Innovations*, Infobase Publishing, New York, 2009.

Kuehni, Rolf G., *Color: Essence and Logic*, Van Nostrand Reinhold Company, New York, 1983.

Kuehni, Rolf G., and Schwarz, Andreas, *Color Ordered: A Survey of Color Systems from Antiquity to the Present*, Oxford University Press, Oxford, UK, 2008.

Kuehni, Rolf G., *Color Space and Its Divisions: Color Order from Antiquity to the Present*, Wiley-Interscience, Hoboken, NJ, 2003.

Lidwell, William, and Manacsa, Gerry, *Deconstructing Product Design: Exploring the Form, Function, Usability, Sustainability, and Commercial Success of 100 Amazing Products*, Rockport Publishers, Minneapolis, 2009.

Livingstone, Margaret, *Vision and Art: The Biology of Seeing*, Abrams, New York, 2002.

Logan, William Bryant, *Dirt: The Ecstatic Skin of the Earth*, W. W. Norton & Company, New York, 2007.

Luiggi, Cristina, "Color from Structure," *The Scientist*, February 1, 2013.

Lynch, David K., and Livingston, William, *Color and Light in Nature*, Cambridge University Press, Cambridge, UK, 2001.

MacLaury, Robert E., Paramei, Galina V., and Dedrick, Don (eds.), *The Anthropology of Color: Interdisciplinary Multilevel Modeling*, John Benjamins Publishing Company, Amsterdam, 2007.

Maerz, A., *A Dictionary of Color*, McGraw Hill Book Company, New York, 1930.

"Making Imperial Purple and Indigo Dyes," *Worst Jobs in History*, http://www.imperial-purple.com/clips.html.

McCandless, David, *The Visual Miscellaneum*, Collins Design, an imprint of HarperCollins Publishers, New York, 2009.

McKinley, Catherine E., *Indigo: In Search of the Color That Seduced the World*, Bloomsbury, New York, 2011.

Mijksenaar, Paul, and Westendorp, Piet, *Open Here: The Art of Instructional Design*, Joost Elfers Books, New York, distributed by Stewart, Tabori & Chang, New York, 1999.

Munsell Soil Color Charts, X-Rite Inc., Grand Rapids: MI, 2009, revised edition.

Nassau, Kurt, *Experimenting with Color*, Franklin Watts, a division of Grolier Publishing, New York, 1997.

Nassau, Kurt, *The Physics and Chemistry of Color: The Fifteen Causes of Color*, John Wiley & Sons, Inc., New York, 1983.

Oliver, Harry, *Flying by the Seat of Your Pants: Surprising Origins of Everyday Expressions*, Penguin, London, 2001.

Pastoureau, Michel, *Blue: The History of a Color*, Princeton University Press, Princeton, NJ, 2001.

Pastoureau, Michel, *Black: The History of a Color*, Princeton University Press, Princeton, NJ, 2008.

Petroski, Henry, *The Pencil: A History of Design and Circumstance*, Knopf, New York, 1992.

Pintchman, Tracy, *Women's Lives, Women's Rituals in the Hindu Tradition*, Oxford University Press, Oxford, UK, 2007.

Poinar, George, and Poinar, Roberta, *The Quest for Life in Amber*, Perseus Publishing, New York, 1994.

Portmann, Adolf, Zahan, Dominique, Huyghe, Rene, Rowe, Christopher, Benz, Ernst,

and Izutsu, Toshihiko, *Color Symbolism: Six Excerpts from the Eranos Yearbook 1972*, Spring Publications, Inc. Dallas, TX, 1977.

"Racial Classifications in Latin America," *Zona Latina*, http://www.zonalatina.com/Zldata55.htm

Schopenhauer, Arthur, *On Vision and Colors*, Princeton University Press, Princeton, NJ, 2010.

Shrestha, Mani, Dyer, Adrian G., Boyd-Gerny, Skye, Wong, Bob B. M., and Burd, Martin. "Shades of Red: Bird-Pollinated Flowers Target the Specific Colour Discrimination Abilities of Avian Vision." *New Phytologist*, 2013, 198(1), 301–310.

Slocum, Terry A., *Thematic Cartography and Visualization*, Prentice Hall, Upper Saddle River, NJ, 1999.

Smith, Annie Lorrain, *Lichens*, Cambridge University Press, London, 1921.

Spanish Word Histories and Mysteries: English Words That Come From Spanish, Houghton Mifflin Harcourt, Boston, 2007.

Stevens, Abel, and Floy, James (eds.) *The National Magazine: Devoted to Literature, Art, and Religion, Volume 12*, Carlton and Phillips, 1858.

Sterman, Baruch, and Sterman, Judy Taubes, *The Rarest Blue: The Remarkable Story of an Ancient Color Lost to History and Rediscovered*, Lyons Press, Guilford, CT, 2012.

Tan, Jeanne, *Colour Hunting: How Colour Influences What We Buy, Make And Feel*, Frame Publishers, Amsterdam, 2011.

Taussig, Michael, *What Color Is the Sacred?*, The University of Chicago Press, Chicago, 2009.

Thaller, Michelle, "Why Aren't There Any Green Stars?," *Ask an Astronomer*, http://www.spitzer.caltech.edu/video-audio/150-ask2008-002-Why-Aren-t-There-Any-Green-Stars-

"The Search for DNA in Amber," Interview with Jeremy Austin and Andrew Ross. Natural History Museum, London, http://www.nhm.ac.uk/resources-rx/files/12feat_dna_in_amber-3009.pdf

Theroux, Alexander, *The Primary Colors: Three Essays*, Henry Holt & Company, New York, 1994.

Theroux, Alexander, *The Secondary Colors: Three Essays*, Henry Holt & Company, New York, 1996.

Tufte, Edward R., *Envisioning Information*, Graphics Press, Cheshire, CT, 1990.

US Department of Veteran's Affairs, "The Purple Heart," http://www.va.gov/opa/publications/celebrate/purple-heart.pdf

Vignolini, Silvia, Rudall, Paula J., Rowland, Alice V., Reed, Alison, Moyroud, Edwige, Faden, Robert B., Baumberg, Jeremy J., Glover, Beverly J., Steiner, Ullrich, "Pointillist Structural Color in Pollia Fruit," Proceedings of the National Academy of Sciences of the United States, 2012, 109(39), 15712-15715.

Walsh, Valentine, Chaplin, Tracey, and Siddall, Ruth, *Pigment Compendium*, Routledge, London, 2008.

Whatsonwhen (ed.), *300 Unmissable Events & Festivals Around the World*, John Wiley & Sons, Inc., New York, 2009.

Whitehouse, David, "Oldest Lunar Calendar Identified," *BBC News*, October 16, 2000.

World Carrot Museum, http://www.carrotmuseum.co.uk

Zimmer, Marc, *Glowing Genes: A Revolution in Biotechnology*, Prometheus Books, Amherst, NY, 2005.

PHOTOGRAPHY AND ART CREDITS

Photographs courtesy of Getty Images, including the following, which have further attributions.

Page 10: Science Photo Library. **12:** Apic. **13:** SSPL. **15** (top): UIG. **20:** SSPL. **28:** Buyenlarge. **30 and 32:** Bridgeman Art Library. **37** (top, left): Dorling Kindersley; (center): Oxford Scientific; (bottom, right): hemis.fr. **38** (bottom): UIG. **39:** Bridgeman Art Library. **42** (left): Bridgeman Art Library; (right): AFP. **43** (top, left): Gallo Images; (top right): De Agostini. **44:** Iconica, **45:** Buyenlarge. **46** (left): Lonely Planet Images; (center): Photolibrary; (right): Workbook Stock. **47:** De Agostini. **48:** Flickr. **50:** Stocktrek Images. **53:** NASA. **54:** Science Faction. **55-58:** Oxford Scientific. **59:** Flickr. **60** (top, right): Stone; (top, left): Riser; (center, right): Flickr Open; (center, left): E+; (bottom, right): Dennis McColeman; (bottom, left): Lonely Planet Images. **61** (top, left): E+; (top, right): Flickr; (center left): Lonely Planet Images; (center, right): Alvis Upitis; (bottom, left): Flickr; (bottom, right): Vincenzo Lombardo. **63:** Photodisc. **64:** Flickr Open. **66** (top,left): Comstock Images; (top, center): MIXA Co.Ltd.; (top, right): Gyro Photography; (bottom, left): Flickr; (bottom, center): Maskot; (bottom, right): Flickr. **68:** Radius Images. **73:** UIG. **74:** Dorling Kindersley. **76** (left): Alinari; (right): Foodpix. **77:** UIG. **78:** Christopher Furlong. **79:** Image Bank. **80:** Flickr. **82** (left): Foodcollection; (right): Bryan Mullennix. **83:** Glowimages. **84:** Taxi. **86** (right, center): Tobias Titz; (left): UIG; (left, center): Photodisc; (center): Flickr; (right): Lonely Planet Images. **87:** Flickr Open. **88:** Flickr; (inset): Tetra Images. **89** (left): Flickr Open; (right): Flickr, **90:** National Geographic. **94** (right): Photolibrary; (left, center): DAJ; (right, center): Datacraft Co.Ltd; (left): Photodisc. **95** (right): Koichi Eda; (right, center): Photodisc; (left, center): Datacraft Co.Ltd; (left) Datacraft Co.Ltd. **96** (top, left): Flickr; (top, left, center): Flickr; (top, right, center): Datacraft Co.Ltd; (top, right): Photodisc; (bottom, left): Bambu Productions; (bottom, left, center): Digital Vision; (bottom, right, center): National Geographic; (bottom, right): Stockbyte. **97:** Flickr. **98** (garnet): Dorling Kindersley; (iron and copper): De Agostini. **99** (manganese): De Agostini; (jade): Photononstop; (ruby): Dorling Kindersley. **100:** UIG, **101** (right): Flickr Open. **104** (right): Frank Cezus; (left): Science Photo Library; (center, bottom): Flickr; (center left and right): Dorling Kindersley. **105** (bottom, left): Flickr; (top right and left): Dorling Kindersley; (bottom, right): E+. **109:** UIG. **110** (top): Stockbyte; (bottom): Galerie Bilderwelt. **111:** Image Bank. **112:** Flickr Open. **117:** Vetta. **118-119:** AFP. **120:** Stock4B. **122** (left): Flickr; (center and right): National Geographic. **124** (top): Visuals Unlimited; (center, left): National Geographic; (center, right): Visuals Unlimited; (bottom): Oxford Scientific. **125:** Flickr. **126** (apricot and tomato): Rosemary Calvert; (chilis and sweet potato): E+. **127** (onion and oranges): Rosemary Calvert; (blueberries): Stuart Minzey; (grapes): Bernard Jaubert; (top , right): Gyro Photography; (top, center): Photodisc; (top, left): Datacraft Co.Ltd. **129** (left, bottom): E+; (right): Datacraft Co.Ltd. **130:** ImageBank. **132** (top, left and right; bottom, left): Photodisc. **133** (top): Imagemore; (bottom): Oxford Scientific, **134** (bottom)-**135:** Minden Pictures. **136:** Flickr. **137** (clockwise from top): Photodisc; Dorling Kindersley; Lifesize; E+; E+; Photographer's Choice; E+; Stockbyte; Flickr; Flickr; Flickr. **138** (center): Flickr. **142:** Gallo Images. **143** (left): Science Photo Library; (right): Stockbyte, **147** (center): UIG; (bottom): Lonely Planet Images. **148** (right): Fotosearch. **149** (left): ImageBank; (right): Bridgeman Art Library; (left, bottom): Peter Arnold. **152:** Flickr. **153** (top): Bridgeman Art Library. **154:** Bridgeman Art Library. **155** (left and right): SSPL. **156:** Dorling Kindersley. **159:** Stockbyte. **160** (left to right): Stockbyte; Stockbyte; Seide Preis; Flickr Open; Photodisc; Photolibrary; National Geographic; Digital Vision; E+; Flickr; Gallo Images; Flickr; Flickr Open; (bottom): Flickr. **161:** Flickr. **162** (left to right): E+; Flickr; Dorling Kindersley; Photodisc; Photodisc; Digital Vision; Photodisc; E+. **164:** Imagebroker. **165** (left): Photodisc; (inset): E+. **167:** Gary Vestal. **169:** Digital Vision. **170:** Comstock Images. **171** (top, left): E+; (right): Stockbyte. **172** (top, left): Flickr; (top, right): Digital Vision; (bottom, left): Photodisc; (bottom, right): Minden Pictures. **173** (top, left): Visuals Unlimited; (right): Minden Pictures. **174** (top): Stone; (bottom, left): Dorling Kindersley; (bottom, right): E+; (right): Dorling Kindersley. **175** (top): Flickr; (top, left): Oxford Scientific; (top, center and right): Flickr; (bottom, center): UIG; (bottom, left): Comstock Images; (bottom, right): Stocktrek Images. **176** (bottom, right):

Imagemore. **177** (left): Gallo Images; (top, left): Design Pics; (top, center): Digital Vision; (top, right): National Geographic; (center, left): Dorling Kindersley; (center, center): Flickr; (center, right): Design Pics; (bottom, left and center): Design Pics; (bottom, right): Dorling Kindersley. **178** (left): Flickr; (right, center): E+; (right): AFP. **179** (top, right): National Geographic; (right, bottom): Flickr; (left top and center): Flickr. **180** (right): Flickr. **184:** (left): Panoramic Images; (center): Photodisc; (right): Dorling Kindersley. **185:** Dorling Kindersley. **186** (left): De Agostini; (right): UIG; (bottom): Dorling Kindersley. **192** (center): E+; (right): UIG. **195:** Photodisc. **196:** Science Photo Library. **198:** AFP. **206:** Axiom. **207:** UpperCut Images. **208** (left): Photolibrary; (center): Photodisc; (right): Vetta. **210:** AFP. **215** (left): Buyenlarge. **216** (top left and right): Image Bank; (center, left): China Span; (center, right and left): Loney Planet Images; (bottom, right) Photodisc. **217** (top, left): hemis.fr; (top, right): Stockbyte; (center, left): LOOK; (center, right): Dorling Kindersely; (bottom left and right): Lonely Planet Images. **224:** SSPL. **225:** Lonely Planet Images. **227:** Don Farrall. **228:** De Agostini. **229:** Franco Origlia. **230:** Time & Life Pictures.

ADDITIONAL PHOTOGRAPHY AND ART CREDITS

Page 14: (bottom) Color Sphere in 7 Light Values and 12 Tones, Johannes, Itten. Digital Image © The Museum of Modern Art/Licensed by SCALA/Art Resource, NY; (center) Proofs for the artist's illustrated "Color Sphere," Philippe Otto Runge. bpk, Berlin/Art Resource, NY. **Page 19:** Copyright © Sam Schmidt. **Page 24:** (left and right) Arielle Eckstut. **Page 31:** Electric Prisms, 1914 by Sonia Delaunay-Terk. SCALA/Art Resource/NY. **Page 32:** (left, center) Study for Homage to the Square: Beaming, 1963, Josef Albers. Tate, London/Art Resource, NY; (right, center) Hommage to the Square: Mild Scent, 1965, Josef Albers. bpk, Berlin/Art Resource, NY. **Page 33:** (top) Study for Homage to the Square, 1969, Josef Albers. Albers Foundation/Art Resource, NY; (bottom) Untitled, 1969 by Mark Rothko. Art Resource, NY. **Page 38:** (top left and right) Juan Cazorla Godoy. **Page 41:** Copyright © Peggy Vigil Herrera. **Page 43:** (bottom) Tara Bradford. **Page 44:** (center) Stefan/Volk/Laif/Redux. **Page 51:** SPL/Photo Researchers. **Page 74:** (right) Kimberly Hughes. **Page 93:** (bottom, left and right) Stan Celestain. **Page 99:** (chromium) Mohd Alshaer; (emerald and amethyst) Stan Celestain; (tourmaline) Jacana/Photo Researchers. **Page 102:** Munsell Soil-Color Charts, Produced by Musell Color. **Page 115:** Historic Koh-I-Noor pencil and relics. Courtesy of Chartpak, Inc.; Hi-Liter. Property of Avery Dennison Corporation. **Page 116:** "A Few Things the Versatile Yellow Kid Might Do for a Living." Billy Ireland Cartoon Library & Museum, The Ohio State University. **Page 123:** Fruits of Pollia condensata conserved in the Herbarium collection at Royal Botanic Gardens, Kew, United Kingdom. Material collected in Ethiopia in 1974 and preserved in alcohol-based fixative. (Image from Paula Rudall.) **Page 124:** (right) Alamy. **Page 126:** (top, left) Nnehring/iStockPhoto. **Page 128:** Emily Mahon. **Page 129:** (top, left) Arielle Eckstut. **Page 132:** (bottom, right) Adam Carvalho. **Page 134:** (top) Owen McIver. **Page 138:** (top and bottom): Kevin Collins. **Page 140 and 141:** All photos courtesy of Taylor F. Lockwood. **Page 148:** (left) Matthew Coleman. **Page 150:** Procession of the Magi, Benozzo Gozzoli. SCALA/Art Resource, NY. **Page 153:** (bottom) Paris Green. Photograph by Theodore Gray, www.periodictable.com. **Page 165:** (right top and bottom) Robert Fosbury. **Page 166:** Robert Fosbury. **Page 167:** (top) Courtesy of The American Museum of Natural History; (left) Courtesy of Paul Sweet, The American Museum of Natural History. **Page 171:** (left, bottom) Jason Farmer. **Page 173:** (bottom, left) Steve Patten. **Page 176:** (left, center) Roger Hanlon; (coral snake) Paul Marcellini. **Page 180:** (left) Ted Kinsman/Photo Researchers. **Page 181:** Michael Bok. **Page 187:** Society of Dyers and Colourists—Colour Experience. **Page 188:** The Great Wave at Kanagawa by Katsushika Hokusai. © RMN-Grand Palais/Art Resource, NY. **Page 190:** (left) Hanoded photography/istockphoto; (center and inset) © 2008 Photography by Hangauer/Kissinger. **Page 192:** Mark Thiessen/National Geographic Stock. **Page 200:** (left) © Soames Summerhays/Science Source/VISUALPHOTOS.COM; (center) Pierre David. **Page 202:** World Skin Color Country Maps by Reineke Otten www.worldskincolors.com **Page 205:** The Empire of Light II by René Magritte. Digital Image © The Museum of Moder Art/Licensed by SCALA/Art Resource, NY. **Page 209:** God creating the waters, detail of folio of late 12th-century Souvigny Bible. Gianni Dagli Orti/The Art Archive at Art Resource, NY; Spectrum, IV. 1967 by Ellsworth Kelly. Digital image © The Museum of Moder Art/Licensed by SCALA/Art Resource, NY. **Page 212:** Copyright Transport for London, May 2013. **Page 213:** (top, right) Rust-Oleum Industrial Brands. **214:** (top) Minnesota Vikings Football, LLC and the Minnesota Sports Facilities Authority. Medieval Flags by Hilarie Cornwell. **Page 215:** Logo Rainbow by Dan Meth. **Page 223:** (left and right) Baruch Sterman. **Page 224:** Fabio Marongiu. **Page 231:** American Independence Museum, Exeter, NH. **Page 232:** IKB 79, 1959 by Yves Klein. Tate, London/Art Resource, NY.